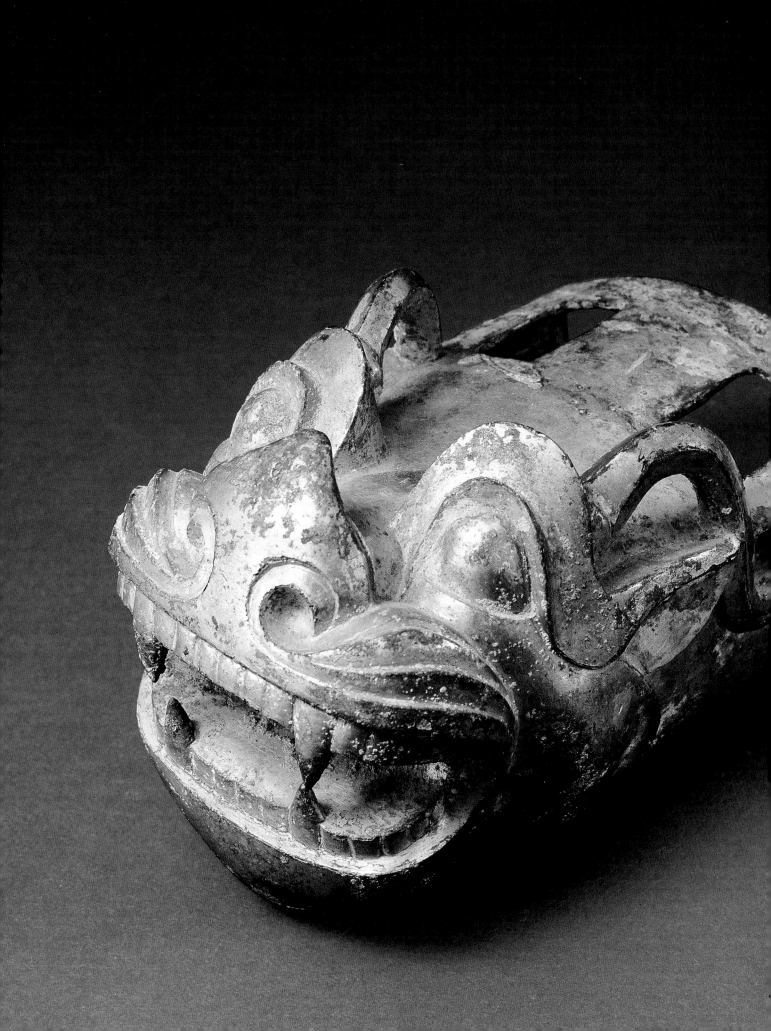

Providing for the Afterlife
"Brilliant Artifacts" from Shandong

Susan L. Beningson and Cary Y. Liu

with contributions from
Annette L. Juliano, Zhixin Sun, and David A. Graff

Edited by J. May Lee Barrett

An exhibition organized by the China Institute Gallery
in collaboration with the
Shandong Provincial Museum

China Institute Gallery
China Institute
New York
2005

Distributed by Art Media Resources, Ltd.

This catalogue was published to accompany the exhibition
Providing for the Afterlife: "Brilliant Artifacts" from Shandong
Organized by China Institute Gallery in collaboration with the
Shandong Provincial Museum
February 3—June 4, 2005

China Institute Gallery
125 East 65th Street
New York, NY 10021
212.744.8181

General Editor and Project Director: Willow Weilan Hai Chang
Editor: J. May Lee Barrett
Designer: Peter Lukic
Catalogue photos courtesy of the Shandong Provincial Museum
Printed in Hong Kong by Pressroom Printer and Designer

The *pinyin* system of romanization is used throughout the text and
bibliography except for the names of Chinese authors writing in Western
languages. Chinese terms cited in Western-language titles remain in their
original form and have not been converted.

China Institute was founded in 1926 by American philosopher John Dewey
and Chinese educator Hu Shih, together with other prominent educators.
It is the oldest bi-cultural and educational organization in the United States
with an exclusive focus on China and is dedicated to promoting the
understanding, appreciation, and enjoyment of Chinese civilization, culture,
heritage, and current affairs through classroom teaching and seminars, art
exhibitions, public programs, teacher education, lectures, and symposia.

Cover illustration (cat. no. 3)
Bird with *ding* vessels
Western Han dynasty (206 BCE–9 CE)
Clay with natural pigment
Collection of Jinan Municipal Museum

Frontispiece (cat. no. 39, detail)
Chariot fitting—draught pole ornament, *yuan shou shi*
Western Han dynasty (206 BCE–9 CE)
Gilt bronze
Collection of Shandong Provincial Museum

Contents

SPONSORS OF THE EXHIBITION

*This exhibition and catalogue have been made possible in part through the generous support of the following**

PATRONS
Blakemore Foundation
E. Rhodes and Leona B. Carpenter Foundation
Lee Foundation, Singapore
New York State Council on the Arts * *

LEADERS
Robert T. and Kay F. Gow
Mary and James G. Wallach Foundation

CONTRIBUTOR
Anonymous donors

SUPPORTERS
John R. and Julia B. Curtis
Margro R. Long
J.J. Lally & Co. Oriental Art
New York Council for the Humanities * * *
Jeannette N. Rider
Marie-Hélène and Guy A. Weill

INDIVIDUALS
Robert H. Ellsworth
Nancy and Hart Fessenden
Robert W. and Virginia Riggs Lyons
Joyce H. and Robert E. Mims
Mechlin and Valerie Moore

We are also grateful for the continuing support to China Institute Gallery from
The Starr Foundation
China Institute's Friends of the Gallery

* At time of printing.
* * This exhibition and publication is made possible with public funds from the New York State Council on the Arts, a State Agency.
* * * New York Council for the Humanities is a state affiliate of the National Endowment for the Humanities. Any views, findings, conclusions or recommendations expressed in this publication do not necessarily represent those of the National Endowment for the Humanities.

LENDERS TO THE EXHIBITION

Changqing County Museum
Jinan Municipal Museum
Linyi Municipal Museum
Shandong Provincial Museum
Zhangqiu Municipal Museum

MESSAGE FROM THE BOARD OF TRUSTEES

Interest in China is flourishing in the face of its astounding economic growth in recent decades. This great Asian country stands ready to fast forward to world leadership in industry and technology. As with its economic growth, the pace of archaeological discoveries in China has also been rapid. They serve as reminders not only of the antiquity and continuity of Chinese civilization but also of its previous exchanges with the West and other Asian cultures. The present exhibition, culled from recent archaeological finds in Shandong Province, is one of the fruits of these discoveries.

China Institute, a non-profit educational organization, has pursued a mission since 1926 to promote an understanding of Chinese civilization and culture. The many exhibitions organized by the China Institute Gallery since 1966 have contributed to its success in that mission. *Providing for the Afterlife: Brilliant Artifacts from Shandong* continues that mission by offering people today a window into the way Chinese people lived and died some two thousand years ago.

Beyond educating the public, China Institute Gallery's exhibitions have also promoted scholarly research, especially among young emerging scholars. Beginning in 2003, we have been able to work directly with museums in the People's Republic of China to organize loan exhibitions and to initiate the presentation of original research. *Providing for the Afterlife: Brilliant Artifacts from Shandong* was one of several ideas suggested to the Gallery Committee by officials from Shandong Provincial Museum. It has been beautifully implemented by China Institute's gallery director Willow Weilan Hai Chang and co-curators Susan L. Beningson and Cary Y. Liu.

On behalf of the Trustees of China Institute, I would like to thank the Director of the Shandong Provincial Museum, Lu Wensheng. I would also like to thank Willow Weilan Hai Chang and the entire Gallery staff, my fellow Trustees, the devoted Friends of the Gallery, the sponsors of this exhibition, and the continuing support of The Starr Foundation.

Virginia A. Kamsky
Chair

前言

在《山東省西漢王陵出土文物》展覽開幕之際，我謹向為舉辦這個展覽付出巨大努力的紐約華美協進社中國美術館，向關心和支持這個展覽的美國朋友們致以衷心的感謝！

山東省處於中國大陸東端，中華民族的母親河—黃河由此入海。自古以來就是中國經濟文化最發達的地方。在距今約兩千五百年前的春秋時代，是當時中國思想文化最活躍和最輝煌的時期。孔子、孟子等一大批思想家就生活在山東，他們創立的儒家學說，成為影響中國幾千年的主流思想。繁榮的文化是建立在發達的經濟基礎之上的，山東地處沿海，境內有多處鐵礦，有"鹽鐵之利"。漢代山東的鐵產量佔全國的一半以上。山東的絲織業發達，素有"冠帶衣履天下"的美譽，是絲綢之路的起點。

漢王朝是中國歷史上第二個統一的封建王朝，也是中國古代政治制度、思想觀念、文化傳統基本確立的時代。漢代實行了郡縣制和分封制並行的行政管理制度，皇帝將功臣子侄分封到全國各地，建立起一批大小不一的諸侯王國。富庶的山東地區，先後分封了幾十個諸侯王國。

這個展覽展出的文物，多出自于西漢前期（公元前二百年左右）的諸侯王墓中。這些文物展現了古代中國人的聰明智慧，也從不同角度反映了當時諸侯王的生活習俗。

願這個展覽能給美國觀眾們以美的享受，從中領略到輝煌的中國古代文明的風采。

魯文生
館長
山東省博物館

MESSAGE FROM THE SHANDONG PROVINCIAL MUSEUM

On the occasion of the opening of "Providing for the Afterlife: 'Brilliant Artifacts' from Shandong," I'd like to extend my sincerest appreciation to China Institute Gallery, whose tireless efforts have made the exhibition possible, as well as to all the friends in the United States who supported this grand show.

Located on the eastern end of China with the Yellow River—the Mother River of the Chinese—flowing through it into the East China Sea, Shandong province has had a highly developed culture and economy since antiquity. In fact it was here in Shandong, as far back as 2,500 years ago during the Spring and Autumn Period, the era in which different Chinese schools of thought flourished, that a large group of major thinkers emerged, most prominently Confucius and Mencius. Indeed, Shandong was the birthplace of Confucianism, which has reigned as the main school of thought in China, helping to shape the Chinese mind over the past two millennia.

Any great culture must be based on a solid economic foundation. As a coastal province abundant with iron mines, Shandong has earned itself the title of a "land of salt and iron." During the Han dynasty the output of iron in Shandong made up more than half of the total production in China. In addition, the making of silk and crepe de chine in Shandong has been historically so advanced and refined that the province well deserves its reputation as the "capital of sartorial splendor unsurpassed," a designation which marked Shandong as the starting point of the "Silk Road."

The Han dynasty (206 BCE–221 CE), the second imperial dynasty of a unified China following that of Qin (255–206 BCE), is characterized as the period during which China's ancient political system, philosophical thoughts, and cultural traditions were firmly established. And, with the establishment and practice of a system of prefectures and counties and a system of enfeoffment, the Han emperors handed over fiefdoms to their favorite dukes and princes all over China, which resulted in many states of different sizes. During this period, scores of such states were founded in the rich land of Shandong.

Most of the artifacts in this exhibition are from the tombs of the dukes and princes of the Western Han period (ca. 200 BCE). As a clear manifestation of the artistic creativity of the ancient Chinese, these relics and works of art shine much as a mirror reflecting the daily lives and customs of the rulers of these states.

I hope whole-heartedly that this exhibit will provide the viewers in America with a feast of beauty, through which the magnificence of China's cultural past can be fully enjoyed.

Lu Wensheng
Director

Translated by Ben Wang

FOREWORD

The name *Shandong*, literally "east of the mountain," first appeared in the Warring States period (ca. 475–221 BCE) in reference to the land on the east side of Mount Hua, located in today's Shaanxi province, or Mount Xiao, located in today's Henan province. Present-day Shandong province, encompassing the ancient states of Lu and Qi, lies along the eastern coast where it faces the Korean peninsula across the Yellow Sea. It includes lofty Mount Tai, most famous of the Five Sacred Mountains of China, and the flat plains of the Huang-Huai delta. Here is where the great "mother river," the Huanghe or Yellow River, empties itself into the Sea after running across the width of China from its source in the Kunlun Mountains far to the west.

This region is important as one of the birthplaces of ancient Chinese civilization, with archaeological evidence as early as the Neolithic ceramics of the Beixin culture seven thousand years ago. The discovery of subsequent Neolithic cultures added to the reknown of this area, but the province already had a proud history of great cultural achievements from later ages. It was the birthplace of many influential figures, notably, Kong Qiu (551–479 BCE), known to the West as Confucius. This ancient teacher has been respected as the sage of education throughout Chinese history; his ideology became the spiritual pillar of the feudal dynasties and formed the core of traditional Chinese culture. In addition, the military geniuses Sun Wu, author of "The Art of War" (see cat. no. 17) during the Spring and Autumn period (ca. 770–456 BCE), and his descendant Sun Bing of the Warring States period are both the natives of Shandong; the influence

of their theories has extended beyond Chinese military history into the modern business world.

During the Han dynasty (206 BCE–220 CE), Shandong was one of the most prosperous areas in the nation. Its industries were involved in the making of such essential consumer products as salt, metals, and textiles. The dynamic commercial environment of this area provided economic support for the custom of elaborate funerals throughout the Han dynasty.

Since the mid-twentieth century, Shandong has been one of the premier archaeological locations in the nation for the large quantity and importance of its excavated Han dynasty tombs. It is known not only for the distinctive local characteristics of its artifacts, but also for the most studied pictorial tomb carvings from this period. Several of these Shandong tombs belong to princes, local rulers under the Han dynasty who received their titles through enfeoffment or inheritance.

This exhibition offered China Institute Gallery a great opportunity to introduce discoveries from the important Han dynasty tombs of Shandong province to an overseas audience for the first time. These special artifacts, made in a variety of media for burial in the subterranean world of the deceased, vividly reveal the aspirations of the Han people and their beliefs about an ultimate afterlife.

From initiation to completion, this project is indebted to a great many participants and contributors on both sides of the world. First of all, I would like to thank Mr. Liu Boqin of the Jinan City Cultural Relics Bureau and Director Lu Wensheng of the Shandong Provincial Museum, who first brought the exhibition

proposal to my attention so that I could present it to the China Institute Gallery Committee. I would especially like to thank Director Lu for being so accommodating of the requests made by the guest curators and for the important role he played in coordinating the loans from several local museums. My gratitude is extended to the staff of the Shandong Provincial Museum, especially to Mr. Wang Zhihou, Curator of the Collections Department, for their assistance and to the people at the National Cultural Relics Bureau, especially Meng Xianmin, Zhang Jianxin, Peng Changxin, and Ding Junjun, for their support.

I am deeply indebted to all the foundations, government agencies, and individual sponsors of the exhibition whose support kept this innovative exhibition from becoming an unfulfilled dream. The trustees of the China Institute, and especially the loyal members of the Friends of the Gallery, also provided invaluable support in this undertaking. They have my heart-felt gratitude not only for making this exhibition possible, but also for their commitment to maintaining the high standards and reputation of the China Institute Gallery.

I would like to thank the Gallery Committee, which at the time was chaired by John Curtis, for accepting the proposal. Our guest curators Susan Beningson, Project Coordinator at Princeton University Art Museum and Ph.D. candidate in Chinese Art at Columbia University, and Cary Liu, Curator of Asian Art at the Princeton University Art Museum, are to be thanked for their dedication and tremendous effort in interpreting the wonderful selection of objects in this exhibition. My sincere gratitude is also extended to many other specialists who contributed their expertise and talents to this project: Annette Juliano, Zhixin Sun, and David Graff, for their scholarly entries in the exhibition catalogue; Ben Wang, for his eloquent translation of the message from Director Lu Wensheng; J. May Lee Barrett, for her careful and knowledgeable editing of a complex manuscript; Perry Hu, for his tasteful installation design; Peter Lukic, for designing this handsome publication under the pressure of an unprecedented short time frame; and Nicole Straus and Margery Newman, for their efforts to promote the exhibition and reach a wider audience.

The entire China Institute staff, as always, are to be thanked for their patience and supportive assistance whenever the need arose. My special thanks go to the president of China Institute, Mr. Jack Maisano, and to the vice-president, Dr. Nancy Jervis, for their diplomacy. Special thanks also go to the devoted gallery staff, Jennifer Choiniere and Pao Yu Chen, for handling the numerous and often difficult tasks that ensured the successful completion of the catalogue and mounting of the exhibition, and to France Pepper, Associate Director of Public Programs, for arranging the exhibition symposium and related lectures. My heartfelt gratitude and love go to the Gallery Docents and Volunteers for their generous devotion.

Finally, for all those who contributed their help and support, this publication is testament to a remarkable achievement that we proudly share with the public.

Willow Weilan Hai Chang
Director
China Institute Gallery

PREFACE

The idea for this exhibition came about as a result of perfect timing. We were working at Princeton University Art Museum on an exhibition entitled "Recarving China's Past: The Art, Archaeology, and Architecture of the 'Wu Family Shrines'" to be held in the spring of 2005. Completely steeped in the archaeology of Han dynasty Shandong, we discussed with Willow Wei-lan Hai Chang, Director of the China Institute Gallery, the idea of pursuing new loan shows from China. China Institute Gallery's first exhibition from China, "Passion for the Mountains: Seventeenth Century Landscape Painting from the Nanjing Museum," which took place at China Institute in the fall of 2003, had already been scheduled. In preliminary talks with Mr. Liu Boqin, Director of the Cultural Relics Division, Shandong Jinan Cultural Relics Bureau, at the end of 2001, Willow discussed the possibility of an international exhibition at China Institute Gallery. Shortly after that, Director Lu Wensheng of the Shandong Provincial Museum sent over several proposals including one containing the core objects in our current exhibition. In the spring of 2002, we went on a whirlwind tour of Shandong with the core team of the Princeton exhibition: Michael Nylan, Professor of History at the University of California at Berkeley, who specializes in Han his-

tory and culture; Anthony Barbieri-Low, Assistant Professor of History at the University of Pittsburgh and an authority in Chinese archaeology; and David Sensabaugh, Curator of Chinese art at Yale University Art Gallery. Together, we visited every conceivable locality to explore Eastern Han pictorial stone carvings and to learn more about the "Wu Family Shrines." On the same trip we had our initial meetings with Director Lu Wensheng and his colleagues at the Shandong Provincial Museum, who along with Mr. Liu Boqin became our key partners in bringing this exhibition to fruition. At that time we began the process of choosing objects and meeting with scholars throughout Shandong, working on both projects as companion exhibitions.

We returned to Shandong in the spring of 2004 accompanied by Dr. Barbieri-Low and Annette L. Juliano, Professor of Asian Art and Associate Dean of the Faculty of Arts and Sciences, Rutgers University-Newark. During both trips Director Lu had been invaluable in arranging for us to visit tomb sites at Weishan, Shuangrushan, Yinan, and Anqiu; in acting as the liaison with all the local museums in Shandong who are loaning us their treasures; and in helping us meet the archaeologists and scholars who excavated the sites where our exhibition objects originate and who know these objects best. We also greatly appreciate his providing

us with the excavation photos that are in the catalogue essay. For their assistance and cooperation, we would also like to thank the directors and staff of the following Shandong museums and institutions: Shandong sheng bowuguan, Shandong sheng Jinan shi wenwu ju, Shandong sheng shike yishu bowuguan, Jinan shi bowuguan, Changqing xian bowuguan, Zhangqiu shi bowuguan, Linyi shi bowuguan, Shandong sheng wenwu kaogu yanjiusuo, Shandong sheng Jiaxiang xian wenwuju- Wushici wenguansuo, Shandong sheng wenhua ting, Shandong sheng wenhua ting wenwu ju, and Shandong sheng wenhua ting wai shi chu. We would also like to extend our heartfelt thanks to Willow Hai Chang, for both her help and patience in this project and for using her magical negotiating skills in China to make this exhibition a reality. This exhibition could not have taken place without her hard work and guidance. At China Institute we would also like to thank the following people: John Curtis, who chaired the Gallery Committee when we began this process and shared our vision of creating a treasure chest of objects from Shandong; Yvonne Wong, who is the current chair of the committee; Virginia Kamsky, Chair of the Board, who is leading China Institute forward to new heights; the Gallery Committee and Trustees of China Institute; Jennifer Choiniere of the gallery staff for all her help; France Pepper and Nancy Jervis, who created the programming for the exhibition; and Jack Maisano, President of the China Institute. We would also like to thank J. May Lee Barrett, who has greatly improved the text of this catalogue with her care and sensitivity.

In addition to their respective catalogues, the China Institute and Princeton exhibitions will be accompanied in the spring of 2005 by two companion symposiums: "The Afterlife in Han China: A Closer Look at the Meaning of 'Brilliant Artifacts'," to be held at China Institute, and "Recarving China's Past: The Art, Archaeology, and Architecture of the 'Wu Family Shrines'," to be held at Princeton University Art Museum.

Susan would also like to thank the Department of Art History and Archaeology at Columbia University, where she is a Ph.D. candidate, and her dissertation committee—Robert E. Harrist Jr., Columbia University, Annette L. Juliano, and Buzzy Teiser, Princeton University—for their patience and support.

At Princeton University, we would like to thank Susan M. Taylor, Director of Princeton University Art Museum, for her unwavering support and the Department of Art and Archaeology for research and travel funding.

We extend special appreciation to our catalogue authors for their participation: Annette L. Juliano, who is also on the gallery committee, Sun Zhixin of the Metropolitan Museum of Art, and David A. Graff of Kansas State University.

Susan L. Beningson
Cary Y. Liu
Princeton University Art Museum
November 2004

CHINESE SUMMARY
中文簡介

古代中國人認為，人死後，就到另一個世界去生活了。這個世界，就叫做"冥界"也叫做"陰間"。既然是到另外的世界去生活，就需要房屋和生活用品。所以人死後，要依據他生前的地位和財富來建造墳墓，叫作"陰宅"，是供亡靈在陰間住的房屋。安葬死者時，除了一定的儀式外，也同時葬入部分生活用品和專門為隨葬製作的物品，叫做"冥器"，也叫"明器"，供他在陰間使用。在封建等級制度下，墓葬規模的大小，隨葬物品的質量和多少，都有一定的規格，依墓主生前的社會地位而定。社會地位高的人，如王、侯、將、相，除了隨葬金銀銅玉器外，還要隨葬一些陶俑，以象徵他們生前的服從侍衛，在陰間也可向主人提供各種服務。

西漢時劉氏皇朝籍分封制，將自己的皇室成員委任到各地，劃地為政，類似諸侯國，以拱衛皇朝的中央統治。山東在漢代是全國經濟最富饒的地區之一，劉氏和呂氏皇室成員都先後在此為各國的諸侯王。因此，自二十世紀五十年代以來，在山東省眾多的漢墓發掘中，便有好幾座王陵令人矚目，據目前資料所知，大約有濟北王、濟南王、魯王和呂王陵等。本展覽展出的是以這些諸侯王的陵墓為主的各類出土文物，這些隨葬的物品，形象地反映了墓主人生前的地位和生活細節。諸侯王陵墓中隨葬的器物，大體上可分為以下幾種：

一是各種俑。俑按人世間的職責，分為幾種：武士俑象徵侍衛、儀仗隊；女俑象徵侍女；廚俑象徵做飯的廚師；舞俑象徵著提供舞樂的藝人。各種各樣的俑可以從俑的服飾、姿態以及在墓葬中的位置判斷出來。

二是車馬俑，象徵墓主人生前使用的車馬。在諸侯王的陵墓中，通常隨葬他生前使用的真車真馬，車馬腐朽後留下精美的車飾和馬具馬飾。漢代規定，只有皇帝和諸侯王才能使用鎏金的車馬具和飾品。

三是生活用具，如盛肉食的鼎、盛酒的壺、熏香用的熏爐、生前讀的書（竹簡）、使用的印章等。這一類器物，往往是用墓主人生前使用過的器物隨葬。除了這些小件的生活用具，漢代還流行將水井、爐灶、房屋等做成模型隨葬。

再一類是墓主人的葬具，包括棺、槨、穿的衣服和佩帶的飾品等等。漢代的人相信用玉做的葬具可以使人肉體不朽，諸侯王可以用玉衣殮葬，差一些的就用玉面罩和玉九竅塞來代替。

總之，隨葬的器物，都與墓主人的身份地位和生活習慣有關，並受當時的風俗時尚影響，也受封建等級制度的各項規定的制約。這次展覽的漢王陵文物，不僅反映出墓主人生前的生活，而且這些隨葬的精美器物，也間接地透露了漢代山東地區的社會文化面貌以及在藝術上的造詣。

劉伯勤

CHRONOLOGY
Chinese Dynasties and Historical Periods

Golden Age of Antiquity	prior to Xia dynasty
Xia dynasty	21st–16th c. BCE
(Erlitou period)	19th–16th c.
Shang	16th–11th c.
Zhou	11th c.–256
Western Zhou	11th c.–771
Eastern Zhou	770–256
Qin	221–206
Han	206 BCE– 220 CE
Western Han	206 BCE–CE 9
Xin (interregnum)	9–23 CE
Eastern Han	25–220
Six Dynasties	220–589
Three Kingdoms	220–280
Wu	222–280
Shu Han	221–263
Wei	220–265
Western Jin	265–317
Eastern Jin	317–420
Period of Northern and	
Southern Dynasties	386–581
Sui	581–618
Tang	618–906
Five Dynasties	907–960
Song	960–1279
Northern Song	960–1127
Southern Song	1127–1279
Jin	1115–1234
Yuan	1279–1368
Ming	1368–1644
Qing	1644–1911

Rulers of the Han Dynasty

Dynastic Title	Personal Name	Accession
(Western Han)		
Gaodi	Liu Bang	206 BCE
Huidi	Liu Ying	194
Gaohou	Lü Exu	187
Wendi	Liu Heng	179
Jingdi	Liu Qi	156
Wudi	Liu Che	140
Zhaodi	Liu Fuling	86
Xuandi	Liu Xun	73
Yuandi	Liu Shi	48
Chengdi	Liu Ao	32
Aidi	Liu Xin	6
Pingdi	Liu Kan	1 CE
Ruzi ying	Liu Ying	6
Wei Xin	Wang Mang	9
Huaiyang Wang		
or Gengshidi	Liu Xuan	23
(Eastern Han)		
Guangwudi	Liu Xiu	25
Mingdi	Liu Zhuang	58
Zhangdi	Liu Da	76
Hedi	Liu Zhao	89
Shangdi	Liu Long	106
Andi	Liu You	107
Shundi	Liu Bao	126
Chongdi	Liu Bing	145
Zhidi	Liu Can	146
Huandi	Liu Zhi	147
Lingdi	Liu Hong	168
Shaodi	Liu Ban	189
Xiandi		
or Mingdi	Liu Xie	189

MAP OF CHINA AND SHANDONG

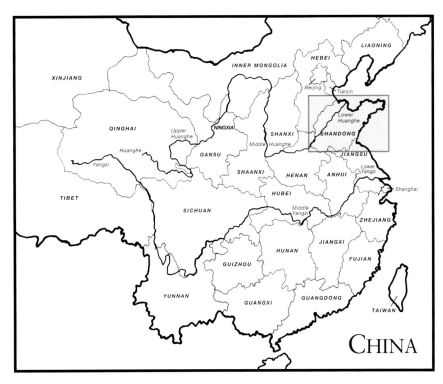

CHINA

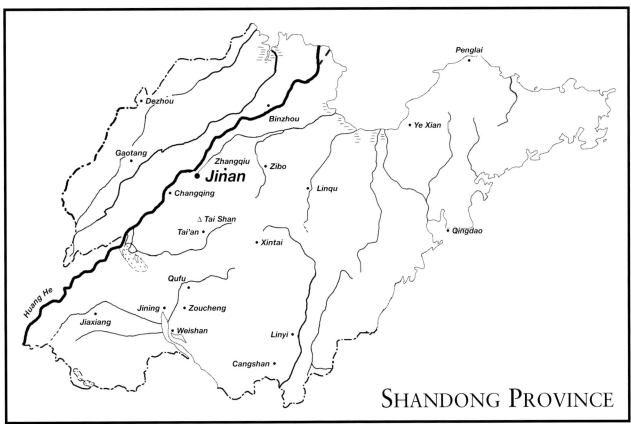

SHANDONG PROVINCE

THE SPIRITUAL GEOGRAPHY OF HAN DYNASTY TOMBS

Susan L. Beningson

Received ritual literature from the Han and earlier dynasties describes in great detail the proper rites for mourning and burying the dead, but does not fully illuminate the expectations for the afterlife from the perspective of the deceased. Archaeologically excavated evidence can help us understand how the contents of a tomb, in terms of the types of objects and their material, imagery, and placement, combined to express an ideal of the afterlife. This complex system of representation served to put the deceased in the most advantageous position from which to ascend to heaven. In the Han dynasty, tomb furnishings and grave goods were thought to provide for the deceased a celestial palace with all the comforts of an idealized home. The tomb would contain favorite objects of the deceased, as well as objects denoting his rank and status, for example, the chariot fittings inlaid with gold and silver (cat. nos. 28–31), and the gold seals in the form of tortoises (cat. nos. 14–15) in our exhibition. These inlaid chariot ornaments were excavated from the royal tomb at Shuangrushan in Changqing county, where Liu Kuan (r. 97–85 BCE), the last ruler of the Jibei Kingdom, reigned during the Western Han dynasty. Tomb 1 is the largest rock-cut royal tomb yet found (fig. 1), and its structure is yet another indicator of the royal status of the deceased. The jade facemask (cat. no. 34) included in the burial (fig. 2) along with other jades (cat. nos. 35–38) and gold ingots (cat. no. 33) indicate that he was still entitled to be buried with a high rank in spite of his licentious behavior with his father's widow, which forced him to commit suicide.[1]

Much of the imagery in tombs, such as the celestial bird ready to carry the deceased to heaven on his wings (cat. no. 3), resounds with positive cosmic representations intended to activate the journey of the deceased to the world of the immortals. Some objects, such as the directional tomb tiles (cat. nos. 46–49) decorated with their corresponding animals (*sishen*), not only provided protection in all directions for the tomb occupant, but also acted as a cosmic map, helping to transform the tomb into a diagram of the heavens. In these ways, the tomb functioned not only as a personal pivot to help the deceased navigate his journey in the afterlife, but also as a generational pivot in the communication between ancestors (past generations), the living (this generation), and future generations. This desire for lineage longevity was inextricably linked with the quest for long life for both the tomb occupant and the tomb itself (see cat. no. 16). The tomb created a dialogue among generations and between the mundane and spiritual worlds; its audience was not only the deceased's lineage, but also gods and immortals in the heavens. This idea fits in neatly with the traditional

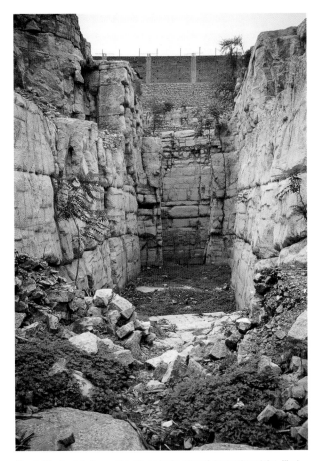

Fig. 1. The burial place of Liu Kuan (r. 97–85 BCE), last ruler of the Jibei Kingdom, as it looks today. View from entrance and tomb ramp looking toward back wall of main tomb chamber. Tomb 1, Shuangrushan, Changqing County, Shandong. Photo by author

My part in this project is dedicated to the memory of my grandmother, Sarah Beningson, and my uncle Irwin Coplin, who left us much too soon. I would also like to give my heartfelt gratitude to Stephen Arons, who has shared my life these past twelve years, for his patience whenever I am physically away in China and when I'm there in my mind while still in New York.

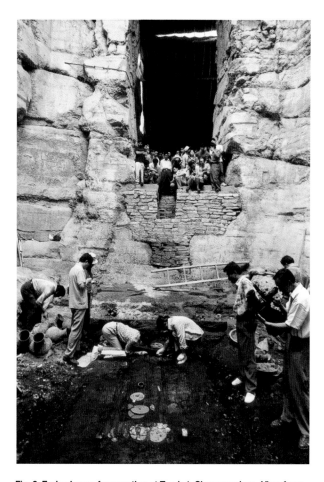

Fig. 2. Early phase of excavation at Tomb 1, Shuangrushan. View from the back wall of the main tomb chamber looking out toward the tomb ramp (*mudao*) and entrance, which is still partially blocked by bricks used to seal the tomb. Exhibition objects in the picture: the jade facemask (cat. no. 34) in the foreground; the jade pillow (cat. no. 35) near facemask but cannot be seen clearly; gold ingots (cat. no. 33) on either side of facemask; jade discs (cat. no. 38) and body plugs (cat. no. 37) where the body was interred; and bronze vessels (*hu*, cat. no. 6) on left side of main chamber. Courtesy of Shandong Provincial Museum

conception of the soul in Han dynasty China. Rather than merely ascending to heaven or descending to hell, the soul of the deceased in pre-Buddhist China was believed to be bifurcated into the *hun*-soul that would travel in the afterlife and the *po*-soul that remained in the tomb.[2] Grave goods would satisfy the *po*-soul, while celestial imagery within the tomb would help the *hun*-soul reach the immortal realm.

This view is nuanced by some of the texts found within Han tombs. These excavated texts not only serve to illuminate the interests or occupational responsibilities of the tomb occupant, but also speak of the hopes and fears of the deceased and his living descendants. Some describe for us how the action of an ancestor in the afterlife could negatively affect the lives and livelihood of the living family. During the Eastern Han dynasty, funerary

texts were sometimes inscribed in vermilion ink on the outside of ceramic "grave-quelling jars." The inscriptions, called either "celestial ordinances" or "grave quelling texts" (*zhenmu wen*), often reveal some of the fears of both the current and past generations of a family. A celestial ordinance written on a grave-quelling jar in 173 CE describes these concerns in what Anna Seidel observes as "coldly bureaucratic" form:

> All misfortune emanating from the earth be banished and annihilated! We order that calamities are to happen no more! After receipt of this document, the netherworld officials are obligated by oath never again to annoy or disturb the Chang clan! Promptly, promptly, in accordance with the statutes and ordinances![3]

The concluding phrase of this inscription, "promptly, promptly" echoes that found in legal documents in the living world. Another inscription focuses on the desire to keep the deceased from impacting negatively on the living family:

> The subject deceased on the *yisi* day has the demon name "Heavenly Brightness." The Divine Master of the Heavenly Thearch has already been informed as to your name. Promptly remove yourself three thousand leagues away! Should you not go away, then the [...] of Southern Mountain will be ordered to come and devour you. Promptly, in accordance with the statutes.[4]

The deceased becomes a dangerous spirit who needs to be placated so as not to inflict harm on future generations. In this context, objects within the tomb are no longer merely there as markers of the rank and status of the deceased or to create a celestial palace, but also as objects to appease the disembodied dead. In this interpretation, as argued by Anna Seidel, the *hun* and the *po* components of a man's soul, as well as his whole social persona and individual being, must descend under the earth, while his physical body becomes united with the earth.[5] Inventories of grave goods, sometimes placed in aristocratic tombs like Tomb 1 at Mawangdui during the Western Han, were another means to appease the deceased; they detailed the lavish resources provided within the tomb, and also verified their contents so that the spirits of the deceased would not be cheated.

In addition to the use of written texts to keep the celestial spirits under control, other practices were followed to help the deceased achieve deathlessness. Placed within grave-quelling jars were ginseng or other pharmaceuticals

as "sacred pharmaka" (shenyao)[6] to help preserve his body, a purpose similar to that of a jade facemask (cat. no. 34) or burial suit.[7] The material jade was an indicator of elite aristocratic status, and the selection of jade burial garments and accoutrements was regulated by the rank of the deceased. A jade facemask would in itself define an elite tomb, whereas grave-quelling jars could be included regardless of rank or wealth. The celestial ordinance from the tomb of Zhang Shujing, dated to 174 CE, offers an alternate reading to the inclusion of ginseng in the tomb. The document states that it has been issued "because the deceased, Zhang Shujing, had a barren fate and died young, and is due to return below and [enter] the mound and tomb." After an invocation of the power of the Yellow God who "rules over the registers of the living and over the records of the dead," the offerings dispatched to the underworld realm during the burial are listed: "medicine for exemption from forced labor, with the desire that there will be no dead among those of later generations; nine roots of ginseng from Shangdang, with the desire that they be taken in replacement of the living; lead men (mingqi), to be taken in replacement of the dead; and yellow beans and melon seeds, for the dead to take to pay the subterrestrial levies."[8] Some of the celestial ordinances inscribed on these jars insist on the separation of the dead from the living, as do the received ritual texts. One inscription dated to 175 CE in the Eastern Han dynasty reads:

> Azure is Heaven above, limitless is the Underworld.
> The dead belong to the realm of Yin, the living
> belong to the realm of Yang.
> [The living have] their village home, the dead have
> their hamlets.
> The living are under the jurisdiction of Chang'an in
> the West,
> The dead are under the jurisdiction of Mount Tai in
> the East,
> In joy they do not [remember] each other,
> [In grief] they do not think of one another.[9]

A question remains. Received texts as well as some excavated texts describe a separation between the living and the dead in terms of ritual prescriptions and reasons for the use of models (mingqi) within tombs, but how can this separation be reconciled with the perceived ability of the dead to negatively impact on the world of the living? Perhaps the reality of religious beliefs in pre-Buddhist China is not as neatly organized as the ritual texts would lead us to believe.

NEGOTIATING THE AFTERLIFE

In Han dynasty China the spirits of the deceased would enter a netherworld governed by the Celestial Thearch (Tiandi) and his Envoy (Tiandi shizhe), also called the Heavenly Thearch's Divine Teacher (Tiandi shenshi).[10] They directed a well-organized administration modeled on that of the living world. As a rule, the registers of the living and the dead were kept separately.[11] The spirits of the dead were under the jurisdiction of Mount Tai, located in Shandong province, while the living were under the jurisdiction of the imperial capital Chang'an, modern-day Xi'an.[12] The deceased were sometimes given new names as in the aforementioned "Heavenly Brightness" on a grave quelling jar. In tomb ordinances written in the name of the Celestial Thearch and his Envoy, the spirits of the soil were informed of the arrival of the departed and the date of his burial, and were asked to avert the curse of his death (yang) from the surviving family.[13] The celestial ordinance had two main purposes. First, the text announced the entry of the deceased into the underworld and transferred him from the registers of the living to the registers of the dead. Secondly, it released the deceased from culpability,[14] particularly for violating the domain of the underworld when digging the grave.[15] Grave goods served to exempt the dead from corvée labor and his descendants from responsibility for misdeeds committed by him while alive.[16] A celestial ordinance dated 147 CE explains how models (mingqi) of lead men were placed in the tomb,[17] enumerating all the tasks these lead figures could perform in place of the deceased rather than just in service to the deceased by cooking (see cat. nos. 24 and 25), grinding grain, writing, and fulfilling other job requirements.

The afterlife bureaucracy functioned much like the real-world administration. It had courts where trials took place, where the deceased was found guilty or released from blame according to a judicial code (lü), and where taxes had to be paid.[18] This explains why we often find coins, both actual and clay imitations, within tombs (cat. nos. 18, 19, 33). Money placed within the tombs enabled the deceased to pay taxes to the underworld government as well as ensured that the deceased would have enough funds to be exempted from corvée labor. A celestial ordinance from the Eastern Han dynasty records a "'yearly subterranean tax of 20,000,000 cash' that will insure that one's posterity attain high position."[19] Coins could also be used as bribes to underworld officials who needed to be convinced of the status of the deceased.[20] The shape of the coin also had cosmological significance; round coins with a square center hole were viewed as cosmic maps

showing that the deceased would ascend to the round heaven from the square earth. For this reason we also find *wuzhu* coins impressed in tomb tiles such as those from the tomb at Linyi, where our directional tiles were excavated (cat. nos. 46–50). We find *wuzhu* coins depicted in the center and corners of the *liubo* game in our exhibition (cat. no. 7), associating both the coin and the game itself with divination and immortality. The name *wuzhu* is itself a reference to the *fusang* tree, which is seen as one of the conduits to the realms of the immortals.[21] In addition to having the requisite amount of money to provide security in the afterlife, the deceased needed to be able to prove his official rank. This explains the presence of the two gold tortoise seals in our exhibition (cat. nos. 14, 15), which would enable the deceased to maintain his rank as an aristocratic member of the bureaucratic elite and in addition would allow him to continue fulfilling the requirements of a high level job in the celestial bureau-

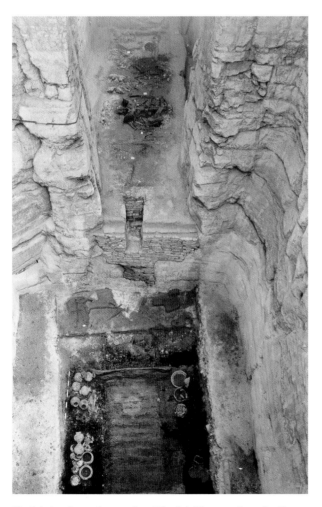

Fig. 3. Later phase of excavation at Tomb 1, Shuangrushan, after the bricks have been removed. View from back wall main chamber looking toward tomb ramp and entrance (at top of photo) and including the bronze *hu* vessels left of where the coffin was originally placed. Courtesy of Shandong Provincial Museum

cracy. It also explains the red ribbons, from which such gold seals would have hung, falling from the waist of the two officials standing in their ceremonial robes behind the head of the ceramic bird in our exhibition (cat. no. 3). Some tomb paintings serve a similar function. For instance, Tomb 1 at Wangdu is in effect the office of the magistrate buried there. The costumed officials that served him, along with the inkstones needed to fulfill their jobs, are depicted in paintings on the wall and identify the deceased to the afterlife bureaucracy.[22] Tomb 2 at Wangdu contained a grave-quelling document detailing the grave site with real measurements of the area, its outer dimensions given in paces, and a description of the boundary markers in the four corners. This is one of the earliest example of the melding of the land contract and grave-quelling genres.[23]

There was also the enduring belief that the underworld bureaucracy might make mistakes.[24] The late Warring States or early Qin bamboo slip manuscripts excavated from the tomb at Fangmatan near Tianshui, Gansu province describe just such an event.[25] According to this account, in 297 BCE Dan injured a man in Yuanyong village by stabbing him and because of this killed himself with his sword. The villagers exposed Dan in the market, and three days later buried him outside the south gate of Yuanyong. Three years later, Dan's patron Xi Wu disputed the Caretaker's life-mandate because he thought Dan was "not yet fated to die." Xi Wu, a general in the living world, submitted a plaint to the Scribe of the Director of the Life-mandate (Siming shi), Gongsun Qiang, who had a white dog dig up the pit to let Dan out (see cat. no. 22). Dan was brought back to life, although his body still bore scars on his throat, his eyebrows had partly fallen out and looked inky, and he had useless limbs. After his resurrection, Dan proceeded to inform the living about how they should take care of the dead. This document represents an official record of Dan's resurrection as submitted to the office of the Royal Scribe at the Qin court. Xi Wu's suit was initiated in the world of the living and directed toward the world of the dead. In received historical records, a man named Gongsun Qiang is notorious for his role in the destruction of the state of Cao in 487 BCE, and it is likely that this is the same man mentioned in the Fangmatan account. Gongsun Qiang's official position in the underworld anticipates the belief in religious Daoism that the underworld bureaucracy was staffed by figures from China's historical past.[26] The last section of the manuscript has quotations from Dan concerning the ghosts of the dead. Dan states

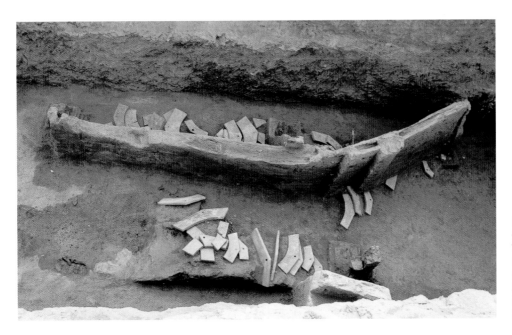

Fig. 4. Chime set discovered during excavation of Pit 14, Tomb of King of Lu (r. ca. 186 BCE), early Western Han dynasty, at Luozhuang, Zhangqiu district, Shandong. Courtesy of Shandong Provincial Museum

the preferences of the dead as follows: The dead require few clothes and do not care what their offerings are wrapped in. They fear spitting, and sacrificial food must be handled in a particular way.[27] Lastly, the place of sacrifice must be cleaned and sacrificial food should not be diluted with the boiled dish (*geng*). Harper argues that these items are not intended to describe aspects of life for the dead in the underworld, as related by someone who lived there for several years, but rather represent rules for how the living should treat the dead when they bury them and later visit them at their tombs. There are a number of outstanding questions that remain about the resurrection account. Why is the report sent to the Royal Scribe of the state of Qin twenty-four years after Dan's resurrection, and why is it buried in a tomb whose occupant was apparently not Dan himself? The possible resurrection of the physical body is an idea that continues in the Han funerary cult and reappears in early Daoist texts. It becomes quite popular in the Six Dynasties period with numerous miracle tales.[28] Such tales also illustrate the idea that those in the living world had the means to interact with the underworld authorities using orderly legal procedures.

An elaborate system of bureaucratic record-keeping concerning births, deaths, and other population data existed in the living world by the late fourth century BCE in Chu.[29] Excavated manuscripts from a tomb in Baoshan, Hubei province, provide a daily register of legal complaints lodged with local officials.[30] Entries concern the non-reporting of a death with two of them concerning the same death. These complaints specify that the place of residence, name, and clan of the deceased were not properly delivered to the capital.[31] Clearly the information was also considered important for the bureaucrats in the netherworld for it to have been buried in the tomb with the deceased. Harper argues that the memoranda from Han bureaucrats informing the authorities in the netherworld of the arrival of a newly deceased person were placed in tombs as a kind of passport to the underworld, just like the documents required for travel between administrative districts in the Han realm.[32] In a document excavated from a Western Han tomb in Hubei province, the Assistant of Jiangling informs the Assistant of the Underworld of the burial of the tomb occupant and a number of slaves, carts, and horses. In contemporaneous documents from Tomb 3 at Mawangdui, the Household Assistant informs the Master of the Storehouse and presents the tomb inventory as well as the land contract for the tomb.[33] Excavated from a Jin dynasty tomb is an inventory listing grave goods, giving the date, name, and age of the deceased, and giving a warning to the denizens of the underworld to not make claims upon her clothing.[34]

People in the mundane world were concerned that there might be mistakes made in supernatural paperwork, resulting in their files becoming implicated in the transfer of the deceased's record to the archives of the dead. In a celestial ordinance dated 156 CE, excavated near Xi'an, The Celestial Thearch's Envoy announces the death of Cheng Taotui to the Deputy of the Grave Mound, the Sire of the Tomb, and the Netherworld Two-Thousand Bushels Officials, and gives them the following orders:

> The day and hour of his death overlap with the life-
> span (of other persons) so that living family member[s]
> have been implicated [in the fate of the deceased].
> Upon receipt of the register, their lifespan is to be

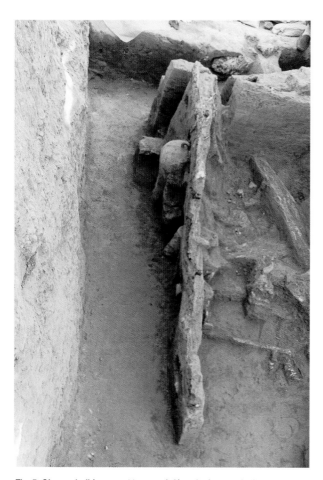

Fig. 5. *Chunyu* bell (cat. no. 11; upper left) and other musical instruments as discovered in Pit 14, Luozhuang, Zhangqiu district, Shandong. Courtesy of Shandong Provincial Museum

restituted to them; the duplicate copy [in the netherworld?] is to be eliminated and their entanglement [with the deceased] in corvée registers is to be dissolved. The dead and the living are to be recorded in different files! For one thousand autumns and ten thousand years, they shall never again lay any claim on each other. Promptly, promptly, in accordance with the statues and ordinances.[35]

According to Seidel, the Celestial Masters in early Daoism linked the regular annual tax payments of rice with the updating of the census registers, threatening remiss households that celestial duplicates of the records would result in the gods disregarding their appeals for help.[36] "Lawsuits of the tomb" (*zhong song*) or sepulchral plaints could be initiated and conducted in the courts of the underworld allowing the deceased to rectify wrongs against either living or deceased people. Such plaints could involve the living, especially the living relatives of the accused, by punishing them with illness.[37] In early Daoism, the sepulchral plaints became the chief

explanation for a person or family's misfortune. Once the ancestor began to be "examined" or "investigated" in the context of such a legal action, his descendants would begin to suffer from demonic harassment and noxious vapors, or "demonic infusions" (*guizhu*).[38]

In addition to the resurrection narrative excavated at Fangmatan, other texts from the same tomb give us evidence of the preoccupation with immortality and controlling of cosmic phenomena which become so important in Han cosmology. There were two "almanacs" containing passages on the calculation of auspicious months and days for diverse activities, which are correlated with other cosmologically significant activities like music.[39] The tomb contained seven geographically accurate maps and mathematical counting rods. Other Qin tombs at the same cemetery yielded another map fragment and a wooden tablet, possibly a *liubo* board (see cat. no. 7), which was painted with a "TLV" cosmic diagram. Von Falkenhausen argues that these texts from Fangmatan, similar to those excavated from Tomb 3 at Mawangdui, might have provided the tomb occupant with a means of measuring and orienting his travels in the terrestrial as well as the heavenly realm. In addition, by orienting his actions with those of the cosmos, it might help him to attain the goal of immortality. Von Falkenhausen interprets the astrological chart and music-related inscriptions found in the tomb of Marquis Yi of Zeng and the stone game board from the tomb of King Cuo of Zhongshan as earlier instances of similar concerns.[40] The texts excavated from Tomb 3 at Mawangdui, Hunan (dated to 168 BCE), have been an extremely rich source of manuscripts on natural philosophy and the occult; they include fifteen writings related to medicine and several astrological works.[41] Additional texts have been discovered among the manuscripts excavated from the second-century BCE tomb at Yinqueshan in Shandong, some of which are included in this exhibition (cat. no. 17). Harper argues that manuscripts were placed in tombs to establish the spiritual prestige of the deceased as someone possessed of knowledge and to protect the tomb from harm with their talismanic magic.[42] He explains that manuscripts from the Shuihudi burial were strategically arranged around the corpse inside the coffin as if magically protecting the deceased from demonic depredations.[43] It might also be possible that certain manuscripts were buried to prevent their contents from being improperly divulged among the living, as was said to have been done with Daoist scriptures in later times.[44] Evidence of a belief in the magical efficacy of writing is found in the

Huainanzi which states that when Cang Jie invented writing, "demons wailed at night." There are also examples of scholar-officials reciting the *Xiaojing* (Book of Filial Piety) and other books to drive off attacks by armed forces and demons.[45] In the case of texts written on grave-quelling jars, it is interesting to note that often the same inscription was written on several vessels in the same tomb.[46] In addition to proving to the netherworld bureaucracy the importance of the written claim, the repetition of the inscription enhanced its vatic power. Perhaps these inscriptions function in similar fashion to repeated inscriptions cast on sets of bronze vessels in ancestral temples during the Shang and Western Zhou dynasties. In those cases, beyond announcing the merit of the deceased to past, present, and future generations of a lineage, the repetition of the same inscription had magical efficacy.

The Quest for Immortality

One of the pervasive themes in Han dynasty cosmology is the search for immortality, or rather deathlessness. The visual evidence for this quest can be found in many of the objects included in our exhibition. Emperor Wudi (r. 141–87 BCE) sent expeditions to the far reaches of his empire in search of a magical elixir which when ingested would give him the ability to live forever, presumably in his accustomed life of luxury. Perhaps it was to be found on Penglai, an island in the eastern seas; visual allusions to this island are evidenced by bronze *hu* vessels (see cat. nos. 3, 6) which may have represented the vase of Peng(lai) (fig. 3). Another source could be Mount Kunlun (see cat. nos. 1, 9, 43, 44), which was seen as a cosmic pillar that would allow a person to access the world of the immortals. The bronze incense burner in our exhibition (cat. no. 9) is a representation of this magical mountain; it connects the mountain as a cosmic structure with the bird at its summit as a celestial vehicle. The conical lid of the bronze is cast in relief with mountain peaks interspersed with waves of clouds. Apertures in the peaks would have allowed the incense burning within the censer to create the impression of mist and clouds enveloping the cosmic mountain. The Western Han text *Huainanzi* describes the potency of Mount Kunlun as the liminal realm linking the mundane and spiritual worlds:

> If one climbs to a height double that of the Kunlun
> Mountains [that peak] is called Cool Wind
> Mountain.
> If one climbs it, one will not die.
> If one climbs to a height that is doubled again, [that
> peak] is called Hanging Garden.
> If one ascends it, one will gain supernatural power
> and be able to control the wind and the rain.
> If one climbs to a height that is doubled yet again, it
> reaches up to Heaven itself.
> If one mounts to there, one will become a god.
> It is called the abode of the Supreme Thearch.[47]

Kunlun is an *axis mundi* connecting heaven and earth. The ascension to each succeeding higher peak of the mountain imparts not only greater supernatural power, but brings the climber closer to the land of the immortals. Such imagery enhances the spiritual geography within the tomb by presenting a visual form to guide the soul on its afterlife journey. Architecture within the tomb is often combined with such cosmic representations for much the same purpose. In the late Eastern Han tomb at Yinan, Shandong province, the mountains of Kunlun are

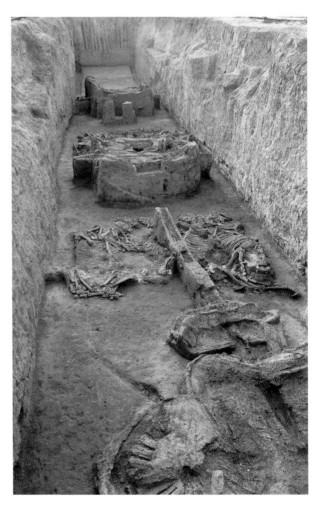

Fig. 6. Live horse and chariot burials as found during excavation of Pit 9, Luozhuang tomb. This pit yielded the cast gold raptor head ornaments (cat. no. 45) and the gilt bronze *danglu*, or frontlet (cat. no. 1), in our exhibition. Courtesy of Shandong Provincial Museum

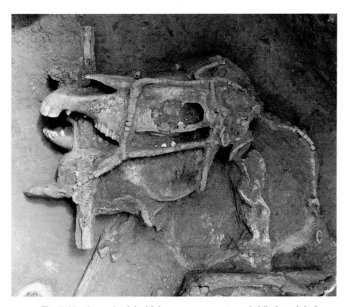

Fig. 7. Live horse burial with bronze ornaments on bridle found during the excavation of pits, Luozhuang tomb, Zhangqiu district, Shandong. Courtesy of Shandong Provincial Museum

depicted on a stone pillar which connects the floor to the ceiling of the tomb. The mountains rest on the back of a dragon and the Queen Mother of the West resides at the apex.[48] Thus, the tomb pillar functions as a cosmic structure, acting like the mountain as a conduit to immortal realms. At Yinan there are multiple pillars creating a path down the center of the tomb. This architectural pattern also occurs in the Eastern Han tombs at Cangshan and Anqiu in Shandong province.[49] At Anqiu, three pillars form an axis down the center of the tomb, each pillar helping to create a path for the soul of the deceased to follow on his journey toward immortality. The pillars have rounded bodies terminating in square ends. This configuration of circle and square is also found in the "celestial well" or "well of heaven" (*tianjing*), a common ceiling motif in Han tombs. The Han *tianjing* is a later-nendecke ceiling, which typically consists of a rotated square within a square, with a central circular design at the apex. As with the *wuzhu* coins previously discussed (cat. no. 19), the combined images of a round heaven and square earth allude to a cosmic diagram of the ascent to heaven. Just as the deceased might reach heaven on the wings of a bird (see cat. no. 3), on the back of a dragon (see cat. nos. 9, 43, 44), or by climbing a mountain or sacred tree, heavenly access could be achieved through the celestial well.[50] At Dunhuang, Gansu province, the "celestial well" is often found as a ceiling motif, at times coupled with central pillars within the cave chapels.[51] These central stupa pillars also function as cosmic pillars, much as the heart pillar down the center of a pagoda,

creating a visual link between the mundane and spiritual worlds and allowing the devotee to begin his journey of spiritual enlightenment. The act of circumambulation, a ritual performance by the worshipper, activated the pillar, just as rituals in the tomb (see cat. no. 3) activated the afterlife journey of the deceased from this world to the spirit world.[52]

Objects were placed in the tomb for apotropaic and cosmological reasons, as well as to assert the elite position of the deceased in the celestial hierarchy. Chariots (see cat. no. 2) not only served as indicators of rank and status within the tomb, but also helped the deceased on his afterlife journey. In our exhibition we have two groups of bronze chariots fittings. The chariot ornaments from the tomb at Jiulongshan, or Nine Dragon Mountain, are gilt bronze (cat. nos. 39–44); they provide the deceased with a variety of animal depictions and dragon and cloud motifs that bridge the distance to the immortal realms. The bronze chariot ornaments from the tomb at Shuangrushan (cat. nos. 28–32) are inlaid with gold and silver in a dynamic cloud breath (*yunqi*) pattern that in itself had cosmological value.[53] Potent imagery on these objects further activated their dual role as vehicles on the immortal journey and as embodied images (*tixiang*) representing the patterns of the cosmos.[54] Sima Qian writes in the *Shiji* about how *xiang* were perceived during the time of Emperor Wudi (r. 141–87 BCE). The emperor honored the exorcist (*fangshi*) Shaoweng with a title and lavish gifts.[55] Shaoweng then

> said to the emperor, "I perceive that Your Majesty wishes to commune with the spirits. But unless your palaces and robes are patterned after the shapes of the spirits, they will not consent to come to you." He fashioned five chariots, symbolizing the five elements and painted with cloud designs, and on the days when each of the five elements was in ascendancy, he would mount the appropriate chariot and ride about, driving away the evil demons. He also directed the emperor to build the Palace of Sweet Springs, in which was a terrace chamber painted with pictures of Heaven, Earth, the Great Unity, and all the other gods and spirits. Here Shaoweng set forth sacrificial vessels in an effort to summon the spirits of Heaven.[56]

Munakata translates the five chariots as *yunqi* chariots (*yunqi che*) meaning that these chariots were possibly adorned, like the ones from Shuangrushan, with fittings bearing images of *yunqi* designed to give the vehicles their requisite ritual efficacy.[57] He posits that this design on the

chariot parts enhanced the effect of exorcism, as they "drive away evil demons."[58] Similar designs decorate the sides of Lady Dai's famous lacquer-painted coffin from the early Western Han Tomb 1 at Mawangdui; its swirls are inhabited by various creatures, some of which are hybrid human-animal figures.[59] Tomb 1 at Shuangrushan exemplifies the changes that occurred in tomb burials in ancient China. By the Western Han dynasty, elite burials like those at Weishan would have had ceramic models of chariots and cavalry officers ready to protect the deceased. At Shuangrushan, both full-size and miniature chariots indicate the high rank of the deceased as well as help him on his journey to immortality. But the earlier traditions, considered more the practice of Shang and Zhou burials and not characteristic of Han tombs, can in fact be illustrated by the early Western Han tomb at Luozhuang highlighted in our exhibition. The site of Luozhuang shows us that changes in mortuary practice did not necessarily coincide with dynastic change, and that earlier Zhou dynasty traditions continued into the early Western Han dynasty.

LUOZHUANG

The tomb and burial pits at Luozhuang are located in Zhangqiu district, Shandong province.[60] This site is counted as one of the greatest archaeological discoveries in China in 1999. More than three thousand objects were excavated from the tomb itself and thirty-six neighboring pits. Although the tomb at Luozhuang dates to the early Western Han dynasty, it exhibits many characteristics more typical of earlier burials and less likely to be found in Han tombs. In burials of elite males during the Shang and Western Zhou dynasties, tombs included objects pertinent to their two main duties of warfare and sacrifice. For the former, chariots and weapons would provide markers of his aristocratic rank and worldly power. For the latter, ritual bronze vessels were included, their number and type determined by ritual regulations according to the rank of the deceased. Such bronzes were indicative of the role that the deceased would continue to play as an ancestor in the rites of the lineage temple. In this context, the ancestor was not the dangerous disembodied dead detailed in the Han texts inscribed on grave-quelling jars, land contracts, and inventory lists placed within the tomb. He was not imprisoned in his subterranean prison, but instead continued to interact with the family in a beneficial and supernaturally supportive way. The *Shijing*, a Zhou dynasty anthology of poems, describes ancestral sacrifices staged as communal meals where ancestors were thought to inhabit their younger descendants who served as impersonators (*shi*). The hymn entitled "Glorious Ancestors" explains the dialogue among generations:

> Ah, the glorious ancestors—
> Endless their blessings,
> Boundless their gifts are extended;
> To you, too, they needs must reach.
> We have brought them clear wine;
> They will give victory
>
> With eight bells a-jangle
> We come to make offering.
> The charge put upon us is vast and mighty,
> From Heaven dropped our prosperity.
> Good harvest, great abundance.
> They come [the ancestors], they accept,
> They send down blessings numberless.[61]

Similar texts are cast into Western Zhou ritual bronzes. The ancestors are worshipped in the ancestral temple and

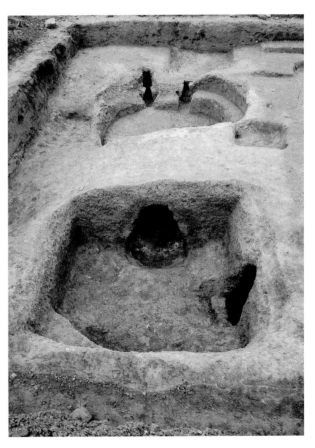

Fig. 8. Kiln where ceramic cavalry, infantry, and horses were fired, located next to the accompanying pits of the Western Han tomb at Weishan, Zhangqiu district, Shandong. Courtesy of Shandong Provincial Museum

9

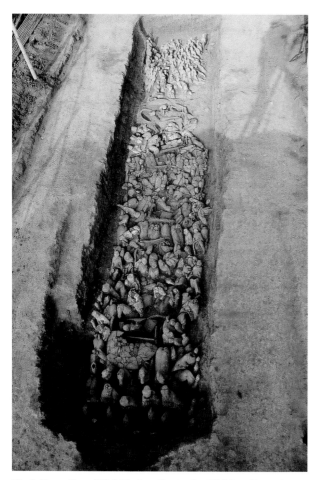

Fig. 9. Excavation of Pit 1, Western Han tomb at Weishan, Zhangqiu district, Shandong. The drum (cat. no. 12) and equestrian figure (cat. no. 13) in this exhibition were found in this pit. Courtesy of Shandong Provincial Museum

given offerings of food and wine in ritual bronzes. In return the omnipresent ancestors provide prosperity for future generations.

At Luozhuang, the tomb and accompanying pits held rich inventories of ritual bronze vessels. The tomb occupant is thought to be the king of Lu, who reigned around the year 186 BCE, based on the tomb layout and content.[62] Lu was the home state of Confucius during the Eastern Zhou period (770–256 BCE). Bronze ritual vessels continued to be important in the Luozhuang tomb; there were over ninety bronze vessels excavated from Pit 5, including the one shown in our exhibition (cat. no. 4).[63] A number of these bronze vessels are prized objects belonging to the tomb occupant and are indicators of his high aristocratic rank. That some of them are included in his tomb hints at social and political relationships that were clearly of high significance to him. At least two of the bronze *ding* vessels, one large and one small, were inscribed with similar inscriptions which tell us that the king of Qi gave the bronze vessel to the king of Lu, the

tomb occupant, as a gift.[64] The first half of the inscription, "*Ding* of the Southern Palace [of the king of Lu]" (*nan gong ding*), is inscribed vertically on the bronze, and the second half of the inscription, "Given by the king of Qi" (*Qi tai wang*), is inscribed horizontally to distinguish the two separate owners of the vessels and to hint at their political alliance. In addition to the wealth of bronze ritual vessels found in the tomb and pits, a chime set and bell set were both discovered in pit no. 14.[65] A *chunyu* bell (cat. no. 11) was also discovered and is included in our exhibition. Excavation photos illustrate how the chimes (fig. 4) and *chunyu* bell (fig. 5) were found in the tomb at Luozhuang. The bird depicted on the outside of the bell is quite similar in design to lotuses depicted on the Han dynasty shrine at Songshan, also in Shandong province.[66] The continuing importance of music in the tomb is yet another indication of Shang and Western Zhou dynasty mortuary practices being continued in this Western Han tomb.[67]

The third feature of Luozhuang that is more characteristic of earlier burials is the practice of chariot burials. At Luozhuang actual chariots were buried with live horses (figs. 6 and 7). There were over fifteen hundred gilt bronze ornaments for horses, including the famous frontlet (*danglu*) in our exhibition (cat. no. 1), which was placed on the forehead between the eyes of the animal.[68] Solid gold raptor heads (cat. no. 45), also made for a horse's bridle, were the most important discoveries. They were among forty solid gold ornaments for horses, weighing over six hundred kilograms, excavated from Pit 9 (fig. 6). Three horse-drawn chariots were excavated from Pit 11; two of them were virtually identical to bronze chariots nos. 1 and 2 discovered at the necropolis of the First Emperor of China, Qin Shihuangdi, located at Lishan.[69] The use of horse-chariot burials is typically associated with the pre-Han era. In the Shang and Western Zhou dynasties they were used primarily for royal or elite tombs. Here the practice indicates the wealth and power of the king of Lu, and alludes to his military strength as well. After the establishment of the Han dynasty, the interment of ceramic models replaced that of actual horses and chariots. The Luozhuang site can thus be viewed as belonging to a transitional phase between Zhou and Han dynasty mortuary practice.

WEISHAN

The Western Han tomb of Weishan is located west of Zhangqiu district in Shandong province, in the suburbs of the capital Jinan.[70] It has been designated one of the

most important new archaeological discoveries in China for the year 2002. In November of that year, farmers within the "Weishan scenic district," were planting trees and came upon nine ceramic figures while digging. The Shandong Provincial Cultural Research Institute, Jinan Municipal Archaeological Institute, and Zhangqiu Municipal Museum joined forces to immediately begin an emergency excavation. In total they discovered one small tomb that may have already been robbed and three funerary pits, one of which was badly damaged and two of which were untouched. These two intact pits have yielded some of the most important new objects discovered in the last decade, including those in our exhibition (cat. nos. 12 and 13). Found near the pits were the kilns where the tomb figures were made and fired (fig. 8). The tomb occupant is thought to be Liu Biguang, who was king of the Jinan Kingdom (Jinan *guo*) during the Western Han dynasty. The site of Weishan is located approximately five kilometers from the royal tomb at Luozhuang. For this reason it is thought that the Weishan area is one of the most important burial locations for kings of the Jinan Kingdom during the Western Han.

Pit One

Pit 1 (fig. 9) is oriented from south to north; it measures 3.3 meters in length, 2.6 meters in width, and 1.4 meters in depth. It had two platforms on top, covered with soil; wooden planks sat on top of the second platform. Discovered within the pit were a total of 172 ceramic figures, 55 ceramic horses, 4 chariots, more than 60 shields, and over 150 other objects, including more ceramic fragments

of horses, chariots, and figures. The objects within the pit were lined up in battle formation with a drummer ready to strike the beat for the cavalry and infantry soldiers. The exact layout of the pit is as follows: At the very front of the pit was a row of five equestrian figures (fig. 10), each rider astride his mount (cat. no. 13). The ceramic figures were made in molds and then colored with natural pigments. This first row of cavalry was painted with red pigment. Placed directly behind this row was the first of four ceramic chariots, drawn by four white horses. Behind the chariot were another two rows of cavalry. There were additional cavalry soldiers placed on either side of the chariot. Behind this group was a second chariot drawn by four horses, which were painted red. The carriage of the chariot also retained traces of red pigment. Lined up in back of this second chariot was another row of cavalry. Following this was the third chariot, also drawn by four red horses. In back of this chariot was the fourth chariot in the pit, which had one white-colored horse. Behind the fourth chariot was found the musician and drum included in our exhibition (cat. no. 12). He leans back ready to strike his drum and to set the pace for a protective mission serving the tomb occupant. Directly behind the drummer, following his beat, were one hundred infantry soldiers, most of them holding their shields high, ready for battle.

Pit Two

The second pit is located parallel to Pit 1, on its west side. From south to north, it measures 3.3 meters long, 2.6 meters wide, and 1.4 meters deep. There were also two

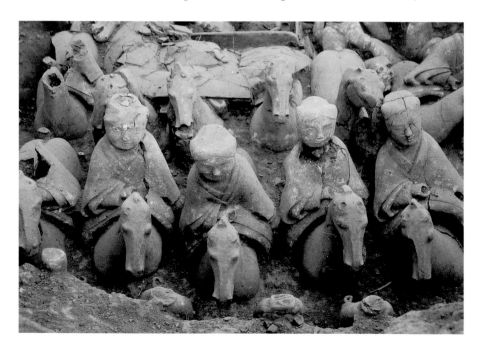

Fig. 10. Front row of cavalry as seen during early phases of excavation in Pit 1, Western Han tomb at Weishan, Zhangqiu district, Shandong. The first chariot can be seen directly in back of them. Courtesy of Shandong Provincial Museum

11

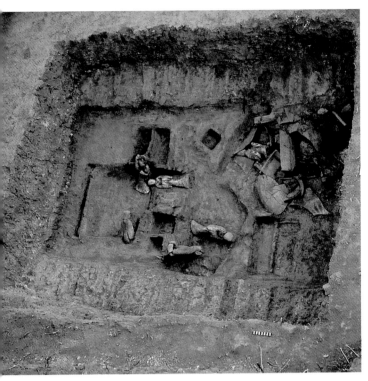

Fig. 11. View of Pit 2, Western Han tomb at Weishan, Zhangqiu district, Shandong, with chariots as well as ceramic female figures with detailed robes and coiffeur, and the original red paint still visible. Courtesy of Shandong Provincial Museum

platforms on top of the pit. The second platform was made of rocky dirt. On top of the second platform, laid out from east to west, were approximately twenty wooden planks used to form a cover for the pit. Inside the pit (fig. 11), on the east side, was a single chariot drawn by two ceramic horses with paint still found on their surfaces. The chariot carriage is divided into two sections, one for a standing ceramic figure and the other for a kneeling ceramic figure. Randomly placed north of the chariot were five female standing figures. Delicately painted details on both the robes and coiffeur of the figures could still be seen. In addition, twelve wooden cases of two different sizes and shapes were discovered within the pit. They all had both bottoms and lids in place. However, because they were seriously decayed, the contents of the cases could not be ascertained.

Tomb M1

The tomb at the Weishan site is located at the summit of the mountain. Constructed in the cruciform shape of the character *zhong* 中 , it measures 3.3 meters long, 3.1 meters wide, and 2.85 meters deep. It was a joint burial with two occupants. The tomb had previously been robbed. What is left of the tomb furnishings included a wooden coffin with remaining traces of lacquer on the surface. The inner coffin (*guan*) was sealed with a top made of wooden planks. The eastern chamber formed the stone outer coffin (*guo*), which measured 2 meters long, 1.14 meters wide, and 1.06 meters tall. A case was placed on either side of the outer coffin. On the east side, the case contained burial objects of a military nature, including crossbows, and arrows. The case located on the west side contained objects used in life, including ceramic jars (*guan*), ceramic *hu* vessels (see cat. no. 6), lacquer-clad *hu* (see cat. nos. 5–6), and lacquer plates (*pan*).

THE AUDIENCE FOR THE TOMB

The tomb at Weishan, with its lavish cavalcade of horses, chariots, and military guard, makes it easy to understand how the textual insistence on separation of the worlds of the living and dead was given visual form. Ceramic representations of warriors, luckily for soldiers in the Han dynasty, were meant as substitutes for the actual cavalry and infantry fighters of earlier interments. But it is clear from the texts on grave-quelling jars, land contracts, and inventory slips—documents written specifically for the tomb rather than real-world documents interred with the deceased—that the boundaries between the mundane and spiritual worlds were not always so clear. In fact, the texts give us clear evidence that such boundaries were volatile and changeable. Lawsuits of the tomb are evidence of how the living could be clearly affected by the dead in their daily lives. This brings us full circle. Who was the audience for the tomb? Was the tomb merely a portal into sacred space, the conduit or cosmic pillar by which the deceased could ascend to heaven? Or, was the tomb itself the sacred space where the deceased would live for eternity. The texts give us arguments for both. This question is made even more intriguing by an inscription recently discovered on the wall of the Eastern Han tomb of King Bin at Xunyi in Shaanxi province.[71] The inscription reads: "For those who want to observe, all must remove their shoes before entering." This might have, of course, referred to the *fangxiang* and other ritual specialists who entered the tomb prior to burial to exorcise the violent demons that might harm the deceased. But they most likely would have been inside the tomb to participate and not to observe. Certain rituals may have continued to take place within the tomb itself after the deceased was interred. This new evidence raises more questions than it answers. Hopefully the controlled excavation of archaeological sites in the future will help us to more clearly understand the relationship between the mundane and spiritual worlds in ancient China.

1. Liu Kuan was said to have maintained improper behavior with his father's widow and cursed the emperor during a sacrifice. He was still granted a royal burial, although he was only allowed to have a jade facemask and body plugs instead of a complete jade suit. Tomb 2 at Shuangrushan, thought to be his wife's tomb, has not yet been excavated, and during our visit in June 2004, it was overrun by roaming goats from the nearby farming village. For the various excavation reports on the site at Shuangrushan, see cat. no. 6, n. 1. Shuangrushan was named one of the most important archaeological discoveries in Shandong province in 1996. For more on rock-cut royal tombs see Huang Zhanyue, "Handai Zhuhouwang mu lunshu" [Discussion of royal tombs of the Han period], *Kaogu xuebao*, no. 1 (1998), pp. 11–34.

2. See Yü Ying-shih, "Life and Immortality in the Mind of Han China," *Harvard Journal of Asiatic Studies* 25 (1964–65), pp. 80–122; Yü Ying-shih, "New Evidence on the Early Chinese Conception of Afterlife—A Review Article," *Journal of Asian Studies* 41, no. 1 (Nov. 1981), pp. 81–85; Yü Ying-shih, "'O Soul, Come Back!' A Study in the Changing Conceptions of the Soul and Afterlife in Pre-Buddhist China," *Harvard Journal of Asiatic Studies* 42, no. 2 (1987), pp. 363–95.

3. These inscriptions end with the same lines that are found on Han legal communications in the living world. Anna Seidel, "Post-Mortem Immortality or: The Taoist Resurrection of the Body," in *Gilgul: Essays on the Transformation, Revolution and Permanence in the History of Religions*, ed. S. Shaked, D. Shulman, G.G. Stroumsa (Leiden and New York: E.J. Brill, 1987), p. 229. Also Ikeda On, "Chūgoku rekidai bokenryakkō," *Tōyō bunka kenkyūjo kiyō* 86 (1981), p. 272, no. 7.

4. Seidel, "Post-Mortem Immortality," p. 229.

5. Ibid., pp. 228–29.

6. Seidel states that grave-quelling jars with *shen yao*, bearing the same inscription, were positioned in the antechamber of the tomb, for the protection of the entrance way. Anna Seidel, "Traces of Han Religion in Funeral Texts Found in Tombs," in *Dōkyō to shūkyō bunka*, ed. Akitsuki Kan'ei (Tokyo: Hirakawa, 1987), p. 25.

7. Jessica Rawson, in Yang Xiaoneng, ed., *The Golden Age of Chinese Archaeology* (New Haven: Yale University Press, 1999), p. 391, writes that jade shrouds "served as armor to protect the bodies of the elite from the attacks of evil demons and forces thought to cause illness, corruption, and decay."

8. Peter Nickerson, "The Great Petition for Sepulchral Plaints," in Stephen R. Bokenkamp, *Early Daoist Scriptures* (Berkeley: University of California Press, 1997), pp. 243–44.

9. Seidel, "Post-Mortem Immortality," p. 229. See also Seidel, "Traces of Han Religion," pp. 21–57.

10. The Zhang Shujing celestial ordinance of 173 CE gives the following description of the supreme ruler, known as the Celestial Thearch or Yellow God: "The Yellow God [governs] the Five Marchmounts. He controls the registers of the living; Summoning spirit souls and vital souls, He controls the files of the dead." Seidel explains that the Yellow God resides in the central constellation, the Northern Dipper, and here represents the deity of the oriented five strong points of space, which were to play a paramount role in the mystic geography of Chinese religion. He is the central Yellow Thearch around whom the other four of the Five Thearchs orient themselves. During the Eastern Han dynasty, Mount Tai was the arbiter of the human lifespan and the destination of those who died. This function is already projected on all the Five Marchmounts to which the Yellow God "summons the souls." Seidel, "Traces of Han Religion," p. 30. Seidel continues her argument that according to this passage and other funerary texts, "The souls do not separate at death but *hun* and *po* together descend into the mountain netherworld." She concludes that "we are far from the literati theories about the spirit soul (*hun*) soaring up into space while the vitality (*po*) lingering with the corpse descends into the tomb. According to this more popular vision, all 'souls' of man fall at death under the jurisdiction of the Five Marchmounts. The Yellow God controls two different sets of registers, those of the living and those of the dead." Seidel, "Traces of Han religion," pp. 30–31.

11. Seidel gives another inscription on a grave-quelling jar as further evidence of the same idea of the separation of the living and the dead: "The living pertain to the number nine; the dead pertain to the number five" (*sheng ren de jiu, si ren de wu*). She argues that whereas the number nine tended to evoke a vertical arrangement of nine progressive stages, the foremost association with the number five was the special layout of the Five Marchmounts corresponding in Heaven to the five planets. Seidel explains that the tomb itself was conceived as a sacred space divided into five compartments like the royal ritual building *mingtang* (Brilliant Hall). However, she describes this sacred space, as shown in the celestial ordinances, "not (as) a crucible of immortality but a fortress guarded at its five strong points, a sealed prison where exact files are kept on all inmates." Seidel, "Traces of Han Religion," p. 31.

12. The expressions "the living and dead have different roads" and "dead men return to Haoli" are found in a document, referred to by Kleeman as a "protograve-quelling contract," excavated from Tomb 2 at Wangdu, dating to 192 CE. Haoli is the small mountain near Mount Tai where the souls of the dead were thought to actually dwell. Terry Kleeman, "Land Contracts and Related Documents," in *Chūgoku no shūkyō shisō to kagaku: Makio Ryōkai Hakushi shōju kinen ronshū* [Religion Thought and Science in China: A Festschrift in Honor of Professor Ryōkai Makio on his seventieth birthday] (Tokyo: Kokusho Kankōkai, 1984), p. 27 n. 24, after Hebei sheng wenhuaju wenwu gongzuodui, ed., *Wangdu erhao Hanmu* (Beijing: Wenwu chubanshe, Xinhua shudian Beijing faxingsuo, 1959), p. 13. Other sources date this tomb to 182 CE. See Jan Fontein and Wu Tung, *Han and T'ang Murals* (Boston: Museum of Fine Arts, 1976), p. 27.

13. Angelika Cedzich, "Ghosts and Demons, Law and Order: Grave Quelling Texts and Early Taoist Liturgy," *Taoist Resources* 4, no. 2 (1993), p. 25, after Anna Seidel, "Geleitbrief an die Unterwelt: Jenseitsvorstellungen in den Graburkunden der späteren Han Zeit," in *Religion und Philosophie in Ostasien* (Wurzburg: Konigshausen und Neumann, 1985), pp. 166–67, app. 2.

14. In a late Han example from the grave of a family named Yang, the grave is quelled and lead men, gold, and jade are offered in return for absolution from culpability. Kleeman, "Land Contracts and Related Documents," p. 5.

15. Ibid., p. 4. Kleeman gives the example of a celestial ordinance written for the Jia family in 147 CE, where an unnamed party seeks expiation from the Envoy of the Heavenly Thearch (Tiandi shizhe), and separately from the Monarch of the Underworld (Dixia hou). Further on in the document the Director of Fate (Siming) and the Director of Fortune (Silu) proclaim the death to the Envoy of the Grave Brilliance (Muhuang shizhe) who is to relay this message to the other subterranean officials. In discussing taboos of digging into the soil, Kleeman cites Wang Chong (27–91 CE), who also mentions the practice of appeasing the spirit(s) of the earth (jietu) after any house remodeling that involves boring into the earth. In his commentary on this same passage, the Ming scholar Huang Hui assembled a number of passages from early texts in which some misfortune is attributed to an "offense against the earth" (fa tu); the earliest of these are from the early Han dynasty. Ibid., p. 29 n. 58.

16. Cedzich, "Ghosts and Demons, Law and Order."

17. Kleeman, "Land Contracts and Related Documents," p. 5.

18. Cedzich, "Ghosts and Demons, Law and Order," p. 25.

19. Kleeman, "Land Contracts and Related Documents," p. 6.

20. Anna Seidel, "Tokens of Immortality in Han Graves," Numen 29 (1982), p. 111.

21. For the derivation of the term wuzhu and its cosmological significance see cat. no. 19, n. 4. For a description of the fusang tree as an axis mundi connecting mortals to the world of the immortals as stated in the Huainanzi, see John Major, Heaven and Earth in Early Han Thought: Chapters Three, Four and Five of the Huainanzi (Albany: State University of New York Press, 1993), pp. 158–59.

22. Beijing lishi bowuguan and Hebei sheng wenwu guanli weiyuanhui, ed., Wangdu Han mu bihua [Han tomb murals in Wangdu] (Beijing: Zhongguo gudian yishu chubanshe, 1955), pp. 3–14, plates 8, 9. For a lengthy discussion in English see Fontein and Wu, Han and T'ang Murals, p. 27–33.

23. Kleeman, p. 6. Both Kleeman and Seidel, "Traces of Han Religion," p. 24, discuss in detail the land contract found in Han tombs. Kleeman discusses the difference between northern and southern documents. Documents from northern tombs tended to have more realistic prices listed for the price of the land where the tomb was placed. In southern tombs, there was often a divine seller listed and the prices were fabulate amounts. For the southern land contracts, the boundaries were also regularly given in supernatural terms, sometimes with the animals of the four directions (see cat. nos. 46–49) given as the boundaries. These are coordinates in sacred space, delimiting the world in which the deceased is to live. Kleeman, p. 14.

24. An inscription on a grave-quelling jar written in 147 CE appeals to the netherworld bureaucracy to check on the case of Mrs. Jia, who had died, perhaps in childbirth, at the age of 24: "Compute your registers of names, whether year and month concord [with the actual time of death], check, compare, and recheck the day of death! Whether day and hour concord, check, compare, and recheck the day of death!" The surviving members of Mrs. Jia's family are asking underworld officials to verify her name and time of death with notations on her register in the archives of fate to determine whether she was actually supposed to die so soon. Seidel explains that the doubt concerning the accuracy of netherworld record keeping is of course in part due to her death at such a young age, but also shows suspicion on the part of the bereaved that errors in supernatural records did take place. She believes this to be an early allusion to Six Dynasties miracle tales where foul-ups in supernatural paperwork summon a mortal to the underworld before his time, and upon the discovery of the error, the soul would be released with detailed descriptions of his adventures in the courts of the netherworld tribunals. Seidel, "Traces of Han Religion," pp. 32–33. The passage also concerns the fear of the living that their own files might be implicated in the transfer of the deceased's records to the archive of the dead.

25. This account is taken from Donald Harper, "Resurrection in Warring States Popular Religion," Taoist Resources 5, no. 2 (1993), pp. 13–29; see also Li Xueqin, "Fangmatan jian zhong de zhiguai gushi" [Stories recording strange occurrences in the bamboo slips from Fangmatan], Wenwu, no. 4 (1990), pp. 43–47.

26. Harper, "Resurrection in Warring States Popular Religion," p. 16.

27. On spitting as a way to protect oneself from demons also see Donald Harper, "A Demonography of the Third Century B.C.," Harvard Journal of Asiatic Studies 45, no. 2 (1985), p. 483. Harper argues that spitting as well as specific body postures (see cat. no. 48) show how the body itself can be exploited as a natural demonifuge even without additional magical devices. The Han warrior hairstyle known as the "teratoid topknot" (tuijie) also had magically prophylactic powers, an idea related to the belief that magical binding had exorcistic powers. Ibid., pp. 476–78.

28. See Robert Campany, "Return-from-Death Narratives in Early Medieval China," Journal of Chinese Religions 18 (1990), pp. 91–125.

29. Cedzich, "Ghosts and Demons, Law and Order," p. 26.

30. Ibid.

31. Harper, "Resurrection in Warring States Popular Religions," p. 6.

32. Ibid., p. 5.

33. At Mawangdui, a proclamation accompanied the inventory of grave goods that listed all the possessions of the deceased. It was written on a wooden tablet by the family retainer of the marquis of Dai. He informed the Assistant in charge of funeral goods (in the netherworld) that he herewith transmitted to him a complete list of all funeral goods and requests its transmission to the Lord Administrator of funeral goods. Seidel, "Traces of Han Religion," p. 25.

34. Kleeman, p. 8. In later sixth-century tombs located near Tulufan, Xinjiang province, documents often include "statements of interred clothing and articles." Although many of the deceased were nominally Buddhist, the structure and content of the documents are related to earlier grave-quelling documents and land contracts excavated from Han tombs. The grave goods often list fabulous amounts of "heaven-climbing silk." Kleeman equates this with the huge amount of cash purportedly paid for land in southern land contracts, where land is bought from the spirits of the netherworld for the tomb. The Tulufan documents announce the death of the deceased to a divine official and close with the same phrase used in Han dynasty southern land contracts, "quickly, quickly, in accordance with the statutes and ordinances." Kleeman, pp. 8–9.

35. Seidel, "Traces of Han Religion," p. 33.

36. Ibid.

37. Peter Nickerson, "Shamans, Demons, Diviners and Taoists: Conflict and Assimilation in Medieval Chinese Ritual Practice (c. A.D. 100–1000)," Taoist Resources 5, no. 1 (1994), p. 53. For further details see Nickerson, "The Great Petition," in Bokenkamp, Early Daoist Scriptures, pp. 230–74. For a discussion of lawsuits in the tomb in later periods, see Valerie Hansen, Negotiating Daily Life in Traditional China: How Ordinary People Used Contracts, 600–1400 (New Haven: Yale University Press, 1995), chap. 7.

38. Nickerson, "The Great Petition," in Bokenkamp, p. 236.

39. Lothar von Falkenhausen, "Sources of Taoism: Reflections on Archaeological Indicators of Religious Change in Eastern Zhou

China," *Taoist Resources* 5, no. 2 (1994), p. 10. A similar pair of almanacs was excavated from Tomb 11 at Shuihudi, Hubei, dated to around 217 BCE in the Qin dynasty.

40. Ibid.

41. Donald Harper, "Manuscripts related to Natural Philosophy," in Edward L. Shaughnessy, *New Sources of Early Chinese History: An Introduction to the Reading of Inscriptions and Manuscripts* (Berkeley: University of California and Society for the Study of Early China, 1997), p. 224. For more on the Mawangdui medical manuscripts see Donald Harper, *Early Chinese Medical Literature: The Mawangdui Medical Manuscripts* (London: Royal Asiatic Society, 1996).

42. Harper says that contemporary sources are silent on the custom of burying books in the tombs of the elite, but as in the world of the living, knowledge was power and it is in this context that books are included as grave goods. Harper, "Manuscripts related to Natural Philosophy," in Shaughnessy, *New Sources of Early Chinese History*, p. 227. He also discusses the secrecy that surrounded the transmission of books during the Han, pp. 227–28, n. 18.

43. Ibid., p. 228, n. 18.

44. Ibid.

45. Rolf A. Stein, "Remarques sur les mouvements du Taoisme politico-religieux au IIème siècle ap. J.-C.," *T'oung Pao* 50 (1963), p. 39.

46. Grave-quelling texts were placed in tombs particularly in the Eastern Han dynasty, and the practice died out after that in most of China. However, they continued to be used in burials in western China, for example, at the Qijiawan tombs located near Dunhuang in Gansu province during the Wei and Jin periods. The grave-quelling jars from Qijiawan have been moved to the Archaeological Institute in Lanzhou where I saw them in May 2004. They are small, unglazed pottery; the inscriptions are found on the outside surface in either red or black ink. For more on the tombs at Qijiawan see *Dunhuang Qijiawan: Xijin Shiliuguo muzang fajue baogao* [Qijiawan, Dunhuang: Excavation report of Western Jin and Sixteen Kingdoms Tombs] (Beijing: Wenwu chubanshe, 1994).

47. John Major, *Heaven and Earth in Early Han Thought*, p. 158. For more on the dating and content of the *Huainanzi* see cat. no. 9, n. 1 and 2.

48. Ibid., p. 153, fig. 4.1. For further discussion of the imagery of the Queen Mother of the West, see Liu et al, *Recarving China's Past*, nos. 8 and 42.

49. See the Cangshan excavation report for further details: Shandong sheng bowuguan and Cangshan xian wenhua guan, "Shandong Cangshan yuanjia yuannian huaxiangshi mu," *Kaogu*, no. 2 (1975), pp. 124–34. This tomb was originally dated to 424 CE, but that date was later revised to be 151 CE. See Fang Penjun and Zhang Xunliao, "Shandong Cangshan yuanjia yuannian huaxiangshi tiji de shidai he you guan wenti de taolun" [A discussion of the dating of the stone relief inscribed the first year of Yuanjia from Cangshan in Shandong province and related questions], *Kaogu*, no. 3 (1980), pp. 271–78. For the Anqiu tomb, see Zheng Yan, *Anqiu Dongjiazhuang Han huaxiangshi mu* (Jinan, Shandong: Jinan chubanshe, 1992).

50. For a further discussion of the "celestial well" as well as tomb architecture (tomb pillars) and objects within the tomb as routes to heaven, see Susan L. Beningson in Liu et al, *Recarving China's Past*, cat. no. 29. Also see Nickerson, "The Great Petition," in Bokencamp, *Early Daoist Scriptures*, p. 260, n. 50; Rolf A. Stein, *The World in Miniature: Container Gardens and Dwellings in Far Eastern Religious Thought*, trans. Phyllis Brooks (Stanford, Calif.: Stanford University Press, 1990), pp. 217–19, 105, 149. For more on the "celestial wall" in early Indian and Central Asian sites and its western route of transmission to China, see Alexander C. Soper,

"The Dome of Heaven." *The Art Bulletin* 29, no. 4 (December 1947), pp. 225–48.

51. The "celestial well" was used as a ceiling motif at Ajanta (India), Bamiyan (Afghanistan), and Kizil (Xinjiang province, China), before being used at Dunhuang. However, I argue that there is also an eastern route of transmission to Dunhuang for this ceiling design, i.e. from earlier Han dynasty tombs, as Buddhist ritual space draws upon earlier Chinese cosmology to sinicize a foreign religion. A detailed discussion of the transmission of tomb architecture and cosmology to early cave chapels at Dunhuang can be found in Susan L. Beningson, "Shaping Sacred Space: The Interaction of Ritual Architecture and Artistic Programs in Early Buddhist Caves and Tombs in Fifth Century China," Ph.D. diss. (Columbia Univ., forthcoming).

52. The question remains, does the "celestial well" have the same meaning when transferred from a tomb to a Buddhist cave chapel? There is compelling evidence that it does. In cave 248 at Dunhuang (Northern Wei), there are a central stupa pillar and *tianjing* squares on the ceiling. On both the north and south walls directly below the *tianjing* are painted windows that are left partly open. They might function like the windows on the Eastern Zhou coffin of Marquis Yi of Zeng, to let the soul move from this world to the next. There have also been reports of an inscription under a *tianjing* motif in cave 249, describing it as a *tianchuang* or "window to heaven," but this could not be verified by the Dunhuang Research Institute during my visit in May 2004.

53. For further discussion of the *yunqi* design on chariot fittings and how this potent imagery activated the chariot as a bridge to immortal realms, as well as of the function of pillars in Han tombs as *axis mundi*, see Beningson in Liu et al., *Recarving China's Past*, cat. no. 29.

54. For a further discussion of *xiang* and their reflecting patterns of the cosmos see Willard J. Peterson, "Making Connections: 'Commentary on The Attached Verbalizations' of The Book of Change," *Harvard Journal of Asiatic Studies* 42, no.1 (June 1982), p. 111. This is discussed in the context of the knowledge of the sages as partly derived from processes at work in the realm of heaven and earth. For a discussion of embodied images (*tixiang*) in the context of calligraphy see also Cary Y. Liu "Embodying Cosmic Patterns: Foundations of an Art of Calligraphy in China," *Oriental Art* 56, no. 5 (2000), pp. 2–9.

55. The term *fangshi*, literally "master of recipes," is first recorded in the *Shiji* to identify specialists in occult techniques who gathered at the court of Qin Shihuangdi (see cat. no. 20). They were credited with the spread of magic, alchemy, and the immortality cult. Their chief attribute was their possession of *fang*, "recipes, methods"—specifically the books of recipes that contained both their knowledge and technique. See Harper in Shaughnessy, *New Sources of Early Chinese History*, pp. 229–30. For more information on *fangshi* see Kenneth J. DeWoskin, "A Source Guide to the Lives and Techniques of Han and Six Dynasties Fang-shih," *Society for the Study of Chinese Religions Bulletin* 9 (Fall 1981), pp. 79–105.

56. Sima Qian, *Records of the Grand Historian: Han Dynasty II*, trans. Burton Watson, rev. ed. (New York: Renditions/Columbia University Press, 1993), p. 28. Unfortunately for Shaoweng, about a year later his "magical arts seemed to grow less and less effective for no spirits appeared to answer his summons" and the emperor caught him faking a prognostication for which he was executed. Ibid.

57. Kiyohiko Munakata, *Sacred Mountains in Chinese Art* (Urbana and Chicago: University of Illinois Press, 1991). In Tomb 1 at Shuangrushan, located near Changqing city, Shandong province, both full size and miniature chariots were found, indicating that the size was less important than completeness in the efficacy of both the chariot and its imagery in the tomb.

58. Ibid., p. 23.

59. For a discussion of how designs originally painted in lacquer became the source for inlaid bronze design and the cloud scrolls found on chariot fittings similar to those from Shuangrushan, see Jessica Rawson, "Chu Influences on the Development of Han Bronze Vessels," *Arts Asiatiques* 44 (1989), pp. 84–99.

60. The information on Luozhuang in this essay is taken from Guojia wenwu ju, ed., *Zhongguo zhongyao kaogu faxian 1999* [Major Archaeological Discoveries in China in 1999] (Beijing: Wenwu chubanshe, 2001), pp. 75–78; Xie Zhixiu, ed., *Shandong zhongda kaogu xin faxian, 1990–2003* [Largest New Archaeological Discoveries in Shandong 1990–2003] (Jinan: Shandong wenhua yinxiang chubanshe, 2003), pp. 132–40; and an exhibition brochure given to the authors in June 2004 at the Jinan shi bowuguan. As we were going to press, an excavation report was published: Jinan shi kaogu yanjiu suo Shandong daxue kaogu xi, Shangdong sheng wenwu kaogu yanjiusuo, and Zhangqiu shi bowuguan, "Shandong Zhangqiu Luozhuang Hanmu peizang keng de qingli" [Summary report of the Han tomb and accompanying burial pits at Luozhuang, Zhangqiu, Shandong], *Kaogu*, no. 8 (2004), pp. 3–16 and color plates following p. 96.

61. Arthur Waley, trans., *The Book of Songs* (New York: Grove Press, 1960), p. 217. The *Shijing*, or *Book of Songs*, includes 305 poems which may be dated between ca. 1000–600 BCE. For a summary of its content and commentaries see Michael Loewe, "Shih ching," in *Early Chinese Texts: A Bibliographical Guide*, ed. Michael Loewe (Berkeley: University of California and Society for the Study of Early China, 1993), pp. 415–23.

62. Jinan shi kaogu yanjiu suo et al., "Shandong Zhangqiu Luozhuang Hanmu," p. 12. This identification was based on two gold seals discovered in the tomb. Ibid., p. 5, figs. 1 and 2. In addition to these seals, there were numerous clay seal impressions (*taoni*).

63. Hu Siyong, *Jing shi Han Wang Ling* (Shandong: Jinan chubanshe, 2001).

64. Cary Liu, Anthony Barbieri-Low, and I saw these bronzes in the collection of the Jinan Municipal Museum during our visit in June 2004. My appreciation to Tony for sharing this observation with us.

65. Pit no. 14 was the musical instrument repository for the tomb; it held over 140 instruments and stands in bronze, lacquer, stone, and other materials. The instruments included numerous *qin* zithers, bell sets, a *chunyu* bell (cat. no. 11), tuning implements, *jiangu* drums (see cat. no. 12), other types of drums, and chimes. In addition, there were three seal impressions (*taoni*) with the legend *lu da hang yin*. For discussions of how music, particularly bell and chime sets, was linked to elite burials and to rulership in China see Lothar von Falkenhausen, *Suspended Music: Chime-Bells in the Culture of Bronze Age China* (Berkeley: University of California Press, 1993), and Jenny So, ed., *Music in the Age of Confucius* (Washington D.C.: Freer Gallery of Art and Arthur M. Sackler Gallery, Smithsonian Institution, 2000).

66. From my personal observations of specific designs on the carved stones from Songshan in the collection of the Shandong sheng shike yishu bowuguan (Shandong Stone Carving Arts Museum).

67. The Shang and Western Zhou practices of including bronze ritual vessels and bell sets started to change with the so-called "ritual revolution" of the Eastern Zhou dynasty whereby bronzes became more important as indicators of wealth and status and not prized for their ritual use. By the Han dynasty, the use of models (*mingqi*) to substitute for actual objects became prevalent. In most Han tombs ceramic models of horses replace the actual animals in burials. For a more detailed discussion on the term *mingqi* and the use of models in Han tombs, see Cary Liu's essay in this catalogue.

68. This was one of two similar *danglu* excavated from the tomb. The second *danglu*, which was not in as good shape as the one in our exhibition, also depicted a celestial horse.

69. For the Qin chariots see Qin yong kaogu dui, "Qin Shihuang ling erhao tong chema qingli jianbao" [A brief report on the excavation of the bronze chariots and horses no. 2 at the mausoleum of Qin Shihuang], *Wenwu*, no. 7 (1983), pp. 1–16; color plate and plates 1–4.

70. No excavation report has yet been published on the excavations of Han sites at Weishan, Zhangqiu district, Shandong province. The information on this tomb is drawn from our visit to the site in June 2004 when we met with archaeologists who had conducted the emergency excavation. Additional information is drawn from Guojia wenwu ju, ed., *Zhongguo zhongyao kaogu faxian 2002* [Major Archaeological Discoveries in China, 2002] (Beijing: Wenwu chubanshe, 2003), pp. 81–86; Wang Shougong, "Jinan guowang de ling yi chu lingdi—Zhangqiu Weishan Handai muzang ji peizang keng" [Another royal mausoleum in Jinan—Han dynasty tomb and accompanying pit at Weishan, Zhangqiu county], in Xie Zhixiu, ed., *Shandong zhongda kaogu xin faxian, 1990–2003*, pp. 151–58; and Wang Shougong, "Weishan Hanmu: di wu chu yong bingma tong pei zang de wang ling" [The Han tomb at Weishan: the fifth royal tomb where cavalry figures have been unearthed], *Wenwu tiandi*, no. 2 (2004), pp. 58–65. See also "Shandong Zhangqiu faxian bingma yong keng" [Discovery of a pit with horse and warrior figures in Zhangqiu, Shandong], *Shijie ribao*, 4 December 2002, sec. A, p. 9; John Noble Wilford, "Terra-Cotta Army from Early Han Dynasty is Unearthed," *New York Times*, 18 February 2003, sec. F, p. 3; Jarrett A. Lobell, "Warriors of Clay," *Archaeology* 56, no. 2 (2003), pp. 36–39.

71. The inscription is described in a short paragraph in "Shaanxi Shunyi faxian Dong-Han bihua mu," *Kaogu yu wenwu*, no. 3 (2002), p. 76, illus. inside front and back cover. My appreciation to Zheng Yan for making me aware of this article. He discusses this tomb in Zheng Yan, "Kaogu fajue chutu de Zhongguo Dong-Han (Binwang mu) bihua" [Archaeological excavation of the Chinese Eastern Han (Tomb of King Bin) paintings], in *Yishu shi yanjiu* [Study of Art History], vol. 5 (Guangzhou: Zhongshan daxue chubanshe, 2003), pp. 510–18.

EMBODYING THE HARMONY OF THE SUN AND THE MOON:
THE CONCEPT OF "BRILLIANT ARTIFACTS" IN HAN DYNASTY BURIAL OBJECTS AND FUNERARY ARCHITECTURE
Cary Y. Liu

The relationship between Han dynasty funerary architecture and both the pictorial images and articles placed in tombs find affinities in the concept of brilliant artifacts (*mingqi*)—burial articles that embody a balance between the sun (*ri*) and moon (*yue*), the two components that make up the character *ming* (figs. 1, 2). While the term *mingqi* is commonly used today in referring to general categories of objects placed in tombs to provide for the dead in the afterlife, an attempt will be made in this preliminary investigation to consider *mingqi* within the context of the Shandong region in the Han dynasty. Funerary architecture in the form of tombs, tumuli and cemetery structures, and offering halls spans the twilight boundary between the realms of life, exposed to the light of the sun, and afterlife, under the glow of the moon. Often viewed as imitations of aboveground buildings for the living, mortuary architecture for the afterlife should also be considered in relation to the concept of *mingqi*. There may be a close relationship between the pictorial images in Han funerary monuments and burial ceramics, bronzes, lacquers, and other items. Many grave artifacts are depicted in Han pictorial stone carvings. Are the pictorial depictions merely pictures of buried artifacts or do they also fulfill the same role as three-dimensional brilliant artifacts? After a brief overview of modern interpretations of the term *mingqi*, this essay brings together some preliminary thoughts on the concept of brilliant artifacts in order to explore the possibility that Han dynasty mortuary structures along with their pictorial decoration and burial articles may sometimes have been conceived as an ensemble with the same shared artistic, ritual, and cosmological program.

This chapter is written in conjunction with an essay included in Cary Y. Liu, Michael Nylan, Anthony Barbieri-Low, et al., Recarving China's Past: Art, Archaeology, and Architecture of the "Wu Family Shrines" (Princeton: Princeton University Art Museum, 2005). I have received invaluable contributions to the research for this chapter from Eileen Hsu. Research travel for this chapter was made possible by the Spears Fund, Department of Art and Archaeology, Princeton University. I am also indebted to Lu Wensheng, director of the Shandong Provincial Museum, for his assistance in visiting excavation sites and viewing objects.

In modern scholarship the term *mingqi* has been variously translated as "glorious vessels" or "spirit articles/vessels."[1] Each partially captures some sense of the meaning of *mingqi*, which Walter Perceval Yetts (1878–1957) in 1928 considered a category of "objects made for burial with the dead." Yetts also noted: "The fact is surprising that until recently Chinese archaeologists have neglected to study the subject [of *mingqi*]."[2] The earliest work to use the term as an archaeological or art historical category may be Luo Zhenyu's (1866–1940) *Illustrated Catalogue of Ancient Mingqi*, written in 1916 to record his own collection of ceramic tomb figures and models.[3] In that publication and others, such as *Chinese Mingqi* (1933) by Zheng Dekun and Shen Weijun, the term *mingqi* is used to refer specifically to burial ceramics.[4] *Mingqi*, however, is commonly used in later studies as a general designation for grave-goods from the pre-Han to Qing dynasty (1644–1912). In each case, the modern application of the term has been adopted primarily to help categorize groups of collected or excavated objects. It is necessary to ask, however, what types of articles actually constitute *mingqi*? Does what is considered *mingqi* differ over time, by region, or by funerary practice?

Starting in 1907, Luo Zhenyu put together what may have been the earliest collection of burial articles to be labeled as *mingqi*.[5] Limited to burial ceramics, the collection ranged widely in date and was divided into four classifications: human figures, various types of models, domestic animals, and, interestingly, architectural tomb tiles showing scenes of exemplary filial piety and loyalty. The term *mingqi*, however, was never clearly defined. A similarly vague definition is found in many attempts to classify large numbers of tomb artifacts that have been unearthed during modern archaeological excavations and salvage. In some cases, all objects buried in a tomb are considered to be *mingqi*, while in others only artifacts believed to have been made specifically for the dead qualify. The lack of a single standard definition is reflected in what scholars have variously identified as the earliest surviving examples of *mingqi*. In *Chinese Mingqi*,

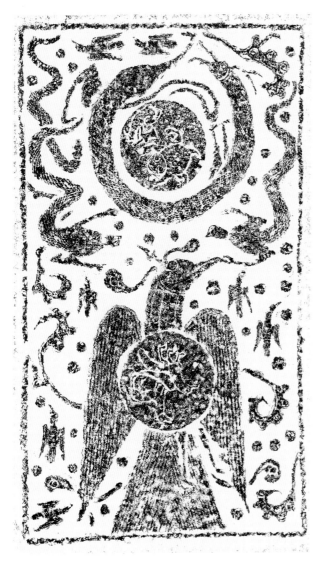

Fig. 1. Moon with toad and hare (top) and sun with three-legged bird (bottom), rubbing (modern) of pictorial stone carving excavated at Dakangliuzhuang at Tengzhou, Shandong. Late Eastern Han dynasty (25–220 CE). Ink on paper. Tengzhou City Museum. After *Zhongguo huaxiangshi quanji* (Jinan: Shandong meishu chubanshe, 2000), vol. 2, no. 165

Zheng Dekun and Shen Weijun characterized decorated pottery unearthed from Neolithic graves as *mingqi*. More recently, some scholars have pointed to late-Shang period tomb artifacts as being the earliest examples.[6] In each case, a modern understanding of *mingqi* has been applied anachronistically to periods when it is unlikely the term had yet come into existence. The modern application of the term *mingqi*, therefore, grew from a need to categorize groups of burial artifacts that had suddenly developed a market and become the focus of new collecting and study in the early twentieth century.

Rather than conceive of a corresponding physical category or group of objects in probing the meaning of *mingqi* in the Han dynasty, it may be better to examine the possible role of the term in differentiating the realms of life and afterlife as reflected in grave articles and funerary architecture for the dead. A glimpse of Han conceptions of *mingqi* may be garnered from scattered discussions of funerary rites contained in pre-Han texts (many compiled in and containing commentary from the Han) as well as Han sources. Such early texts make a distinction between artifacts appropriate for life and those for afterlife. In discussing the official duties of the palace gatekeeper (*hunren*) in the Zhou dynasty, the *Zhou Rites* (*Zhouli*) notes that "funerary garments and mourning artifacts (*xiongqi*) are not allowed to enter the palaces" of the living. Mourning artifacts are equated with *mingqi* in a Han commentary to this passage by Zheng Xuan (127–200).[7] The term *xiongqi* is similarly glossed by Zheng Xuan in his commentary to the *Zhou Rites* discussion of the role of the tomb officer (*zongren*)

> who takes charge of the royal cemetery and sets the boundaries and makes drawings [for the tomb]. For royal funerals (*dasang*), once the date is determined, the [tomb officer] requests [approval for] the dimensions [and permission] to begin building the tomb pit, and acts as a stand-in body (*shi*) [for the deceased]. At the time the tomb pit [is dug], he follows the measurements for the mound and the ramp, and supplies the funeral equipment. At the time for the funeral, he speaks to the effigy (*xiangren*) [of the deceased] in the bell hearse (*luanche*). During the interment of the coffin, he holds an ax [to assist] and weeps. He then buries the mourning articles (*xiongqi*).[8]

In Zheng Xuan's commentary, the bell hearse is a vehicle with cloth decoration as well as bells (*luanhe*) and pennants that is used to transport the corpse to the grave.[9] According to a later sub-commentary by Jia Gongyan (fl. 650), the hearse and effigy are forms of *mingqi*. If this is an accurate reflection of Han practice, it suggests that some bronze, ceramic, and wood chariots and human figures recovered from Han tombs may correspond to the bell hearse and effigy mentioned in this passage (cat. no. 2 and fig. 3). In the above passage, it is also important to note that both apparitions of the deceased, as impersonator and as effigy, seem to have the ability to embody the spirit brilliance (*shenming*) of the dead (discussed later). Controversy over the lifelikeness of figures, vessels, and even implements came to play a significant role in determining the characteristics of *mingqi*.

Distinctions are made in the early texts between

objects for the living and those for the afterliving. In discussions of burial rituals for "gentlemen," or "servicemen" (*shi*),[10] in the *Ceremonials* (*Yili*), burial objects are divided into many types, including utilitarian artifacts (*yongqi*), banquet and musical objects (*yanyueqi*), sacrifice vessels (*jiqi*), warrior articles (*yiqi*), and brilliant artifacts (*mingqi*).[11] These types of objects were generally divided into those made for the living, known as "objects for living people" (*renqi* or *shengqi*), and those made for burial, known as "fearsome artifacts" (*xiongqi*), objects for the dead (*guiqi*), or "brilliant artifacts" (*mingqi*).[12] Articles made for the dead were not to enter the palaces of the living except after being properly announced during certain indoor funerary ceremonies.[13] On the other hand, articles for the living could reside in a tomb along with those made for the dead. Concerning burial rituals for gentlemen, in the *Ceremonials* it is regulated that "there will be no sacrifice vessels." Commenting on this line in the Han dynasty, Zheng Xuan notes that "In burial ceremonies for gentlemen, [sacrifice vessels] are omitted. [However, for those with the official rank of] Counsellor (*dafu*) or above, both objects for the dead (*guiqi*) and objects for living people (*renqi*) are used."[14] Depending on rank, then, burials could include both objects for the living and objects for the dead, or be limited to just those made for the dead.

Objects made for both the living and the dead have been found in combination in Han royal tombs, such as Tomb 1 of Mount Shuangrushan in Changqing county, excavated in 1995.[15] Carved into the limestone cliffs, it is the largest rock-cut royal tomb found to date. In comparison, each of the four Western Han rock-cut royal tombs excavated in 1970 at Mount Jiulongshan in Qufu county, Shandong, was less than one-third as large in excavated square footage but more complicated in plan.[16] Tomb 1 was never robbed and contained over 2,000 burial artifacts, more than all the items found in the four tombs at Jiulongshan combined. It is now believed to belong to Liu Kuan (r. 97–85 BCE), the last ruler of Jibei Kingdom (Jibei *guo*) during the Western Han. Liu was forced to commit suicide for his licentious behavior with his father's widow and for cursing the emperor during a sacrifice.[17] If the tomb's attribution is correct, Liu Kuan was granted royal burial privileges despite his disgrace. Ironically, the tomb's attribution is mostly based on his ignominy. At the time of Liu Kuan's death, the tomb may already have been carved into the mountain at its present large size. Although granted a royal burial, Liu Kuan was only bestowed a jade mask

(cat. no. 34), body-orifice fillers, and hand grips (cat. nos. 36, 37) instead of a complete jade suit (*yu yi* or *yu xia*).[18] In addition, the rock-cut walls and ramp of the tomb were crudely finished leaving behind a random patchwork of depressed rectangular panels that may have had something to do with the stone chiseling process (figs. 4, 5).[19] Although over 2,000 burial items were unearthed in this tomb, most were small items, and the numbers of certain notable types of ritual objects were below the standards found in other royal tombs.[20]

Burial objects found in Tomb 1 include bronze, ceramic, jade, lacquer, iron, and gold articles. Bronzes are by far the most numerous with over 1,000 items, mainly articles of daily use along with horse and chariot fittings. There are only six ceramic pots (*guan*) as well as ceramic figures of domestic animals and fowl, including cows, sheep, chickens, and fish, placed in the side compartments around the coffin chamber. Similar animal figures have been found in numerous other Han tombs (cat. nos. 22, 23). The skeletal remains of chicken and fish were also found inside some of the burial vessels and containers in

Fig. 2. Fuxi with the sun (right) and Nüwa with the moon (left), rubbings (modern) of carved pictorial tomb stones from Baizhuang, Linyi county, Shandong. Eastern Han dynasty (25–220 CE). Ink on paper, image height approx. 117 cm (46 in.). After *Linyi Han huaxiangshi*, ed. Feng Yi et al. (Jinan: Shandong meishu chubanshe, 2002), p. 23, figs. 32-33

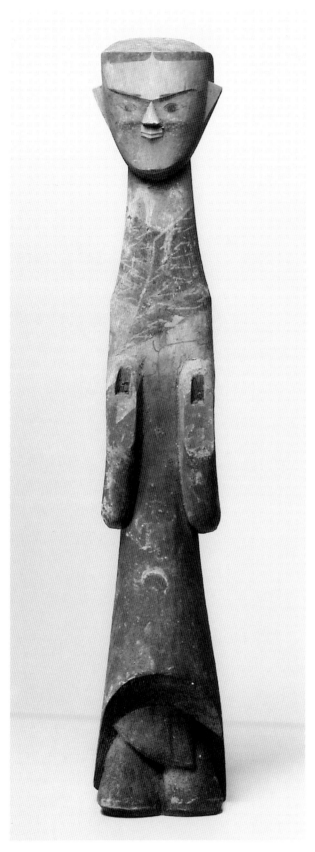

Fig. 3. Human figure, ca. 3rd century BCE. Late Eastern Zhou period (770–256 BCE) or early Western Han dynasty (206 BCE– 9 CE). Wood with lacquer pigments, height 56.5 cm (22 ¼ in.). Princeton University Art Museum, Museum purchase, Carl Otto von Kienbusch, Jr., Memorial Collection, y1948-75

Tomb 1, as well as in the royal tombs at Jiulongshan.[21] Jade artifacts include an eighteen-piece burial mask, one of the most elaborate examples found to date (cat. no. 34). Other jades include a headrest constructed of fourteen parts (cat. no. 35), a paltry number of *bi* discs (cat. no. 38), and a full set of body-orifice fillers and pig-shaped hand grips. The lacquer items have deteriorated beyond recognition. A small gold button was found at the waist of the corpse, and nineteen gold button-ingots (*jin bing*) with incised and stamped characters, including *wang* (king) (cat. no. 33) were found next to the head beside the jade pillow.[22] Besides these ingots, bronze *wuzhu* coins (cat. no. 19) were also unearthed.

Tomb 1 at Shuangrushan also included life-size one-, two-, and four-horse chariots along with a half-size chariot that were found in a front-to-back row in the outer depository (*waizang guo*) (fig. 6).[23] Next to the chariots, but not attached to them, were buried a row of seven horses as well as two deer. A second miniature chariot was found in the north side compartment of the main coffin depository (*zhengzang guo*). At the four Jiulongshan royal tombs, there were a total of about twelve chariots and fifty horses along with several miniature chariot models. Because the horses were buried alive, they inflicted heavy damage on the attached chariots, hindering attempts to reconstruct the vehicles from the recovered fittings and ornaments (cat. nos. 39–44). At both sites, some of the miniature chariots may correspond to the *mingqi* hearse discussed above in the passage about the duties of the tomb officer in the *Zhou Rites*. In non-royal tombs where life-size chariots could not fit in terms of size or propriety, miniature replicas (cat. no. 2) and carved or painted images of chariots could have been sufficient for the occupant's afterlife needs.

In Han burials it is often difficult to distinguish between objects made for the living and those for the dead. Certain vessels, such as *ding* tripods (cat. nos. 3–5), *hu* jars (cat. no. 6), and *guan* pots, may have been sacrifice vessels (*jiqi*) or storage articles originally made for the living but then placed in the tomb. They also could have been made specifically for burial. Many items such as belt-hooks, weapons, musical instruments, books (cat. no. 17), and lamps, made in jade, metal, or wood, were used in ordinary life but are also commonly found in tombs. Some jade artifacts, such as burial masks, body-orifice fillers, and hand grips, were definitely made for burial. Jade and glass *bi* discs could have been made to serve the living as ritual symbols of power—as evidenced in Eastern Han pictorial stone carvings showing the First

Emperor of the Qin dynasty (Qin Shihuangdi) grasping a disc (fig. 7)—or could have been made just for burial. The corpse in Tomb 1 at Shuangrushan was found with large jade discs on top of and under his torso, and smaller discs on top of his solar plexus. In the case of many other objects commonly recovered from tombs, there is ambiguity as to whether they were made for the living or meant for interment. Mirrors and coins (cat. nos. 18, 19), for instance, were used in daily life, but they also seem to have been produced just for burial.[24] Were the gold button-ingots, such as those found in Tomb 1 at Shuangrushan, ever used as money in daily life? There are also indications that objects originally made for daily use and rituals could be ritually converted to burial purposes.

Moreover, there are further distinctions made between gift burial articles (*jiuqi*) from mourning guests and burial items belonging to the deceased. In royal tombs, many of the burial items, including clothes, jade suits, and lacquer coffins, were supplied through the Artisans of the Eastern Garden (Dong yuan jiang) department within the Superintendent of the Lesser Treasury (Shaofu) and were known as funerary or hidden equipment (*biqi*).[25] In the context of royal funeral equipage, terms such as *biqi* and *mingqi* may also have been applied to distinguish between types of burial items supplied by different official departments.

The ambiguity or confusion over what sorts of items placed in tombs are to be considered made for the living and what sorts for the dead is not only a problem of mod-

ern interpretation. That the issue was already controversial during the Han dynasty is reflected in exegetical commentary to the three Confucian canons on rites and other ritual texts.[26] In the "Tan Gong" chapter of the *Rites Records (Liji)*, it is recorded that " At the burial of his wife, Duke Xiang of Song placed [in the grave] a hundred jars of vinegar and pickles. Zengzi said, 'They are called *mingqi*, and yet he filled them!'"[27] In this passage, Zengzi, a disciple of Confucius (551–479 BCE), remarks on the impropriety of giving a life substance to *mingqi* by filling them with real food, that is, by using them as if they were ordinary vessels for the living.[28] In his commentary to this passage, Zheng Xuan notes that although burial jars for the dead are called *mingqi*, they are filled and used just like sacrifice vessels (*jiqi*) for the living, and this "confuses objects for the dead (*guiqi*) with objects for living people (*renqi*)."[29] Intimated in this passage is a distinction between objects for the living and those for the afterlife that hinges on the artifacts' ordinary use or extraordinary uselessness.

The characteristics of *mingqi* are discussed in the "Tan Gong" chapter of the *Rites Records*, where Confucius is quoted as saying:

In dealing with the dead, if we treat them as if they were entirely dead, that would show a want of affection, and should not be done; or if we treat them as if they were entirely alive, that would show a want of wisdom, and should not be done. On this account

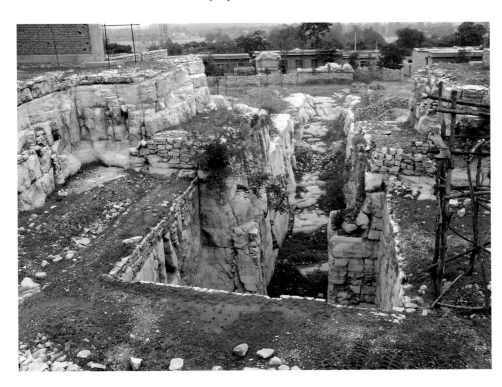

Fig. 4. View from south overlooking coffin chamber and ramp of Tomb 1 at Mount Shuangrushan, Changqing county, Shandong. Photo by author, 2004

Fig. 5. View of coffin-chamber wall with patchwork of depressed rectangular panels from Tomb 1 at Mount Shuangrushan, Changqing county, Shandong. Photo by author, 2004

bamboo artifacts [used in connection with the burial of the dead] are not fit for actual use; those of earthenware cannot be used to wash in; those of wood are incapable of being carved; the lutes and harps are strung, but not evenly; the reed pipes are complete, but not in tune; the bells and musical stones are there, but they have not stands. They are called brilliant artifacts (*mingqi*); that is, [the dead] are thus treated as if they were spiritual brilliances (*shenming*).[30]

According to this passage the spiritual brilliance of the deceased occupies a medial zone of an afterlife between the entirely dead and entirely living.[31] This parallels the belief that the departed soul lingers but gradually diminishes over time, which is "attested to by the ancient saying that 'the spirit of a newly dead is large and that of an old one is small' (*xin gui da gu gui xiao*)."[32] In order to provide proper treatment for spiritual brilliances in this afterlife realm, therefore, *mingqi* are conceived of as artifacts that are not quite artifacts; that is, they are simulacra having the appearance and form of articles made for the living, but are devoid of their use and function.[33] If this is the distinction between objects for the dead (*guiqi*) and objects for living people (*renqi*), then how are the life-size chariots, vessels buried containing food, and coins found in Han tombs to be reconciled? Is it possible that objects that were used during life could be simply converted for burial use by taking away their function? Could unhitched chariots or missing reins and harnesses be enough to negate a vehicle's ordinary use? Musical instruments could be made inharmonious, or bells and stone chimes could be buried without stands to suspend

them or hammers with which to strike them. Similarly, extraordinarily useless simulacra could be made in miniature or in different materials so that they only imitate the form of daily objects or activities but impeded their ordinary function. Wine vessels could be made of permeable earthenware that would leak, while miniature replicas of architecture, wells (cat. no. 26), chariots, domestic animals and fowl (cat. nos. 22, 23), and human figures of cooks (cat. no. 24), entertainers (cat. no. 12), attendants (cat. no. 27), warriors, and equestrians (cat. no. 13) all have "the appearance but not the substance or proper qualities"[34] of a person or thing.

Does the characterization of *mingqi* as objects that imitate those made for the living yet are devoid of their lively use and function find parallels in the notion that in China underground funerary architecture for the dead is modeled after aboveground architecture for the living? The idea that mortuary architecture imitates that of the living had currency from as early as "A Discussion of Rites" (*Lilun*) in the *Writings of Xunzi*, attributed to Xun Qing (late 4th–3rd century BCE), a man who served in office and lived in the Lanling region in southern Shandong:

> The grave and grave mound in form imitate a house; the inner and outer coffin in form imitate the sideboards, top, and front and back boards of a carriage; the coffin covers and decorations and the cover of the funeral carriage in form imitate the curtains and hangings of a door or a room; the wooden lining and framework of the grave pit in form imitate railings and roofs. The funeral rites have no other purpose than this: to make clear the principle of life and death, to send the dead man away with grief and reverence, and to lay him at last in the ground.[35]

In this imitative relationship, the architecture for the dead is often presented as being the polar opposite of architecture for the living.[36] The relationship should now be reevaluated in terms of the concept of *mingqi*. Funerary structures are not architecture for the entirely dead. Instead, they are better viewed as architecture for spiritual brilliances in the afterlife, a realm between the entirely living and the entirely dead. Tombs imitate the functional divisions of the palace with front chamber and rear chambers, storage areas, lavatories, and horse and chariot stables; yet, the living function and ordinary use of the chambers are negated. The front doors of a tomb once closed do not open, the lavatories cannot be used, the ceilings in tomb chambers are often too low for any-

one to stand, and the stored items are often *mingqi* artifacts that cannot be used. Beyond this relationship, tomb architecture and *mingqi* artifacts share other similarities that need further scrutiny. The brick wall tiles of some tombs are sometimes decorated with painted, stamped, or relief designs of pictorial figures and geometric patterns (cat. nos. 46–50), and the same decorative techniques are used on ceramic *mingqi* vessels. Likewise, the walls of stone tombs are often decorated with pictorial carvings in fine incised lines, intaglio, relief, and openwork, sometimes combined with the application of paint or other decorative treatments. All of these techniques find comparable examples in ceramic, bronze, jade, stone, and lacquer *mingqi* artifacts buried in tombs.

Beyond similarities in artistic techniques, many of the subjects and themes depicted in pictorial stone carvings (*huaxiangshi*) in tombs are also found in the decoration and shape of *mingqi* placed in tombs. Shared images include horses and chariots (cat. no. 2), equestrians (cat. no. 13), food preparation scenes (cat. nos. 24, 25), domestic animals (cat. nos. 22, 23), supernatural beasts (cat. no. 43), and fabulous concatenations (cat. no. 3). Additionally, one cannot ignore that the identification of tomb chambers as reception halls, kitchens, stables, inner chambers, and other functional rooms often depended on the types of *mingqi* artifacts placed inside. In some cases the placement of *mingqi* may be tied to the location of pictorial images decorating the tomb walls. This allowed tomb chambers to be seen as copies of palace chambers; but, in tombs the living function of the artifacts and chambers was negated in order to provide proper treatment of spiritual brilliances in the afterlife.

What then are the proper qualities of an afterlife person or thing? In his commentary to the foregoing "Tan Gong" passage, Zheng Xuan notes: "That which are spiritual brilliances (*shenming*) cannot be understood by living people, so their artifacts are also this way." [37] Examining the meaning of the individual characters *shen* and *ming* may provide some understanding. Passages that include the character *shen* are some of the most enigmatic in the *Book of Change* (*Yijing*). *Shen* can be translated as "numen" or "numinous," "divinities" or "divine," or "spirits" or "spiritual." Regarding this term, Willard Peterson notes: "The 'Commentary on the Attached Verbalizations' seeks to establish that the *Book of Change*, as a book and as a technique, effectively crosses the boundary of the square (which symbolically represents all-under-heaven, human society, the domain of sages, the man-made, what is known and knowable) into the realm of heaven-and-earth, the ten-thousand things, what is not man-made, what is not directly and never perfectly known, including what is numinous [*shen*]." [38] As something "not directly and never perfectly known," *shen* is described as a numinosity found in all things in heaven-and-earth, in life and afterlife. [39] The reason that the concept of brilliant artifacts has never been clearly defined may stem from this fundamental unknowability of spiritual brilliances.

Fig. 6. Chariots from Tomb 1 at Mount Shuangrushan (modern reconstructions) in an exhibition gallery at the Changqing Museum, Shandong. Photo by author, 2004

23

Fig. 7. First Emperor of the Qin dynasty grasping a *bi* disc, rubbing of detail from "Wu family shrine" pictorial stones, Wuzhaishan, Jiaxiang, Shandong. Eastern Han dynasty (25–220 CE). Ink on paper, late 19th-early 20th century. Princeton University Art Museum, Far Eastern Seminar Collection, 2002.307.36

We should also examine the term *ming*, which can be translated as "brilliant," "bright," or "intelligent."[40] *Ming* is often associated with objects used in funerals and sacrifices. For example, vestments worn when performing sacrifices are called "brilliant clothes" (*mingyi*), and water used in sacrifices is called "brilliant water" (*mingshui*).[41] Why this term is so closely tied to burial and sacrificial ceremonies, however, is a matter of speculation. A possible explanation would have us understand *ming* as a brilliance that makes evident the moral virtues (*mingde*) of a family through the body of a person, or a state through the body of the ruler. Burial objects and funerary architecture frequently include scenes of exemplary conduct and correct moral behavior, which may be meant to make manifest the virtues of the deceased, as well as those of his ancestors and descendants. Brilliant artifacts, then, can be viewed as embodying the virtue of a person's life and that of his family line. This brilliant aspect of artifacts is the focus of a passage concerning the size and weight of tripod (*ding*) vessels in the *Zuo Commentary* (*Zuozhuan*) to the *Spring and Autumn Annals* (*Chunqiu*), which chronicles events affecting the state of Lu (in modern Shandong), the home state of Confucius during the Eastern Zhou period (770–256 BCE):

Long ago, when the Xia dynasty was still possessed of virtue, the distant regions sent pictures of various objects and tribute of metal was submitted from the governors of the nine provinces. This was used to cast tripods with various objects depicted on them…Thus the superior and the inferior were brought into harmony and they enjoyed the providence of heaven… When virtue is bright and comely, then the tripods, though small, are heavy. But when there is depravity and disorder, then although they are large, they are light.

The bright virtue (*mingde*) bestowed by heaven has its limit and end.[42]

In a royal context, the Nine Tripods (*jiuding*) embody the virtues of the sovereign and the harmony of the state.[43] If all is in harmony, it was popularly believed, then tripods could cook even when there is no fire, and food could be taken out even if none had been put inside. This belief is found as early as the latter half of the fifth century BCE in the *Writings of Mozi* (*Mozi*) by Mo Di, who is said by some to have been a native of Shandong in the state of Lu.[44] The belief continued into the Han dynasty, and was repeated in the *Disquisitions* (*Lunheng*) by Wang Chong (27–ca. 100).[45]

Besides tripods, other objects buried in tombs were probably imbued with a similar brilliance that served to make evident the exemplary virtues and moral rectitude of the deceased.[46] When all is in harmony, replicas of stoves would cook (cat. no. 25), wells would supply water (cat. no. 26), musical instruments would play (cat. nos. 11, 12), storage vessels and measures would always be filled (cat. nos. 6, 20), and gaming sets would bring success and winnings (cat. nos. 7, 8). Apparently, the brilliance inherent in buried objects could only shine during conditions of harmonious balance, which by the Han dynasty may be what is symbolized by the sun (*ri*) and moon (*yue*) components that constitute the character for brilliance (*ming*). This equilibrium may derive from the early conception of the human soul as *po*, meaning "lunar brightness." By the Han dynasty, the soul was popularly conceived as a dualistic conception of *po* and *hun* souls that correspond to the lunar *yin* and solar *yang* elements. In some texts the new *hun* soul is said to originally derive from the *po* soul.[47]

In the Han, it is this harmony of spiritual brilliance between the cosmic *yang* and *yin* forces, respectively, of the sun and moon that is often portrayed in pictorial stone carvings in funerary architecture (figs. 1, 2).[48] The balance of the sun and moon is also represented on mortuary shrouds or mantles (*hu* or *feiyi*) that were draped over a newly dead body and, later, the interred coffin (fig. 8).[49] This harmonious balance may also be the basis

for understanding the royal ritual structure known as the Brilliant Hall (*mingtang*).[50]

The attainment of this harmony through rites is discussed in the *Writings of Xunzi*:

> Through rites heaven and earth join in harmony, the sun and moon are brilliant (*ri yue yi ming*), the four seasons proceed in order, the stars and constellations march, the rivers flow, and all things flourish.[51]

The harmonious balance between the sun and moon, however, is upset if the burial artifacts are too lifelike. As discussed earlier, *mingqi* are conceived as items made for the afterlife between the realms of the entirely dead and entirely living. In order to maintain a balance, they are simulacra having the appearance and form of articles made for the living, but are devoid of their use and function. The lifelike function of vehicles, vessels, architectural replicas, musical instruments, and implements could be severed from the likeness of the artifact. However, when it came to burial figures of people—attendants (fig. 3 and cat. no. 27), musicians (cat. no. 12), equestrians (cat. no. 13), cooks (cat. no. 24), entertainers, and warriors—lifelikeness was inseparable from appearance and form.

This concern over the form likeness of human burial figures was a sensitive issue to Confucius, who worried that the burial of lifelike figures would eventually lead to a return to human and live burial sacrifices. Recorded in the "Tan Gong" chapter of the *Rites Records*:

> Confucius said, "He who made the vessels which are so [only] in imagination, knew the principles underlying the mourning rites. They were complete [to all appearance], and yet could not be used. Alas! If for the dead they had used the vessels of the living, would there not have been a danger of this leading to the interment of living with the dead?"

It continues:

> They were called "vessels in imagination," [the dead] being thus treated as spiritual brilliances. From of old there were the carriages of clay (*tuche*) and the figures of straw (*chuling*)… Confucius said that the making of straw figures was good, and the making of the (wooden) automaton (*yongzhe*) was not benevolent. Was there not a danger of its leading to the use of (living) men?[52]

Fig. 8. Line drawing of Western Han dynasty silk mortuary banner with painted designs of the sun and moon, unearthed in Tomb 9 at Jinqueshan, Linyi county, Shandong and now in the Shandong Provincial Museum. After *Wenwu*, no. 11 (1977), front inside cover

These "vessels in imagination," as translated by James Legge, are what I have termed "brilliant artifacts" (*mingqi*). Confucius approved of the practice of burying clay carriage replicas (*tuche*) that do not function and straw effigies (*chuling*) of human figures that are not realistic in appearance. In Zheng Xuan's commentary to the latter passage, he notes that straw was used to make effigies of people and horses. As for human burial figures (*yong* or *ou*), he notes that because they have faces and some are mechanized, allowing them to move or jump (*yong*; hence "automaton"), they are considered too lifelike. For Confucius, burying such lifelike figures of people or objects that still functioned as if made for the living, was not far removed from returning to the practice of burying living people (*xun*).

It is commonly assumed that during Confucius' lifetime human burial figures were made of wood (fig. 3), but by the Eastern Zhou period and Han dynasty they were also made of ceramic (cat. nos. 12, 27). Crude, painted earthenware human figures about 10 centimeters in height were found in a tomb complex near Linzi in southern Shandong that dates to the fifth century BCE.[53] Roughly contemporary with Confucius and located not far from where he lived, the Linzi burial complex included several accompanying burials and skeletons of twenty-six human victims, some of whom may have been buried alive. While live burials date from as early as Neolithic times and were not uncommon in the Shang period, they grew less popular by the late Eastern Zhou period. Still, the practice continued until the time of Confucius even as straw, wood, metal, and ceramic figures began to be used—sometimes in combination with human victims and sometimes as substitutes—to provide for the deceased soul in the afterlife.[54]

Prohibited in the Han dynasty, the use of human burial victims became rare but not unknown.[55] Despite warnings by Confucius and his followers, however, the practice of burying lifelike human figures in wood and ceramic increased in popularity. One cannot dismiss the life-size terracotta army buried at the mausoleum of the First Emperor of the Qin dynasty or the smaller figures found at Han dynasty royal tomb sites, including those excavated in late 2002 at Weishan in Shandong (cat. nos. 12, 13).[56] Besides lifelike human figures, actual horses, deer, and other animals continued to be buried alive or sacrificed in Han tombs, as seen at Tomb 1 at Shuang-rushan. Also, what are we to make of the prints of a left hand impressed into wall tiles found in a third-century late-Han or post-Han tomb excavated in 1988 at Mount Jinqueshan near Linyi, Shandong (cat. no. 51). These may be the most intriguing items in the exhibition. The handprint tiles, along with other tiles bearing designs of the Four Deities (*sishen*) of the cardinal directions and a feline, or *qilin*, beast (cat. nos. 46–50) from this tomb, all have the family name Zhang stamped in relief on their sides.[57] Who is this man named Zhang? Do the handprints belong to him? Is he the workman responsible for building the tomb, as some speculate, or is he the tomb occupant? In either case, the imprint of an actual person was included in the tomb. One cannot get any closer to a human sacrifice, and if Confucius knew, he would probably be rolling in his grave. From a different perspective, the handprints can be considered the ultimate brilliant artifact. They are negative embodiments of a real person. They identify the individual and can be understood to make brilliant the exemplary virtues and moral rectitude of the man or woman.

NOTES

1. Carl Hentze, *Chinese Tomb Figures: A Study in the Beliefs and Folklore of Ancient China* (London: Edward Goldston, 1928); Robert Thorp, "Mortuary Art and Architecture of Early Imperial China," Ph.D. diss. (University of Kansas, 1979); and Eng-Lee Seok Chee, "Mingqi and other Tomb Furnishings as Reflections of Han Culture and Society," in *Spirit of Han* (Singapore: Southeast Asian Ceramic Society, 1991), pp. 30–40.

2. W. Perceval Yetts, "Foreword," in Hentze, *Chinese Tomb Figures*, p. vii.

3. Luo Zhenyu, *Gu mingqi tulu* [Illustrated Catalogue of Ancient Mingqi] (Shangyu: Luo shi, 1916).

4. Zheng Dekun and Shen Weijun, *Zhongguo mingqi* [Chinese Mingqi] (Beijing: Harvard-Yenjing Institute, 1933).

5. A brief history of the formation of his collection is included in the preface of Luo Zhenyu, *Gu mingqi tulu*. For an English summary, see Yetts, "Foreword," p. vii.

6. Zheng and Shen, *Zhongguo mingqi*, pp. 11–15. On Shang, see Thorp, "Mortuary Art and Architecture," p. 30; and for the earliest *mingqi* human figure, see Cao Zhezhi, *Zhongguo gu dai yong* [Ancient Burial Figures of China] (Shanghai: Shanghai wenhua chubanshe, 1996), pp. 2–3. The traditional inclination that *mingqi* existed before the Zhou dynasty derives from the *Rites Records* (*Liji*), which has a passage saying *mingqi* were used to accompany the dead in the Xia dynasty, ritual artifacts (*jiqi*) were used in the Shang dynasty, and both in the Zhou dynasty. See *Liji ji jie* [*Rites Records* and Collected Explications], comp. Sun Xidan (Beijing: Zhonghua shuju, 1989), p. 219. On the sole basis of this passage, Rao Zongyi speculates that *mingqi* "originated before the Yin-Shang period"; see Jao Tsung-i [Rao Zongyi], *Chinese Tomb Pottery Figures*, exhibition catalogue (Hong Kong: Hong Kong University Press, 1953), pp. 1, 5.

7. *Zhouli zhushu* [*Zhou Rites* and Annotations], in *Shisan jing zhushu* (Beijing: Zhonghua shuju, 1980), p. 686. The term *xiongqi* is again equated to *mingqi* by Zheng Xuan in *Liji ji jie*, p. 115. In modern scholarship *xiongqi* is sometimes translated as "inauspicious vessels" (e.g., Thorp, "Mortuary Art and Architecture," p. 57). This is misleading because it implies an opposition to "auspicious vessels" (*jiqi*), which to my knowledge is not used as a term in a funerary context. The more likely parallel is to daily dress for the living (*jifu*) versus mortuary dress (*xiongfu*) for the afterliving. In certain contexts, *xiongqi* can also be translated as "fearsome articles" and refers to military weapons.

8. *Zhouli zhushu*, p. 786.

9. Also see *Zhongwen da cidian* [Grand Dictionary of Chinese], ed. Zhongwen da cidian bianzuan weiyuanhui (Taibei: Zhongguo wenhua daxue, 1973), nos. 39917.8 and 48485.13.

10. In Denis Twitchett and Michael Loewe, ed., *The Ch'in and Han Empires, 221 B.C.–A.D. 220*, vol. 1 of *Cambridge History of China* (Cambridge: Cambridge University Press, 1986), p. 28, the *shi* are described as being from "the lower fringe of the aristocracy…men of good birth without titles of nobility, who served as warriors, officials, and supervisors in the state governments and noble households, or who lived on the land…" Also see Charles O. Hucker, *A Dictionary of Official Titles in Imperial China* (Stanford: Stanford University Press, 1985), no. 5200.

11. See *Yili zhushu* [*Ceremonials* and Annotations], in *Shisan jing zhushu*, pp. 1148, 1149.

12. For *renqi*, *shengqi*, and *guiqi*, see Zheng Xuan's commentary in *Yili zhushu*, pp. 1148, 1149. For *shengqi*, also see *Xunzi*, in *Yingyin Wenyuange Siku quanshu* (Taibei: Taiwan shangwu yinshuguan, 1983–86), *juan* 13, pp. 15b–16b.

13. For rare instances when burial objects (*xiongqi*) along with the burial register and funeral clothes were permitted inside the palace gates after being properly announced, see *Liji ji jie*, p. 115; and James Legge, *The Li Ki*, in *The Sacred Books of the East*, ed. F. Max Müller, vol. 28 (Oxford: Clarendon Press, 1885), p. 103.

14. *Yili zhushu*, in *Shisan jing zhushu*, p. 1149. Translation of *dafu* as "Counsellor" follows Michael Loewe, *A Biographical Dictionary of the Qin, Former Han and Xin Periods (221 B.C.–A.D. 24)* (Leiden: Brill, 2000), pp. 757, 759.

15. Although the tumulus and upper layers of this tomb were removed by mining and blasting before excavation work started, the untouched tomb interior provides valuable information about royal burial practices. See Shandong daxue kaogu xi, Shandong sheng wenwu ju, and Changqing wenwu ju, "Shandong Changqing xian Shuangrushan yihao mu fajue jianbao" [Brief excavation report on Tomb 1 at Shuangrushan, Changqing county in Shandong] (hereafter "Jianbao"), *Kaogu*, no. 3 (1997), pp. 1–9, 26; Ren Xianghong, "Shuangrushan yihao mu muzhu kaolue" [Examination into the occupant of Tomb 1 at Shuangrushan], *Kaogu*, no. 3 (1997), pp. 10–15; Liu Shanyi, "Shuangrushan Xi-Han Jibei wangling" [Western Han Jibei kingdom royal mausoleum at Shuangrushan], in *Tokubetsuten kandai "Ōsha" no kagayaki: Chūgoku Shantō-shō Sōnyūzan seihoku ōryō shutsudo bunbutsu*, exhibition catalogue (Kyoto: Kyōto fu Kyōto bunka hakubutsukan, Yamaguchiken hagi bijutsukan, and Urakami kinenkan, 2001), pp. 18–23 (Japanese), 123–25 (Chinese); Ma Qianwei and Li Yong, "Changqing Jibei wangling fajue ji" [Record of the excavation of the Jibei kingdom royal mausoleum], in *Jinan zhongda kaogu fajue jishi* (Jinan: Huanghe chubanshe, 2003), pp. 170–80; Ren Xianghong, "Zao shi liangda de Han wangling—Changqing Shuangrushan Xi-Han Jibei wangling" [Largest rock-cut Han royal tomb—the Western Han Jibei royal tomb at Shuangrushan, Changqing, Shandong], in Xie Zhixiu, ed., *Shandong zhongda kaogu xin faxian 1990–2003* (Beijing: Shandong wenhua yinxiang chubanshe, 2003), pp. 113–31.

16. These royal tombs are believed to belong to kings of the Lu Kingdom (Lu *guo*). See Shandong sheng bowuguan, "Qufu Jiulongshan Han mu fajue jianbao" [Brief excavation report of the Han tomb at Jiulongshan, Qufu], *Wenwu*, no. 5 (1972), pp. 39–44, 54.

17. *Hanshu* [History of the Former Han], comp. by Ban Gu (Beijing: Zhonghu shuju, 1962), *juan* 44, p. 2157.

18. On jade burial suits, see Michael Loewe, "State Funerals of the Han Empire," *Bulletin of the Museum of Far Eastern Antiquities (Östasiatiska museet) Stockholm* 71 (1999), pp. 14–34.

19. The rectangular panels of Tomb 1 at Shuangrushan are described as niches (*kan*) in the 1997 excavation report and remain unexplained; see "Jianbao," p. 3. Apparently, the outlines of each panel were chiseled first, and then the inner zone was removed to a depth of about 2 cm. These carved panels are only found in the lower level

of the tomb on the walls and floor of the ramp and coffin chamber. The walls of the upper platform level of the tomb are more roughly hewn, and no comparable panels are evident. This differentiation in carving techniques for the upper and lower sections of the tomb raises the possibility that the rectangular panels may have had some meaning. Perhaps different stone carving techniques may have been specified for different parts of rock-cut tombs.

20. See Ren Xianghong, "Shuangrushan yihao mu muzhu kaolue," pp. 14–15; and Liu Shanyi, "Shuangrushan Xi-Han Jibei wangling," pp. 124–25.

21. "Jianbao," p. 7; and Shandong sheng bowuguan, "Qufu Jiulong-shan," p. 40.

22. Large button-ingots were worth 10,000 cash in the Han dynasty. See Ren Xianghong, "Shuangrushan yihao mu muzhu kaolue," p. 12.

23. The chariot remains have survived in a remarkable state of preservation, which has allowed their reconstruction. On the modern reconstruction of one chariot, see Cui Dayong, "Shuangrushan yihao Han mu yihao mache de fuyuan yu yanjiu" [Study and restoration of Chariot 1 in the Han dynasty Tomb 1 at Shuangrushan], *Kaogu*, no. 3 (1997), pp. 16–26. On the term "outer depository" (*waizang guo*), see Loewe, "State Funerals," pp. 44–45.

24. According to Anthony Barbieri-Low's entry on coin casting molds in Cary Y. Liu et al., *Recarving China's Past: Art, Archaeology, and Architecture of the "Wu Family Shrines"* (Princeton: Princeton University Art Museum, 2005), thousands of coins could be placed in tombs, but sometimes, clay imitation coins were buried. In some instances, actual coins were embedded inside miniature roof tile caps on ceramic architectural constructions made for burial. An example is a 1st–2nd century, three-storey tower model illustrated in *Kaikodo Journal 9* (1998), cat. no. 48. In addition, coin designs were sometimes found as decoration on tomb bricks; see Linyi shi bowuguan, "Shandong Linyi Jinqueshan huaxiang zhuan mu" [Pictorial brick tomb at Jinqueshan, Linyi county, Shandong], *Wenwu*, no. 6 (1995), p. 76, fig. 12.3. For architectural burial ceramics, see Candace J. Lewis, "Pottery Towers of Han Dynasty China," Ph.D. diss., (Institute of Fine Arts, New York University, 1999).

25. See Loewe, "State Funerals," pp. 45–46, 47. On the Artisans of the Eastern Garden, see Anthony Barbieri-Low, "The Organization of Imperial Workshops during the Han Dynasty," Ph.D. diss. (Princeton University, 2001), pp. 71–73.

26. On the *Ceremonials* (*Yili*), *Rites Records* (*Liji*), and *Zhou Rites* (*Zhouli*), see Michael Nylan, *The Five "Confucian" Classics* (New Haven: Yale University Press, 2001), pp. 168–201; and Michael Loewe, ed., *Early Chinese Texts: A Bibliographical Guide* (Berkeley: The Society for the Study of Early China and The Institute of East Asian Studies, University of California, Berkeley, 1993), pp. 24–32, 234–43, and 293–97.

27. *Liji ji jie*, p. 225. Translation modified from Legge, *Li Ki*, p. 154. Legge actually translates *mingqi* as "vessels to the eye of fancy."

28. This passage expressing Zengzi's concern for impropriety was appropriated in the "Miscellaneous Dissatisfactions" (*San buzu*) section of the *Discourses on Iron and Salt* (*Yan tie lun*) by Huan Kuan (1st century BCE), to serve as an admonition against lavish burial furnishings and wasteful expenditures. See *Yan tie lun jiaozhu* [*Yan tie lun* with Critical Annotations], annot. Wang Liqi (Tianjin: Tianjin guji chubanshe, 1983), p. 355.

29. *Liji ji jie*, p. 225. Sub-commentaries to the *Rites Records* by Kong Yingda and Jia Gongyan in the Tang dynasty try to explain away this confusion by citing the *Ceremonials*' regulation (discussed above) that *mingqi* for the dead and sacrifice vessels for the living are both allowed in burials for those above the Counsellor rank. They note that the tomb for a duke's wife, therefore, would have contained both. Kong and Jia are also of the opinion that because only *mingqi* vessels were allowed for tombs of gentlemen (*shi*) and those of lower rank, the vessels had to serve double duty and needed to be used, i.e., filled, during funerary ceremonies. See *Liji ji jie*, p. 225; and *Yili zhushu*, p. 1149.

30. *Liji ji jie*, p. 216. Translation modified from Legge, *Li Ki*, p. 148. Legge translates *mingqi* as "vessels to the eye of fancy" and *shen-ming* as "spiritual intelligences." My translation as "brilliant artifacts" and "spiritual brilliances," respectively, is more in line with the French translation as *instruments brillants* and *esprits brillants* in Séraphin Couvreur, *Li Ki ou Mémoires sur les bienséances et les cérémonies*, 2nd ed. (Ho Kien Fou: Imprimerie de la Mission Catholique, 1913), vol. 1, p. 164.

31. On early conceptions of the afterlife, see Ying-shih Yü, "'O Soul, Come Back!' A Study in the Changing Conceptions of the Soul and Afterlife in Pre-Buddhist China," *Harvard Journal of Asiatic Studies* 47, no. 2 (1987), pp. 363–95.

32. Yü, "O Soul, Come Back!" p. 380.

33. The ideas expressed in this passage about distinctions between types of burial items and their relationship to the afterlife were appropriated in the "Miscellaneous Dissatisfactions" section of the *Discourses on Iron and Salt* to serve as an admonition against lavish burial furnishings and wasteful expenditures. See *Yan tie lun jiaozhu*, p. 355.

34. *The New Shorter Oxford English Dictionary* (Oxford: Clarendon Press, 1993), s.v. "simulacrum."

35. *Xunzi jinzhu jin yi* [Modern Annotation and Explanation of *Xunzi*], annot. Xiong Gongzhe, rev. ed. (Taibei: Taiwan shangwu yin-shuguan, 1984), p. 396; and Burton Watson, trans., *Basic Writings of Mo Tzu, Hsün Tzu, and Han Fei Tzu* (New York: Columbia University Press, 1963), p. 105. On the *Xunzi*, see Loewe, *Early Chinese Texts*, pp. 178–88.

36. See Thorp, "Mortuary Art and Architecture," pp. 52–53. A modern, possibly twentieth-century, elaboration asserts that underground architecture was built of imperishable stone and aboveground architecture was built of perishable wood. Before the Han, tomb chambers were predominantly built of wood, and this practice was still common in the Han. Moreover, the number of aboveground structures built of stone or masonry may far outnumber those built of wood.

37. *Liji ji jie*, p. 216.

38. Willard Peterson, "Making Connections: 'Commentary on the Attached Verbalizations' of the *Book of Change*," *Harvard Journal of Asiatic Studies* 42, no. 1 (1982), pp. 15–16.

39. I have discussed the concept of *shen* elsewhere in the context of calligraphy as "embodied images" (*tixiang*). See Cary Y. Liu, "Embodying Cosmic Patterns: Foundations of an Art of Calligraphy in China," *Oriental Art* 56, no. 5 (2000), pp. 2–9.

40. Henri Maspero, "Le mot *ming*," *Journal Asiatique* 223, no. 2 (1933), pp. 249–96. Maspero notes that while the character originally meant "brightness" or "light," it was also later used as a phonetic loan character (*jiajie*) meaning "sacred." The latter is the meaning associated with *mingqi*, which Maspero translates as *objets sacrés*: objects consecrated for the dead. See ibid., pp. 283–84. I want to thank Michael Loewe for bringing this article to my attention.

41. *Wang Li guhanyu zidian* [Wang Li's Dictionary of Ancient Chinese], ed. Wang Li et al. (Beijing: Zhonghua shuju, 2000), s.v. "ming"; Henri Maspero, "Le mot *ming*," pp. 252–55, 283–84.

42. Translation slightly modified from Burton Watson, trans., *The Tso Chuan: Selections from China's Oldest Narrative History* (New York: Columbia University Press, 1989), p. 82. Also see translation by James Legge, *The Chinese Classics*, reprint ed. (Taibei: Southern

Materials Center, Inc., 1985), vol. 5, pp. 292–93. On the *Spring and Autumn Annals* and *Zuozhuan*, see Nylan, *Five "Confucian" Classics*, pp. 253–306.

43. On the Nine Tripods or Vessels and their connection to the establishment of capital cities (*ding ding*), see Cary Y. Liu, " The Yüan Dynasty Capital, Ta-tu: Imperial Building Program and Bureaucracy," *T'oung Pao* 78 (1992), pp. 265–66.

44. *Mozi*, in *Yingyin Wenyuange Siku quanshu*, "Gengzhu" sec., *juan* 11, p. 9b.

45. Wang Chong, *Lunheng suoyin* [Concordance to the *Lunheng*], ed. Zhang Xiangqing et al. (Beijing: Zhonghua shuju, 1994), "Ru zeng pian" sec., p. 1383. For an informed discussion of the symbolism and legends surrounding tripod vessels, see the catalogue entry by Filippo Marsili in Liu et al., *Recarving China's Past*, cat. no. 23.

46. This concept of *mingqi* may reflect changes in Han belief systems, paralleling the changes in burial practices discussed in Jessica Rawson, "The Eternal Palaces of the Western Han: A New View of the Universe," *Artibus Asiae* 59 (1999), pp. 5–58. Rawson suggests there was a new preoccupation in the early Han to manifest "a microcosm of the universe within the confines of the tomb for the benefit of the tomb's occupant, as well as to assert the tomb occupant's claims to a prominent place in the afterlife hierarchy"; see ibid., p. 6.

47 . See Yü, "O Soul, Come Back!" pp. 370, 372; Mu-chou Poo, *In Search of Personal Welfare: A View of Ancient Chinese Religion* (Albany: State University of New York Press, 1998), pp. 62–66.

48. Paired images of the sun and moon are also carved on a ceiling stone of Tomb 1 at Zhangzhuang in Shandong. See Shandong sheng wenwu kaogu yanjiusuo, "Shandong Jinan Zhangzhuang Han dai mu di fajue jianbao" [Brief excavation report on the Han dynasty tomb grounds at Zhangzhuang, Jinan, Shandong], in *Shandong gaosugonglu kaogu baogao ji (1997)* [Collected Shandong Highway Construction Archaeological Reports of 1997], ed. Shandong sheng wenwu kaogu yanjiusuo (Beijing: Kexue chubanshe, 2000), pp. 309 and 311, fig. 18. Another example dating to the early Eastern Han was excavated in 1999 at Zaozhuang, Shandong, and is reproduced in *Zhongguo huaxiangshi quanji* [Collected Pictorial Stones of China] (Jinan: Shandong meishu chubanshe, 2000), vol. 2, no. 145.

49. A silk mortuary banner with sun and moon designs was found on top of a coffin in Tomb 9, excavated in 1976 at Jinqueshan, Linyi county, Shandong. See Linyi Jinqueshan Han mu fajue zu, "Shandong Linyi Jinqueshan jiuhao Han mu fajue jianbao" [Brief excavation report on the Han dynasty Tomb 9 at Jinqueshan, Linyi county, Shandong], *Wenwu*, no. 11 (1977), pp. 24–27; and Liu Jiaji and Liu Bingsen, "Jinqueshan Xi-Han bo hua linmo hou gan" [Later thoughts and copy of the Western Han cloth painting at Jinqueshan], *Wenwu*, no. 11 (1977), pp. 28–31, front inside cover, and plate 1. Other well-known Han-dynasty mortuary banners with the sun and moon imagery include silk examples at Tombs 1 and 3 at Mawangdui in Changsha, Hunan, and silk and hemp examples from tombs at Mozuizi in Wuwei, Gansu. On burial mantles in the Han, see Yü, "O Soul, Come Back!" pp. 365–69 passim.

50. During the Western Han several ritual structures including a Brilliant Hall were built south of the city walls at the capital Chang'an (modern Xi'an). The designs of the ritual structures were meant to conform to Western Zhou models as recorded in ancient ritual texts such as the *Zhou Rites*. On the archaeological remains of what is believed to be the hall and its fanciful restoration, see Tang Jinyu, "Xi'an xi jiao Han dai jianzhu yizhi fajue baogao" [Excavation report on Han architectural relics in the western outskirts of Xi'an], *Kaogu xuebao*, no. 2 (1959), pp. 45–55; Yang Hongxun, "Cong yizhi kan Xi-Han Chang'an mingtang (biyong) xingzhi" [Configuration of the Mingtang (Biyong) as viewed from the remains at Western Han dynasty Chang'an], in idem, *Jianzhu kaogu xuelun wenji* [Essays on Archaeology and Architecture in China] (Beijing: Wenwu chubanshe, 1987), pp. 169–200; and Nancy Shatzman Steinhardt, "The Han Ritual Hall," in *Chinese Traditional Architecture* (New York: China Institute in America, 1984), pp. 69–77. For general discussions on *mingtang*, see also William E. Soothill, *The Hall of Light* (London: Lutterworth Press, 1951), and James Liu, "The Sung Emperors and the *ming-t'ang* or Hall of Enlightenment," in *Études Song in memoriam Étienne Balazs*, ed. Françoise Aubin, ser. 2, no. 1 (Paris: Mouton, 1973), pp. 45–58. On the early meaning of the term, also see Henri Maspero, "Le mot *ming*," pp. 268–69, 276–77, 284; Idem, "Le Ming-Tang et la crise religieuse chinoise avant les Han," *Mélanges chinoises et bouddhiques* 9 (1948–1951), pp. 1–71.

51. *Xunzi jinzhu jin yi*, p. 380; translation modified from *Basic Writings*, p. 94. Conversely, an imbalance between sun and moon is deemed unbeneficial. For example in Liu Xi (fl. ca. 200), *Shiming* [Explanation of Names], in *Yingyin Wenyuange Siku quanshu*, *juan* 8, p. 7a, it is noted: "If the sun and moon are not complete then the burial is called parched; that is to say [if one] wants to rush, then the burial is without blessings."

52. *Liji ji jie*, p. 265. Translation slightly modified from Legge, *Li Ki*, p. 172–73.

53. Shandong sheng bowuguan, "Linzi Langjiazhuang yihao Dong-Zhou xunren mu" [Excavation of Eastern Zhou Tomb 1 with human sacrifices at Langjiazhuang, Shandong], *Kaogu xuebao*, no. 1 (1977), pp. 90, plate 18.

54 . On the belief of using figures and other burial articles to serve and provide for the deceased soul in the afterlife, see Poo, *In Search of Personal Welfare*, pp. 170–75 passim.

55. *Hanshu*, *juan* 53, pp. 2421–22. Wang Zhongshu, *Han Civilization* (New Haven: Yale University Press, 1982), p. 208.

56. Wang Shougong, "Jinan guowang de ling yi chu lingdi—Zhangqiu Weishan Handai muzang ji peizang keng" [Another royal mausoleum at Jinan—Han dynasty tomb and accompanying pit at Weishan, Zhangqiu county], in Xie Zhixiu, *Shandong zhongda kaogu xin faxian 1990–2003*, pp. 151–58. Also see "Shandong Zhangqiu faxian bingma yong keng" [Discovery of a pit with horse and warrior figures in Zhangqiu, Shandong], *Shijie ribao*, 4 December 2002, sec. A, p. 9; John Noble Wilford, "Terra-Cotta Army from Early Han Dynasty is Unearthed," *New York Times*, 18 February 2003, sec. F, p. 3; and Jarrett A. Lobell, "Warriors of Clay," *Archaeology* 56, no. 2 (2003), pp. 36–39.

57. Linyi shi bowuguan, "Shandong Linyi Jinqueshan huaxiang zhuan mu," pp. 72–78.

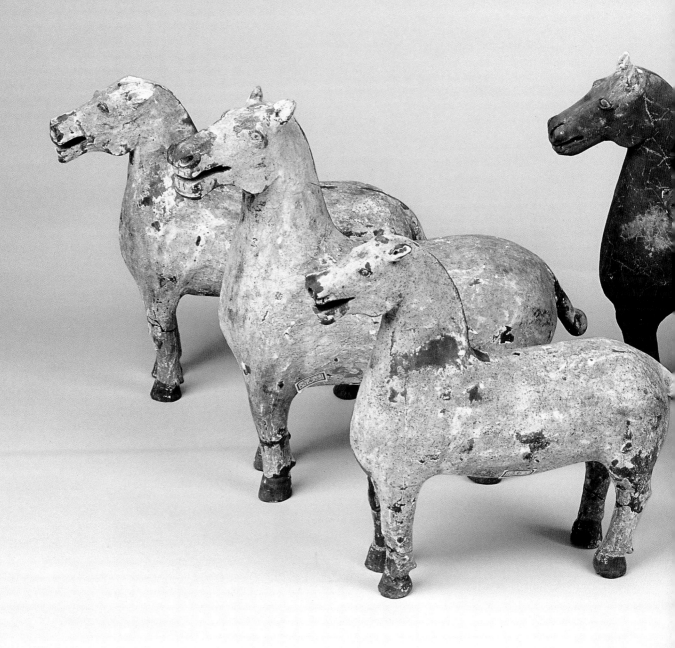

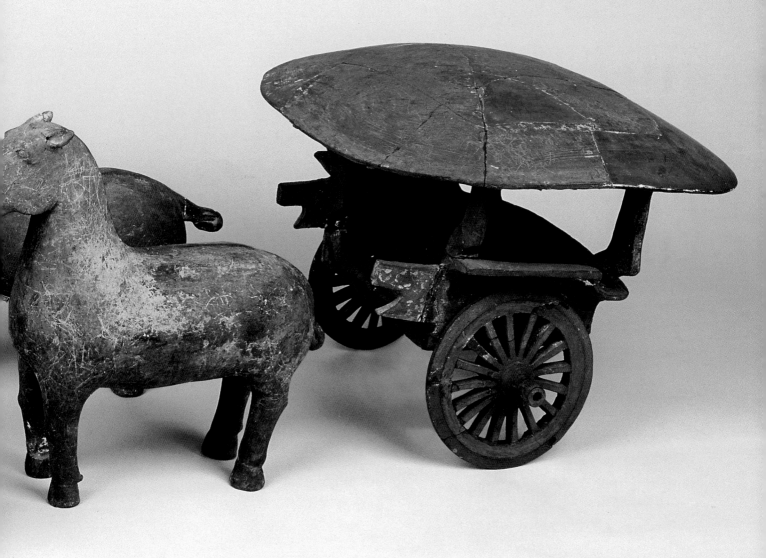

CONTRIBUTORS

AJ	Annette L. Juliano
SLB	Susan L. Beningson
ZS	Zhixin Sun
DG	David A. Graff

1. Frontlet for a horse's bridle (*danglu*)

西漢　鎏金銅當盧

Western Han dynasty (206 BCE–9 CE)
Gilt Bronze; L. 16.5 cm, W. 7.5 cm
Excavated 1999, Luozhuang, Zhangqiu County
Collection of Jinan Municipal Museum

This gilt bronze masterwork, which hung down between the horse's eyes, was the frontlet (*danglu*) of an elaborate bridle. It is decorated in openwork with the image of a celestial horse. This magical equine has delicately striated wings on his back. His body, in profile, forms a reverse S-curve within the confines of the *danglu*. The horse's ears are perked, his front legs are curled forward within the frame while his hind legs buck out on the bottom right. His tail curls under and through his bottom leg. Bird heads punctuate the scrolls of cloud breath (*yunqi*), a reference to the ability of this horse to help the tomb's occupant fly to heaven, much like the famous "flying horse of Gansu"; that prancing steed, excavated from the Eastern Han tomb at Leitai, rests his hoof on the back of a swallow. The luxuriant scrolling plumes and openwork technique of this frontlet originate in certain jade carvings where feline dragons do combat with birds.[1] A jade carving with similar openwork patterns within a double circular frame has been excavated from the tomb of the king of Nanyue in Guangdong province.[2] The flowing linear design of the frontlet also recall the scrolls painted in lacquer as on the outer coffin of Lady Dai, the wife of the marquis of Dai, from the early Western Han Tomb 1 at Mawangdui in Henan province.[3] Flying deer or horses appear among scrolls on the inner coffin at Mawangdui; a horse-like figure on the side panel strikes a twisting pose that is known from both Mongolia and Southern Siberia.[4] This same scrolling is also found in textile patterns from Mawangdui Tomb 1, as shown in a "long life" embroidery.[5]

A poem from the *Hanshu* (Historical Chronicles of the Han Dynasty) describes the allusions associated with this divine steed. The song is written in the voice of the emperor Wudi, whose search for immortality dominated both the philosophy and material culture of the Western Han. The emperor writes: "I raise myself up, off we go to Kunlun. A celestial horse has come, mediator of the dragon. We wander the heavenly gates, view the jade terrace." This asserts the emperor's desire to ride this heavenly horse to the peaks of Mount Kunlun, where the immortals were thought to reside.[6]

This frontlet, the gold bridle pieces in the shape of raptor heads (cat. no. 45), and the bronze *chunyu* bell

(cat. no. 11) are significant objects from the famous excavation at the Luozhuang site, which ranked among China's most important archaeological discoveries for the year 1999.[7]

SLB

1. Jessica Rawson argues that feline forms, particularly in an S-shape, are derived from forms imported from the West into China during the Eastern Zhou dynasty. The Chinese felines often appear combined with birds in Western poses. They also appear on Jin state bronzes as bell handles or belt-hooks, as well as on copper inlays in bronze. She believes them to be the basis for the feline dragons on Han dynasty sword fittings. Jessica Rawson, *Chinese Jade from the Neolithic to Qing* (London: British Museum, 1995), p. 69.
2. See Yang Xiaoneng, ed., *The Golden Age of Chinese Archaeology* (New Haven: Yale University Press, 1999), pp. 418–19, no. 141, for a jade *pei* ornament with dragon and bird openwork from the tomb of the king of Nanyue, second century BCE. Other foreign influences in this tomb can also be seen in the western shape of a remarkable jade rhyton. Rawson, *Chinese Jade from the Neolithic to the Qing,*" p. 70, fig. 61.
3. Hunan sheng bowuguan and Zhongguo kexueyuan kaogu yanjiusuo, eds., *Changsha Mawangdui yihao Hanmu* [Han Tomb No. 1 at Mawangdui in Changsha] (Beijing: Wenwu chubanshe, 1973), vol. 2, plates 28–31.

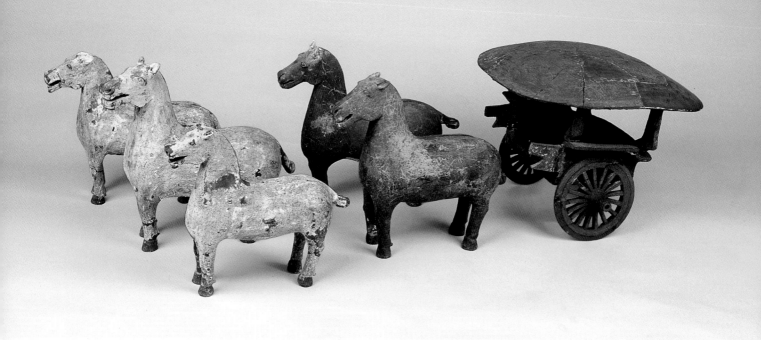

4. This is pointed out by Jessica Rawson in Yang, *The Golden Age of Chinese Archaeology*, p. 419. For the Mawangdui coffin panels, see Hunan sheng bowuguan et al., *Changsha Mawangdui yihao Hanmu*, vol. 2, plates 33 and 35.

5. Shanghai shi fangzhi kexue yanjiu yuan wenwu yanjiu zu and Shanghai shi sichou gongye gongsi, ed., *Changsha Mawangdui yihao Hanmu: chutu fangzhipin de yanjiu* [Han Tomb Number One at Mawangdui in Changsha: Research on excavated woven silk textiles] (Beijing: Wenwu chubanshe, 1980), plate 22.

6. David R. Knechtges, "The Emperor and Literature: Emperor Wu of the Han," in *Court Culture and Literature in Early China*, Variorum Collected Studies Series (Hampshire, England and Burlington, Vt.: Ashgate Publishing, 2002), p. 65. There is a similar counterpart to this poem in the *Shiji*, but it is shorter than the *Hanshu* version. In the *Hanshu* version each stanza begins with the refrain "A celestial horse has come" (*tianma lai*).

7. See the recently published report in Jinan shi kaogu yanjin suo, Shandong daxue kaogu xi, Shangdong sheng wenwu kaogu yanjiusuo, and Zhangqiu shi bowuguan, "Shandong Zhangqiu Luozhuang Hanmu peizang keng de qingli" [Summary report of the Han tomb and accompanying burial pits at Luozhuang, Zhangqiu, Shandong], pp. 3–16 and color plates following p. 96.

2. Five horses pulling chariot

西漢　陶馬車

Western Han dynasty (206 BCE–9 CE)
Clay with natural pigments
Chariot: H. 29.5 cm; Horses: H. 31–33 cm
Excavated 1969, Wuyingshan, Jinan Municipality
Collection of Jinan Municipal Museum

This group of five horses pulling a chariot was excavated from Wuyingshan, as was the bird with *ding* vessels on its wings in this exhibition (cat. no. 3). The five horses are of slightly different sizes, three are white and two are reddish brown. One of the white horses, with bared teeth and nostrils flaring, tilts his head rakishly toward the viewer, while the others seem to be smiling. With its squarish canopy, the carriage is more typical of the Qin dynasty than of the Eastern Han, when canopies were more rounded.[1] Bronze sculptures of chariots with these rounder canopies have been excavated at the famous tomb of the "flying horse" in Leitai, Wuwei, Gansu province, and such chariots are depicted in pictorial stone carvings at the "Wu Family Shrine" in Jiaxiang county, Shandong.[2]

In the Shang and Zhou dynasties, chariots were included in elite burials as status icons indicating the rank of the deceased, as well as his wealth and power. Real chariots were often interred complete with their horses, and in some of these early cases burials included the charioteers themselves. By the Qin and Western Han dynasty, models began to replace live burials in the tomb, as can be seen in the monumental ceramic horses buried with actual chariots in the necropolis of the First Emperor, Qin Shihuangdi (see cat. no. 20). This transition was gradual, and in the early Western Han tomb of Luozhuang, where many of our exhibition objects were excavated, the actual chariots placed in the tomb were still accompanied by their horses.[3] The eventual completion of this change to representational *mingqi* can be seen in the ceramic cavalry found in the tomb at Weishan (cat. nos. 12, 13). That chariots were still important can also be seen in the gilt bronze chariot parts from Jiulongshan and the bronze chariot fittings inlaid with gold and silver from Shuang-

rushan that are shown in our exhibition. The five horses and chariot from Wuyingshan could also have served as a vehicle for the deceased on his journey to the afterlife.

SLB

1. Of the horses and carriages excavated from the necropolis of the First Emperor, Qin Shihuangdi, chariot no. 2 has a similar canopy to the one in our exhibition; the carriage is equally squat and has large wheels. However, this carriage is completely enclosed. Carriage no. 1 from the emperor's necropolis has a much rounder canopy but is not enclosed; the structure is quite different than our example. Both carriages were pulled by four horses each and not five. *Chang'an zhenbao* [Treasures of Chang'an] (Beijing: Zhongguo sheying chubanshe, n.d.), pp. 22–23.

2. Rubbings of the Han pictorial stone carvings at Jiaxiang are reproduced in Cary Y. Liu et al., *Recarving China's Past: The Art, Archaeology, and Architecture of the "Wu Family Shrines"* (Princeton: Princeton University Press, 2005).

3. Objects from this site included in the exhibition are cat. nos. 1, 4, 11, and 45. See Susan L. Beningson, "Spiritual Geography of Han Dynasty Tombs," figs. 6 and 7, in this catalogue, for photographs of the chariot burial at Luozhuang.

3. Bird with *ding* vessels

西漢　繪彩載人載鼎陶鳩

Western Han dynasty (206 BCE–9 CE)
Clay with natural pigments;
 H. 53.5 cm, L. 40 cm, W. 45 cm
Excavated 1969, Wuyingshan,
 Jinan Municipality
Collection of Jinan Municipal Museum

The bird stands with its legs spread wide to support the ritual ceremony taking place on its outstretched wings. Plump calves and webbed feet anchor it to the square base. A carefully painted pattern of white feathers, each outlined with gray-black strokes and accented with a red dot, enlivens the surface of its body. It seems to stare ahead, waiting to take flight. This white bird might represent a celestial conveyance for the deceased, who must be placed in a cosmologically ideal position in his tomb for his soul to reach paradise and the land of the immortals.[1] On each wing rests a *ding* tripod vessel, more often found in bronze (cat. nos. 4, 5), indicating that a ritual performance is in progress. The legs of each tripod are in the shape of human figures, bearing witness to the event with arms respectfully crossed. They have wide-set eyes and sport mustaches that have the semblance

of whiskers; their faces are painted pink, as are those of the other figures. An attendant figure behind the *ding* vessels holds an umbrella over the head of the two main participants in the ritual. He stands respectfully and discreetly stares forward. The umbrella is painted red with a red and black decorative edge reminiscent of lacquer design. At one time the hooks on its rim might have been adorned with fittings similar to those found at the Shuangrushan tomb (cat. no. 31).

The two largest human figures face each other in a prominent position just behind the head of the bird. Their court robes strain around their corpulent bodies; the red ribbons of their waist sashes are edged in black and fall to mid-thigh. The presence of these red ribbons indicates the official rank of prince.[2] Gold seals of office (cat. nos. 14, 15) would have hung from the red ribbons, evidence of their acceptance into the elite strata of political power in the mundane world. These figures might give the deceased the ability to authenticate his rank and to carry out official business in the afterlife bureaucracy, or their rituals might activate his journey.[3] Their headgear, called

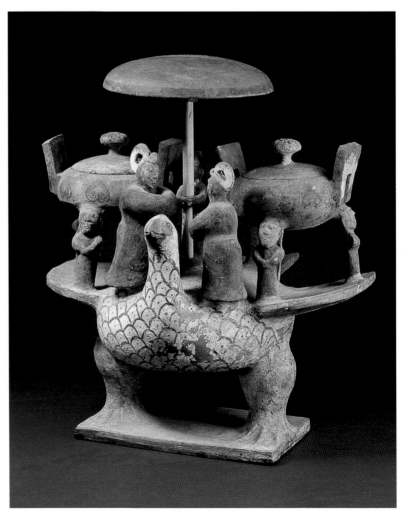

mianguan, was to be worn along with official robes only by emperors, princes, dukes, and ministers for ritual occasions.[4] The figures have large indented eyes with black pupils and thinly outlined red irises, dark eyebrows, and small red mouths with mustaches. They bow toward the empty space in front of them under the umbrella, indicating perhaps the presence of the deceased. Although this is pre-Buddhist China, similar iconography can be found in India at Sanchi, where aniconic images included a parasol or footprints to indicate the presence of the Buddha.

Excavated from this same tomb at Wuyingshan was a second bird,[5] similar to ours but with its head tilted back and a more defined beak, carrying large *hu* vessels (*cf.* cat. no. 6) on either wing.[6] It has been argued that these *hu* vessels might have contained the elixir of immortality, allowing the deceased to more quickly ascend to the land of the immortals. The shape of the *hu* vessel itself is thought to indicate Mount Penglai, a cosmic pillar, where this elixir could be found.[7] Other finds from this tomb include the horses and chariot in this exhibition (cat. no. 2) and the famous tableau of acrobats where princes wearing *mianguan* and ritual costume supervise the performance of these entertainers, accompanied by musicians playing bells, chimes, and other instruments.[8] In these three objects from Wuyingshan, rituals are being performed with bronze vessels, as well as bells and chimes, to activate the celestial imagery allowing the deceased to begin his journey to eternity.

SLB

1. White is the color associated with ancient Chinese mortuary rituals. Furthermore, in the Han dynasty, Emperor Wudi was said to fill his hunting park primarily with white animals, the color also being associated with immortality. See cat. no. 43, n. 2 for more on the royal hunting park. From Sima Qian and Ban Gu's descriptions, the islands of immortality are inhabited by "creatures, birds and beasts completely white" (see cat. no. 47).
2. In the official costumes of the Han dynasty, reddish yellow ribbons were worn by the emperor, red ones by princes, purple ones by the nobility or generals, and blue or black ones by lower officials. The aristocracy would wear silk girdles with a silk ribbon to which was attached an official seal. Since the seal and the ribbon symbolized the power vested in an official, they were issued by the court. According to the system, officials carried their seal in a leather bag fastened on the waistband, with the silk ribbon hanging down. Size, color, and texture of the silk ribbons worn by different people at all levels, from the emperor down to officials, were so specific that one could tell at a glance the social status of the wearer. Zhou Xun and Gao Chunming, *Zhongguo fu shi wu qian nian* [5000 Years of Chinese Costumes], 3rd Chinese ed. (Hong Kong: The Commercial Press, 1988), p. 32.
3. On the uppermost part of the banner excavated from Tomb 1 at Mawangdui, there are two male figures guarding the portals of paradise. Michael Loewe, in *Ways to Paradise: The Chinese Quest for*

Immortality (London: George Allen and Unwin, 1979), pp. 48–49, quotes a passage from the *Chuci* in which the pilgrim "bade heaven's gate-keeper open up his doors, and he pushed the portals open and looked out at me." Perhaps the two princes are validating the rank of the deceased and making it easier for him to enter heaven.

4. Headgear was the primary means to indicate a person's rank, although dress, boots, and ribbons were also prescribed. The *mianguan* was used solely for ritual occasions. The official costume worn with the *mianguan* consisted of a black garment with red skirt, pants underneath that folded at the knees, a silk ribbon, and specified shoes. In the tableau of acrobats found in the same tomb, the officials wear the same costume as the figures on the bird. They are also the largest figures in the group, with the acrobats and musicians of smaller size.
5. Jinan shi bowuguan, "Shitan Jinan Wuyingshan chutu de Xi-Han yuewu, zaji, yanyin taoyong" [Concerning the ceramic figures of dancers, acrobats, and entertainers excavated from the Western Han tomb at Wuyingshan, Jinan], *Wenwu*, no. 5 (1972), p. 19.
6. The *hu* vessels are painted with the same colors: black with a red line at the middle of their bulbous bodies and long angular red triangles painted on the neck of each vessel. Shandong wenwu shiye guanli ju, ed., *Shandong wenwu jingcui* [The Best Cultural Relics from Shandong] (Shandong: Meishu chubanshe, 1996), cover illus., p. 66, no. 61.
7. Loewe, *Ways to Paradise*, pp. 37–39.
8. Jinan shi bowuguan, "Shitan Jinan Wuyingshan," pp. 20–21, figs. 2–5. The group of acrobats, dancers, and musicians is attached to a rectangular base of the same thickness and shape as that of the bird and measures 67 cm long, 47.5 cm wide and 22.7 cm tall. On the right side of it are five standing court officials wearing their *mianguan* and ritual costumes. The figures include a drummer with drum (similar to cat. no. 12) and two ceramic *hu* vessels, whose paint is missing and whose tops lack the three red curled knobs that are on top of the *hu* vessels on the second bird's wings. The figures on the right side of the tableau, wearing dark robes with bright red sashes and trim, have the same coloring as the bird with the *hu* vessels on its wings. All the faces of the figures are either the same pink as the figures on our bird or a darker red color. See also Shandong wenwu shiye guanli ju, *Shandong wenwu jingcui*, p. 64, no. 59.

4. Covered Qi da guan *ding* vessel

西漢　齊大官銅鼎

Western Han dynasty (206 BCE–9 CE)
Cast bronze; H. 19 cm
Seven-character inscription:
Qi da guan Xu Nan Gong ding
Excavated 1999, Luozhuang, Zhangqiu County
Collection of the Jinan Municipal Museum

This covered *ding* vessel has a beautifully balanced form. Its flattened spherical body rests on three cabriole legs and is flanked by L-shaped handles attached below the rim; three rings adorn the cover.[1] This shape is characteristic of *ding* from the late Eastern Zhou (6th century BCE) through the Han dynasty. However, by the Han, the richly ornamented surfaces of the late Eastern Zhou vessels have become elegantly plain and smooth. Here, a single raised ridge accents the curved body by wrapping around

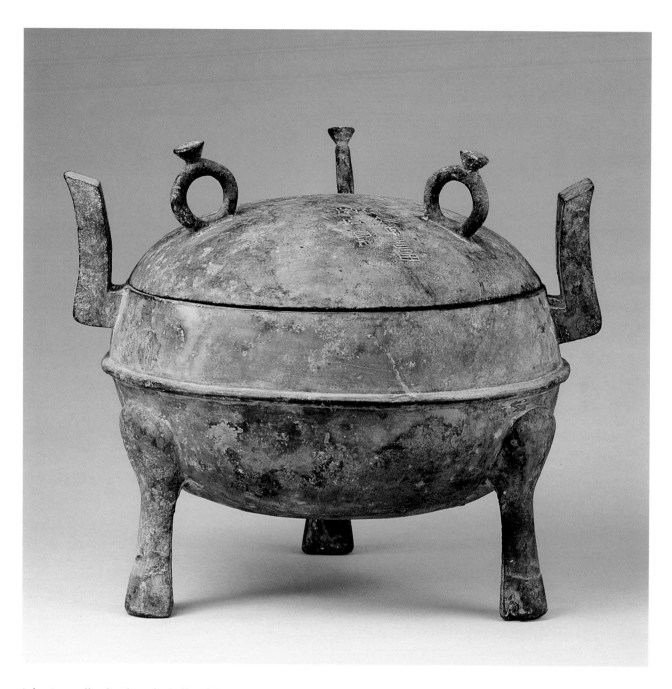

it horizontally, dividing the belly of the vessel in half and complementing the horizontal line of the rim just above it. Each of the three rings on the cover has a small wedge-shaped projection; these serve both as handles and as feet when the cover is removed and set down.

This *ding* comes from an early Western Han tomb at Luozhuang in Zhangqiu county, a tomb that reflects a culture and society in transition from feudal warring states to imperial empire. Much of the tomb's contents, as well as its architecture, conforms to late Warring States burial practices and includes sets of bells and chimes (see p. 5, fig. 4), life-size chariot burials with horses (see p. 7, fig. 6), horse and chariot fittings, bridle ornaments of nomadic style (cat. no. 45 and p. 8, fig. 7), painted lacquer, bronze vessels, and rudimentary wooden human

figures.[2] The main tomb, believed to belong to a marquis or king of Lu, was accompanied by thirty-six burial pits filled with the kind of grave goods described above.[3]

Pit 5 contained over 90 bronze objects including vessels such as the *yu*, the *yi*, and over 19 covered *ding*, many with inscriptions. By the Han dynasty, these still-revered bronze vessels maintained only a tenuous connection with their original ritual and ceremonial roles in Shang and Zhou society. Bronze vessels were sometimes replaced in burials by clay models, such as the *ding* from Yinqueshan, Linyi county, Shandong (cat. no. 5), which has been lacquered to replicate a shiny metal surface. Like chariots (see cat. no. 28), bronze ritual vessels also became symbols of status and wealth. The seven-character inscription *Qi da guan Xu Nan Gong ding*, just above one

cabriole leg on the side of the vessel, refers to "the great Qi official Xu and Southern Palace *ding*." The inscription on the much larger covered *ding* in the tomb suggests that it was a gift from the king of Qi to the king of Lu, who, from the clay seals excavated in Pits 3 and 4, is believed to be the owner of this tomb.[4] It is possible that the reference to an official of Qi indicates that this vessel was also a gift to the king of Lu as well. In the Luozhuang tomb and accompanying pits, the number of bronze vessels and the content of the short inscriptions underscore the role of vessels in political and diplomatic exchanges.[5]

AJ

1. The three photographs published by Kwang-chih Chang in "The Chinese Bronze Age: A Modern Synthesis," in *The Great Bronze Age of China*, ed. Wen Fong (New York: The Metropolitan Museum of Art, 1980), pp 46–47, clearly illustrate the changes in the shape and décor of the *ding* from the Shang through the Western and Eastern Zhou dynasties.
2. See the recently published report in Jinan shi kaogu yanjiu suo et al., "Shandong Zhangqiu Luozhuang Hanmu peizang keng de qingli, pp. 3–16 and color plates following p. 96. See also Guojia wenwu ju, ed., *Zhongguo zhongyao kaogu faxian 1999* [Major Archaeo-logical Discoveries in China in 1999] (Beijing: Wenwu chubanshe, 2001), no. 6, pp. 75–76, for the tomb plan, lacquer ware fragments, and collapsed wooden logs from one pit; see also, Hu Siyong, *Jing shi Han Wang Ling* (Shandong: Jinan chubanshe, 2001).
3. See the Luozhuang tomb plan in Hu Siyong, *Jing shi Han Wang Ling*, p. 63.
4. This was discussed with Tony Barbieri-Low, Susan Beningson, and Cary Liu while viewing some of the *ding* on a visit to Jinan in May of 2004. See also Guojia wenwu ju, ed., *Zhongguo zhongyao kaogu faxian 1999*, no. 6, p. 78.
5. See also Susan L. Beningson, "The Spiritual Geography of Han Dynasty Tombs," in this catalogue, pp. 9–10.

5. Covered *ding* vessel

西漢　漆衣陶鼎

Western Han dynasty (206 BCE–9 CE)
Lacquered gray clay; H. 19.2 cm, W. 26.3 cm
Excavated 1972, Tomb M4, Yinqueshan,
 Linyi County
Collection of Shandong Provincial Museum

Similar in form to the inscribed bronze covered *ding* (cat. no. 4), this gray clay version has a squat spherical body,

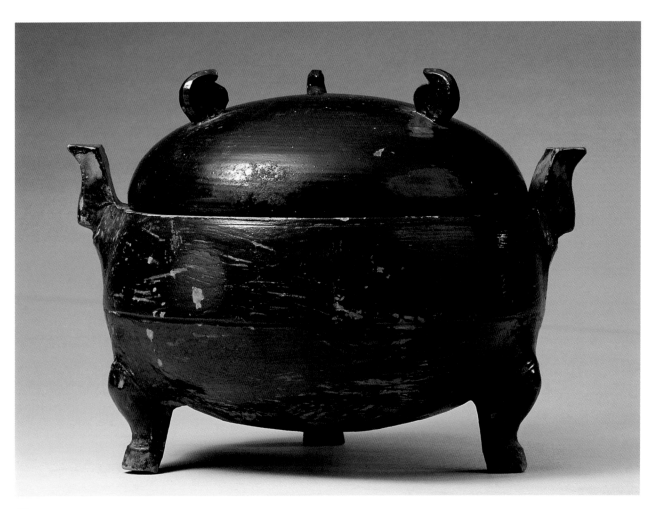

three short cabriole legs, two solid square handles, and three solid comma-shaped handles or feet perched on the cover. While the body of the *ding* was wheel thrown, the legs and handles have been mold cast or hand modeled. Red-brown lacquer was applied to the outside and inside surfaces of the vessel after firing, creating a shiny metallic-like surface.[1] Some of the earliest fragments of pottery with red lacquer designs were excavated from Shang dynasty tombs.[2] Although never very popular in China, lacquered pottery continued to be manufactured through at least the Han dynasty. A number of Han tombs contained lacquered pottery with surfaces painted in red, red-brown, and black.[3]

This lacquered *ding* was excavated from Tomb M4 at Yinqueshan in Linyi county. One of two important Western Han tombs discovered in this area, M4 yielded twenty-one examples of lacquered vessels. The *ding* was accompanied by *he* covered boxes, *hu* vases, *pan* basins, and *yi* ewers.[4]

AJ

1. The Chinese excavation report refers to this kind of pottery as "lacquer-clad" to distinguish it from traditional lacquer with a wood or hemp cloth core. Shandong sheng bowuguan and Linyi wenwu zu, "Linyi Yinqueshan sizuo Xi-Han mucang" [Four Western Han tombs at Yinqueshan, Linyi county], *Kaogu*, no. 6 (1975), p. 364.
2. Suzanne G. Valenstein, *A Handbook of Chinese Ceramics* (New York: The Metropolitan Museum of Art, 1989), p. 25.
3. Ibid., p. 34. See also the early Western Han site in the Xiangyang area in Hubei; *Kaogu*, no. 2 (1982), p. 151; p. 154, fig. 10:5 and plate 1:1,2,6.
4. See Shandong sheng bowuguan, "Linyi Yinqueshan," pp. 363–72, 351, plates 6–10. For a translation of the site report, see Albert E. Dien, Jeffrey K. Riegel, and Nancy T. Price, eds., *Chinese Archaeological Abstracts, 3: Eastern Zhou to Han* (Los Angeles: The Institute of Archaeology, The University of California, 1985), pp. 1094–1109.

6. *Hu* with ring handles

西漢　銅壺
Western Han dynasty (206 BCE–9 CE)
Cast bronze; H. 45.5 cm, D. 17.3 cm
Excavated 1966, Tomb 1, Shuangrushan,
　　Changqing County
Collection of Changqing County Museum

Western Han Tomb 1, discovered at the top of Shuangrushan Hill, had been undisturbed and contained over 2,000 artifacts including lacquered chariots with fittings of gilt bronze and bronze inlaid with gold and silver (cat. nos. 29, 30), bronze vessels, and a jade suit. The number and quality of the objects parallel the contents of similar tombs of Han marquises, suggesting that this tomb may be presumed to have belonged to a Han marquis.[1] Typically, for a tomb of such status, objects made for the living mingle with those made for the dead. More than a thou-

sand bronzes, including vessels, articles for daily use, and horse and chariot fittings, comprised the largest category of objects in Tomb 1 (see p. 4, fig. 3).[2]

All of the bronze vessels in Tomb 1 had been buried in the outer tomb tunnel. They included the standard types: eight *hu* of varying sizes, nine *ding* (one inscribed), four square *fang* vases, two lamps, and other items such as crossbow and mirrors.[3] The combination of *hu*, *ding*, and *fang* vase seem to be a standard grouping found in many Han tombs along with other miscellaneous vessel types. This vessel, with its magnificently taut S-shaped profile, is one of the largest and most beautifully balanced and proportioned examples of the *hu* type. The circular foot supports a fully rounded belly that contracts to a flared neck and mouth. Only a few flat raised bands embellish the smooth contours, accentuating the shape of the vessel at critical points of the form. Two ring handles held by *taotie*-like masks rest at the shoulder. A number of similar ring-handled *hu* vessels have been excavated from Western and Eastern Han tombs across China.[4]

Bronze *hu* vessels have a long history stretching back to the Shang dynasty. As often discussed by scholars of Chinese art, this *hu* vessel as well as other bronze vessels in this tomb reflect the culmination of a process of secularization begun as early as the Western Zhou.[5] By the Western Han, bronze vessels had only a tenuous link with the ancient and solemn religious rituals of Shang but still retained value, perhaps to commemorate events, to make offerings on home ancestral altars, and to store precious foodstuffs in the tomb. The *hu* also makes an auspicious allusion to immortality, achieved by the deceased through a successful final journey to the islands of the immortals, particularly Penglai, situated in the eastern seas. Its presence in the tomb may be a cryptic reference to Penghu (the vase of Peng[lai]), another name for the mythical island Penglai. A painted silk banner from Mawangdui in Changsha, Hunan, supports this interpretation. The vertical part of the T-shaped banner displays two dragons with tails interlocked through a jade *bi* disc, forming the image of a *hu*-shaped vase with a lid. This lid has a fleur-de-lis-shaped knob and two double-tailed birds facing inward; an owl hovers below with its wings spread. In this painting, the *hu* vessel can be interpreted as a representation of Penglai, the Island of the Vase, through which the deceased must pass to reach eternity.[6] This quest for immortality permeated Han life, burial practices, and the arts.

AJ

40

1. See excavation report Shandong daxue kaogu xi, Shandong sheng wenwu ju, and Changqing wenwu ju, "Shandong Changqing xian Shuangrushan yihao mu fajue jianbao" [Brief excavation report on Tomb 1 at Shuangrushan, Changqing county in Shandong], *Kaogu*, no. 3 (1997), pp. 1–9, and for a discussion of the contents and possible owner, see Ren Xianghong, "Shuangrushan yihao Hanmu zhu kaolun" [A preliminary study of the occupant of Han tomb no. 1 at Shuangrushan], *Kaogu*, no. 3 (1997), pp. 10–15. This author suggests that Tomb 1 belongs to Liu Kuan (r. 97–85 BCE), the last ruler of the Jibei Kingdom during the Western Han dynasty.

2. See Cary Liu's essay, "Embodying the Harmony of the Sun and Moon: The Concept of 'Brilliant Artifacts' in Han Dynasty Burial Objects and Funerary Architecture," pp. 17–29 of this catalogue, in which he discusses the categories of objects placed in tombs, such as *mingqi*, "spirit articles" or vessels made specifically for the dead; *jiuqi*, gift burial objects from mourning guests; and *renqi*, objects for living people as well as other categories.

3. Shandong daxue kaogu xi et al., "Shandong Changqing xian," pp. 4–5, figs. 5–6; plate 3:1–5,7.

4. For a *hu* recently excavated from a large Western Han tomb in Xi'an, Shaanxi, with very similar contents to those of the Shuangrushan Tomb 1, see *Wenwu*, no. 12 (2003), p. 31, fig. 4 and p. 33, fig. 8; and for Eastern Han tombs in Guangxi, see *Kaogu*, no. 10 (2003), plate 6:5.

5. Jenny F. So, "The Inlaid Bronzes of the Warring States Period," in *The Great Bronze Age of China* (New York: Metropolitan Museum of Art, 1980), pp. 308–309, and Jessica Rawson, *Chinese Bronzes, Art and Ritual* (London: The British Museum, 1987), pp. 55–57.

6. The symbolism of the Mawangdui silk banner, Penglai, and the vase has been thoroughly explored by Loewe, *Ways to Paradise*, pp. 34–43. In 1969, a pair of large painted pottery birds were excavated from Western Han tomb at Wuyingshan, Jinan, Shandong; one, included in the exhibition (cat. no. 3), supports two *ding* vessels and two figures with a servant holding a parasol over their heads and the other supports two large *hu* vessels. Perhaps both are allusions to the journey to Penglai, Island of the Immortals. For the painted pottery bird with *hu* vessels see Shandong wenwu shiye guanli ju, *Shandong wenwu jingcui*, p. 66, no. 61.

7. Tile with *liubo* game board
西漢　六博陶磚
Western Han dynasty (206 BCE–9 CE)
Molded gray clay; H. 26 cm, W. 25 cm, Thickness 8 cm
Excavated 1975, Zhangqiu
Collection of Zhangqiu Municipal Museum

Molded in low relief, this gray clay tile shows the configuration of T, L, and V shapes characteristic of the *liubo* game board. This game board typically has a square positioned in the center with a T projecting from each side and V- and L-shaped markings aligned facing the square and its Ts. At each corner of the tile, a V shape points inward to a corner of the square, while from each side, an L shape extends its base to parallel the top of each T. The placement and alignment of these elements suggest visual axes, vertical and horizontal as well as diagonal,

that focus attention on the center of the square, which is filled with the image of a *wuzhu* coin.[1] Additional faint representations of *wuzhu* coins are still visible in some of the Vs and near the Ls. Four highly stylized, long-legged birds with striated bodies and necks fill the spaces created between the square and the Vs.

Such *liubo* game boards were described in texts as early as the Spring and Autumn (770–475 BCE) and Warring States (475–221 BCE) periods of the Eastern Zhou dynasty.[2] However, to date, the earliest examples found were preserved in tombs from the Warring States. The many boards excavated from Western Han tombs

throughout China testify to the popularity of this game during the first half of the Han dynasty.[3] Most have been crafted from lacquered wood with a very few made from ceramic, stone, bronze, or bone. There are two similar wooden boards also dating from the Western Han dynasty but with much smaller flying birds: one was excavated in 1983 from another Shandong site at Jinqueshan, Linyi, and a second, in lacquered wood, was discovered in Tomb M3 at Mawangdui, Changsha, Hunan, in 1973.[4]

The *liubo* game unearthed from Tomb M3 at Mawangdui is the most complete set yet discovered, containing the pieces used in playing the game.[5] In excellent

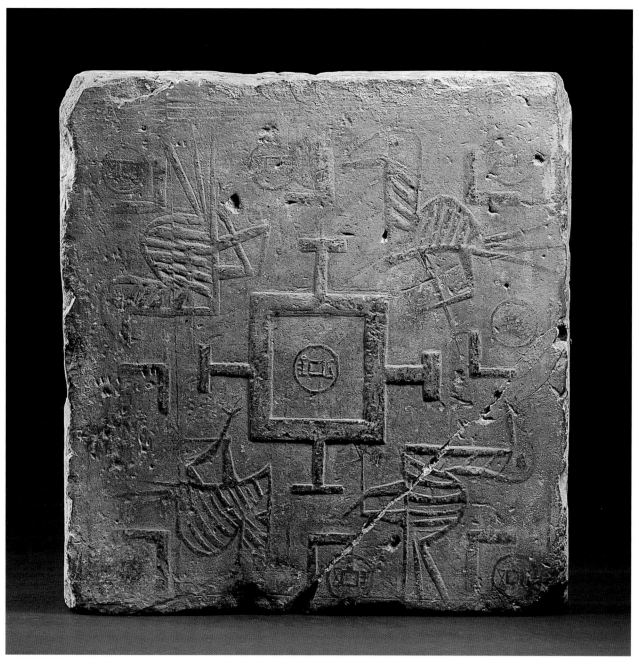

condition, the lacquered board (*boju*) had its own wooden case and was accompanied by one wooden die (*tou*) similar to the bronze one included in this exhibition (cat. no. 8), twelve playing pieces (*xiangqi*), long and short tallies (*chou*), and a knife (*dao*). The stands or small table that may have supported the board are the only equipment missing from the Mawangdui find. *Liubo* is usually played by two people with one die, and the throw of the die determined the moves of the players. The twelve playing pieces tracked the moves of the players while the tallies were used for scorekeeping. There are a considerable number of pictorial and sculptural representations that depict mortals and immortals animatedly engaged in this game; the best-known are stone tomb relief carvings with immortals broadly gesticulating over the game board from Chengdu in Sichuan as well as clay tomb figures (*mingqi*) from Lingbao in Henan.[6] Although *liubo* remained popular for more than 500 years, there have been no games or representations of it found after the Han. It seems to have lost favor to other games such as *weiqi*, known in the West by its Japanese name *go*.[7]

Liubo is often associated with another game board, *saixi*; both together were often referred to as *bosai* and are considered ancestors of Chinese chess, *xiangqi*. The main difference between the two games is that the die is thrown in *liubo* but not in *saixi*.

Apparently, *saixi* was considered a more difficult game to play, requiring intellectual acuity rather than depending on chance. Though not consistent, there is some evidence that the boards of the two games may differ slightly, the L shapes on the *liubo* board pointing in a counterclockwise direction while those on the *saixi* board point clockwise.[8] As Zheng Yan'e observed, the direction of the L shapes could have been an artisan's mistake.[9] If this distinction proves accurate, this board from Zhangqiu, Shandong, would have been used to play *saixi* rather than *liubo*.

It has long been recognized by scholars that there is a connection between *liubo* and divination. Gaming and divination have been important to China's civilization from ancient times through to the present day. One of China's leading authorities on ancient divination, Li Ling, has written an essay suggesting that the connection between divination and gaming derives from essentially the same source, numerology.[10] The TLV pattern on *liubo* game boards had two dimensions, as game and as cosmic diagram for divination. This connection was confirmed with the discovery in 1993 of a wooden slip, excavated from Tomb 6 (dated to 10 BCE) at Yinwan, Jiangsu, which showed a TLV diagram like the *liubo* game board and instructions for divination as well as a chart listing events that require divination, such as marriage, travel, death, and illness.[11] On the *liubo* board, gaming and divination blended. This TLV pattern can also be found on a group of mirrors known as TLV mirrors or gaming board mirrors, a type that dominated throughout the Han. In round mirrors the TLV configuration creates a schematic model of the universe with the central square inscribed within a circle; the circle and square in Chinese cosmology refer symbolically to heaven and earth.[12] The buried *liubo* game boards and TLV mirrors were intended to guide the deceased soul on its journey to another world and immortality as well as to gratify the spirits of the dead with suitable comforts drawn from life.

AJ

1. Since *wuzhu* coins were first made during the reign of Wudi (r. 140–87 BCE), this tile cannot be earlier than 140 BCE.
2. Zheng Yan'e discusses the appearance of the *liubo* game as early as the Western Zhou period in the *Mu Tianzi zhuan*, which describes this as a game played by King Mu of Western Zhou and Duke Jing. Apparently, this apocryphal work was derived from pre-Qin sources. This could suggest an even earlier origin for *liubo*. See Zheng Yan'e, "Preliminary Remarks on the Games of *Liubo* and *Saixi*," *China Archaeology and Art Digest* 4, no. 4 (April-May 2003), p. 80. One of the earliest important publications on this game was written by Yang Lien-sheng, "An Additional Note on the Ancient Game of *Liu-po*," *Harvard Journal of Asiatic Studies* 15 (1952), pp. 124–39.
3. See Zheng Yan'e, "Preliminary Remarks," pp. 89–95 for a table listing actual *liubo* boards excavated from tombs as well as sculptural models and pictorial representations of players of *liubo* or a related game, *saixi*. Boards have been found from Shandong, Hebei, Shanxi, and Henan to Anhui, Jiangsu, Hubei, Hunan, Guangzhou, Guangxi, and Gansu. Many pictorial and sculptural representations of people playing the game are extant from these same provinces and Sichuan. For additional pictorial representations, see Mark Edward Lewis, "Dicing and Divination in Early China," *Sino-Platonic Papers* 121 (July, 2002), pp. 21–22.
4. See Linyi shi bowuguan, "Shandong Linyi Jinqueshan jiuzuo Handai muzang" [Nine Han dynasty tombs at Jinquechan in Linyi, Shandong], *Wenwu*, no. 1 (1989), p. 40, fig. 40; and Xiong Zhuanxin, "Tan Mawangdui sanhao Xi-Han mu chutu de liubo" [Discussion of the *liubo* game excavated from Western Han Tomb M3 at Mawangdui], *Wenwu*, no. 4 (1979), p. 35, fig. 1 and p. 38, fig. 6. The wooden set from Mawangdui was included in an exhibition focusing on Asian games at The Asia Society and Museum in New York, Fall 2004, accompanied by a catalogue edited by Irving Finkel and Colin Mackenzie, *Asian Games: The Art of Contest* (New York: The Asia Society and Museum, 2004). An overview of The Asia Society exhibition with a short discussion of *liubo* was published by Colin Mackenzie, "Games as Signifiers of Cultural Identity in Asia: *Weiqi* and Polo," *Orientations* 35, no. 6 (September, 2004), pp. 48–55.
5. Xiong Zhuanxin, "Tan Mawangdui sanhao Xi-Han mu," p. 36,

fig. 3; p. 38, figs. 5–7; p. 39, figs. 9–11. As Zheng Yan'e points out, the high level of craftsmanship displayed by the Mawangdui *liubo* game set not only suggests the importance of the deceased in the tomb but also indicates that the game had undergone a long period of development. Zheng Yan'e, "Preliminary remarks," p. 80. Three other complete sets have been discovered, two from the Qin dynasty tombs at Shuihudi and one from a Western Han tomb at Fenghuangshan, Jiangling, Hubei. See Lewis, "Dicing and Divination," p. 9 and Changjiang liuyu di er qi wenwu kaogu gongzuo renyuan xunlianban, "Hubei Jiangling Fenghuangshan Xi-Han mu fajue jianbao" [A brief report on the discovery of a Western Han tomb from Fenghuangshan in Jiangling, Hubei province], *Wenwu*, no. 6 (1974), pp. 41–61.

6. For immortals gaming see Lucy Lim, et al., *Stories from China's Past: Han Dynasty Pictorial Tomb Reliefs and Archeological Objects from Sichuan Province, People's Republic of China* (San Francisco: The Chinese Culture Foundation, 1987), plate 57D (left). For the green-glazed *mingqi*, see Grace Wong, ed., *Treasures from the Han* (Singapore: Historical and Cultural Exhibitions, 1990), p. 60.

7. Mackenzie, "Games as Signifiers," p. 49.

8. Zheng Yan'e, "Preliminary remarks," p. 83.

9. Ibid.

10. An abridged version of a much longer essay by Li Ling, "The Common Origins of Divination and Gaming," appears in *China Archaeology and Art Digest* 4, no. 4 (April-May, 2002), pp. 49–52; p. 52 of this issue cites Li Ling's other studies.

11. A number of discussions have been published on the Yinwan wooden slip from Jiangsu. See Zeng Lanying [Lillian L. Tseng], "Divining from the Game *Liubo*: An Explanation of a Han Wooden Slip Excavated at Yinwan," *China Archeology and Art Digest* 4, no. 4 (April-May, 2002), pp. 55–62; this article was published earlier in *Wenwu*, no. 8 (1999), pp. 62–65. See also Li Jiemin, "'Yinwan Hanmu boju mudu shijie' zengbu" [Supplement to 'A tentative interpretation of the Han dynasty wooden slip from Yinwan bearing the *liubo* board divination'], *Wenwu*, no. 8 (2000), pp. 73–74.

12. For discussions of the TLV mirror and divination and game boards see Schuyler Cammann, "The 'TLV' Pattern on Cosmic Mirrors of the Han Dynasty," *Journal of the American Oriental Society* 68 (1948), pp. 159–67; Yang Lien-sheng, "A Note on the So-Called TLV Mirrors and the Game of *Liu-po*," *Harvard Journal of Asiatic Studies* 9 (1947), pp. 202–206; Loewe, *Ways to Paradise*, pp. 60–85; Ju-hsi Chou, *Circles of Reflection: The Carter Collection of Chinese Bronze Mirrors* (Cleveland: The Cleveland Museum of Art, 2000), pp. 3–6, nos. 24–31; Cheng Linquan and Han Guohe, "A Study of Gaming Board (TLV) Mirrors Unearthed in the Northern Suburbs of Xi'an," *China Archaeology and Art Digest* 4, no. 4 (April-May, 2002), pp. 97–110.

8. Faceted die, *tou* (also read *shai*)
漢　銅骰子
Han dynasty (206 BCE–220 CE)
Bronze with characters; Diam. 5.5 cm
Collection of Shandong Provincial Museum1

Found independent of the game board from Zhangqiu (cat. no. 7), this bronze die is the kind used to play *liubo*. It is a hollow bronze sphere that has been cast with eighteen disks or faces attached to each other; sixteen faces show numbers while two have seal characters. Such dice can vary both in the number of faces, which range from as few as six to as many as eighteen, and in the markings on the faces. Much like the *liubo* boards, most excavated dice have been fashioned from wood and a few from bronze. Apparently dice were also made from silver or bamboo. A similar bronze die dating to the Western Han was excavated in the Linzi area in Shandong while a handsome brown and white lacquered solid wooden sphere was found as part of the Mawangdui set from Tomb M3 in Changsha, Hunan.[1]

As described in the entry for catalogue number 7, the *liubo* game was played by two people using one die, and

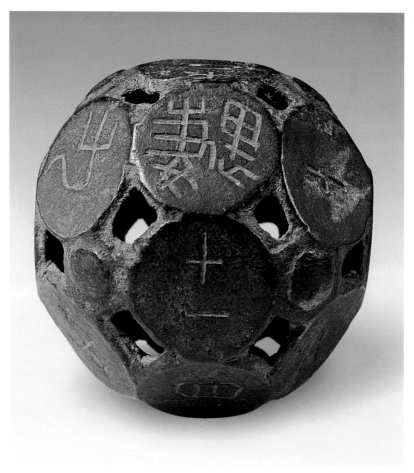

the throw of the die governed the player's moves. The higher the number obtained by the throw of the die, the farther the one player could move his or her pieces. Since the key to winning *liubo* was a matter of chance, luck rather than skill determined the winner. Apparently, the immense popularity of the game inspired opposition and derision from educated scholar-gentlemen, including Confucius, who perceived this game of chance as cultivating the way of evil and decadence.[2] A poetic description of Linzi (the city retains the same name today), the capital of the State of Qi and one of the largest and most beautiful capital cities during the Warring States, conveys the wealth of its residents, who enjoyed the "luxury of musical instruments, fighting cocks, running dogs, dice, and soccer."[3]

AJ

1. The bronze die from the Linzi area was excavated in 1978 and is published in the Japanese catalogue, *Chūgoku sennin no furusato* [China, Homeland of the Immortals] (Osaka: Ōsaka Furitsu Yayoi Bunka Hakubutsukan [Museum of Yayoi Culture], 1996), no. 48; the lacquered wooden die from Tomb M3 of Mawangdui is published by Zheng Yan'e, "Preliminary Remarks," p. 79, fig. 2. Another wooden die was found in the Western Han Tomb M10 at Fenghuangshan, Jiangling, Hubei, see *Wenwu*, no. 6 (1974), p. 59, fig. 37. A handsome multifaceted die inlaid with precious materials was exhibited in Fall 2004 at The Asia Society and published by Irving Finkel and Colin Mackenzie, eds., *Asian Games: The Art of Contest* (New York: The Asia Society and Museum, 2004) and by Irving Finkel, "On Dice in Asia," *Orientations* 35, no. 6 (September, 2004), p. 59, fig. 5.
2. Zheng Yan'e, "Preliminary Remarks," pp. 85–86.
3. Thomas Lawton, *Chinese Art of the Warring States: Change and Continuity, 480–222 B.C.* (Washington DC: Freer Gallery of Art and Indiana University Press, 1982), p. 15.

9. Incense burner, *boshanlu*
西漢　銅博山爐

Western Han dynasty (206 BCE–9 CE)
Bronze; H. 29.3 cm, Diam. (base) 23 cm,
　　H. (upper section) 12 cm
Excavated from the Han tomb at Fangbei village,
　　Shuangshan District, Ye County
Collection of Shandong Provincial Museum

At the base of this mountain censer (*boshanlu*), a tiger-like *chihu* dragon undulates and twists in the shallow pan. Rising up from the mouth of the creature is the bulbous body of the incense burner, surmounted at its apex by a majestic bird. The stylized scrolling of his plumage and elaborate tail feathers, and his elongated neck heighten his verticality, making him appear ready to take flight. The mountain is a cosmic structure. In Han cosmology,

it is seen as a conduit to the heavens and the bird as a celestial vehicle (see also cat. nos. 43, 44). The conical lid is cast in relief with mountain peaks interspersed with waves of clouds; the apertures in the peaks would have allowed the incense burning within the censer to create mist and clouds that envelope the cosmic mountain.

The Western Han text *Huainanzi* describes the potency of mountains as the visual form that links the liminal realm between the mundane and spiritual worlds.[1]

> If one climbs to a height double that of the Kunlun Mountains, [that peak] is called Cool Wind Mountain. If one climbs it, one will not die. If one climbs to a height that is doubled again, [that peak] is called Hanging Garden. If one ascends it, one will gain supernatural power and be able to control the wind and rain. If one climbs to a height is that is doubled yet again, it reaches up to Heaven itself. If one mounts to there, one will become a god. It is called the abode of the Supreme Thearch.[2]

The ascension to each higher peak of the mountain imparts not only greater supernatural power, but brings the climber closer to the land of the immortals. Such imagery placed within the tomb allows the deceased to more easily access heaven on the wings of the bird (see cat. no. 3) or on the back of the dragons (see cat. no. 43) at the base of the mountain censer. The desire to reach immortal realms in the Han dynasty, explains in large part why mountain censers such as ours began to appear in Western Han tombs during the reign of Wudi (r. 141–87 BCE).[3] Excavated from his tomb in Xingping county, Shaanxi province was a silvered bronze mountain censer with inscriptions on the lid and base indicating that it had been made in 137 BCE for use in one of the imperial palaces at the capital, the Weiyang Gong. It stands relatively high at 58 centimeters and has dragons at its base. Clearly it was a treasured object that was chosen for his tomb to help facilitate his journey to the afterlife. Other early bronze mountain censers were also found in Tomb 1 at Mawangdui and in the tombs at Mancheng which belonged to Emperor Wu's half brother, Liu Sheng, who died in 113 BCE, and his wife Dou Wan.[4] Mountain censers continued to be placed in tombs throughout both the Western and Eastern Han dynasties.

SLB

1. The *Huainanzi* is a collection of essays, compiled some time before 139 BCE, encompassing a broad range of topics including ancient

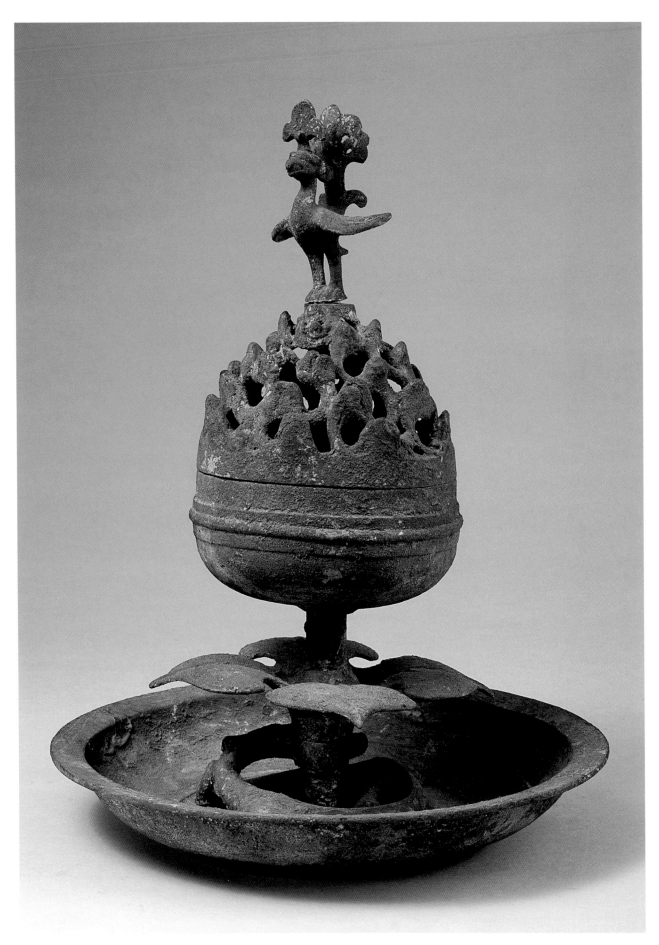

myths, topography, astronomy, and philosophy. For a summary of the content and text history of the work see Charles Le Blanc, "Huai nan tzu," in Michael Loewe, ed., *Early Chinese Texts: A Bibliographical Guide*, Early China Special Monograph Series No. 2 (Berkeley: Society for the Study of Early China and Institute of East Asian Studies, 1993), pp. 189–95. For an English translation of chapters 3, 4, and 5, see John S. Major, *Heaven and Earth in Early Han Thought* (Albany: State University of New York Press, 1993).

2. Major, *Heaven and Earth*, pp. 158–59. This passage also discusses the role of trees as cosmic pillars. For a further discussion of trees in this context, see cat. no. 19, n. 4. For more on mountains and trees as links to the realm of the immortals see also Kiyohiko Munakata, *Sacred Mountains in Chinese Art* (Urbana: University of Illinois, 1991); and Susan N. Erickson both in "Boshanlu Mountain Censers of the Western Han Period: A Typological and Iconological Analysis," *Archives of Asian Art* 45 (Dec. 1992), pp. 6–28, and in Liu et al., *Recarving China's Past*.

3. Erickson, "Boshanlu Mountain Censers," p. 6.

4. Ibid.

10. Stand with leonine creature

東漢　獸首銅支架

Eastern Han dynasty (25–220 CE)
Bronze; H. 43 cm, Diam. (at the foot) 26.5 cm
Excavated from a tomb at Jiunüdun,
　　Dongzhifang, Cangshan County
Collection of Shandong Provincial Museum

The shaft of this bronze stand, which rises from a wide and circular domed base, tapers from both top and bottom and appears to be cinched in the middle by a ring in high relief. At the top a fantastic leonine creature endowed with a large round belly and sagging chest kneels on a cushion with its feet tucked under and front paws resting on its knees. The powerful head is dominated by jowly cheeks, a flat pig-like snout with pronounced nostrils, and bulging eyes framed by thick curled brows. Between the jowled-cheeks that are further emphasized by a curled moustache, a partly opened mouth bares teeth and fangs. The two long horns, visible from the front as bumps just above the eyes, curve down the back of the head and end in curls. Also on the back are wispy striated wings, which emerge just behind the arms. Many other embellishments on the creature's bear-like body, such as the circle on its belly and the striations on the wings or horns, and its cushion are barely visible, covered by layers of patina and corrosion.

A D-shaped hole piercing the shaft just below the creature's cushion is designed to hold a long handled utensil at right angles to the stand. Among the stands that have survived complete, most are bronze and show the long horizontal handle supporting a shallow basin. In one example

the basin serves as an oil lamp, in another as a brazier or basin covered with an openwork lid, and in a third as a *he* or kettle.[1] A number of stands fashioned from bronze or clay have survived without any utensils or bases.[2] In the Liaoning Provincial Museum, a bronze stand that survived without a utensil has been the subject of a short study in Chinese. The author identifies the function of these bronze animal-headed stands as a lamp or "holding an iron," *tangren*.[3] Many of the stands seem to date from the Eastern Han through the Jin-Wei period, or the third century CE. A bronze stand similar to the Shandong example but with a higher domed base was excavated at Zhangzhuangqiao in Hebei province and dates to the Eastern Han period.[4] Two ceramic examples, one excavated from Yanshi, Henan, and another from Luoyang, Henan, are dated just post-Han or Jin-Wei, i.e. third century.[5]

This sturdy animal combining bear-like and leonine features belongs to the richly imaginative pantheon of mythological and fantastic hybrid creatures that characterized ancient China's culture from its beginnings but were particularly prevalent during the Han dynasty. The tombs built amidst the notions of paradise and immortality that flourished during the Han dynasty provided ample opportunities to depict these creatures in all media: from painted and carved images on tomb walls and on sarcophagi to stands supporting musical instruments and stone beasts guarding spirit roads.[6]

AJ

1. For stands holding basins, see the bronze example excavated at Zhangzhuangqiao, Handan county, Hebei, in *Hebei chutu wenwu xuanji* [Selection of Cultural Relics Excavated from Hebei Province] (Beijing: Wenwu chubanshe, 1980), p. 156, fig. 271. For a bronze example with an openwork lid added to the basin, considered a brazier, in the Shodo Museum in Tokyo, see *Sekai bijutsu zenshū* [Complete Works of Art of the World] (Tokyo: Kadokawa Shoten, 1962), vol. 13, fig. 96, or *Rokucho no bijutsu* [Art of the Six Dynasties] (Tokyo: Heibonsha; Osaka: Osaka Municipal Museum of Art, 1976), fig. 31. For the bronze example with a *he* kettle, see *The Robert Hatfield Ellsworth Collection of Chinese Archaic and Gilt Bronzes* (New York, 2003), pp. 62–63, no. 45.

2. For a bronze example without a long handled utensil, see the stand from Liaoning Provincial Museum published in *China Archaeology and Art Digest* 4, no. 4 (April-May, 2002), p. 105 bottom. For a ceramic stand without a utensil, dating to the Jin period, see *Wenwu*, no. 9 (1997), p. 52, fig. 9. For two stands without bases, see Jessica Rawson and Emma Bunker, *Ancient Chinese and Ordos Bronzes* (Hong Kong: Oriental Ceramic Society of Hong Kong, 1990), p. 142, no. 47, and *Kaikodo Journal* 54 (Hong Kong: Kaikodo, Spring 2001), pp. 186–89, 316.

3. Liu Ning, "'Tangren' xiaokao" [A short study on ironing stands], *Liaohai wenwu xuekan*, no. 2 (1997), pp. 111–14. It is not clear from this article exactly what an ironing stand is or how it would function.

4. *Hebei chutu wenwu xuanji*, p. 156, fig. 271 and n. 1.

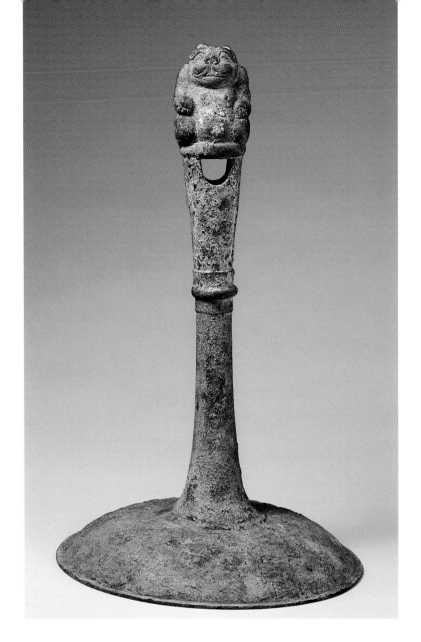

5. "Luoyang Gushui Jinmu (FM6) fajue jianbao" [A brief report of the excavation of the Jin tomb (FM6) at Gushui, Luoyang] *Wenwu*, no. 9 (1997), p. 52, fig. 9. The 3rd century Jin-Wei example from Yanshi, Henan, has been published in *Kaikodo Journal* 19 (Hong Kong, 2001), p. 188, fig. 2.

6. For a discussion of some of the Han belief systems, see three books by Michael Loewe: *Ways to Paradise: The Chinese Quest for Immortality* (London: George Allen & Unwin, 1979); *Chinese Ideas of Life and Death: Faith, Myth and Reason in the Han Period (202 BC–AD 220)* (London: George Allen & Unwin, 1982); and *Divination, Mythology and Monarchy in Han China* (London: Cambridge University Press, 1994). Actual black or brown bears rather than hybrid mythological creatures are frequently represented in Han art as individual gilt bronze images and often as supports on various bronze and clay vessels. Although the breed of black or brown bear may not be identified with complete certainty, the long tapered snout, usually belonging to a black bear, is unmistakable. For example, the small gilt bronze caryatid with turquoise inlay, originally in the late Dr. Paul Singer's collection, is undoubtedly a seated black bear with a long pointed snout and fine chasing of the gilded surface simulates fur; see Max Loehr, *Relics of Ancient China from the Collection of Dr. Paul Singer* (New York: The Asia Society and Harry N. Abrams, Inc., 1965), no. 116, p. 162.

11. Bell, *chunyu* type

西漢　青銅錞于
Western Han dynasty (206 BCE–9 CE)
Bronze; H. 44 cm, Diam. (at base) 24.5 cm
Excavated at Luozhuang, Zhangqiu County
Collection of Jinan Municipal Museum

This elegantly simple bell has a hollow, cylindrical form that is open at the bottom and rounded at the top where a loop handle is attached. The curved profile gently expands near the top and flares slightly towards the bottom. Just below the center of the bell, a single thin, interlacing line in low relief forms the stylized image of a bird of prey. It is shown frontally with wings extended and beaked head in profile. Near the top of the head, a single eye is defined by a circle with a small boss in the center; a pair of circles with bosses sit at each shoulder. The raised line also interlaces across the chest forming a pattern of

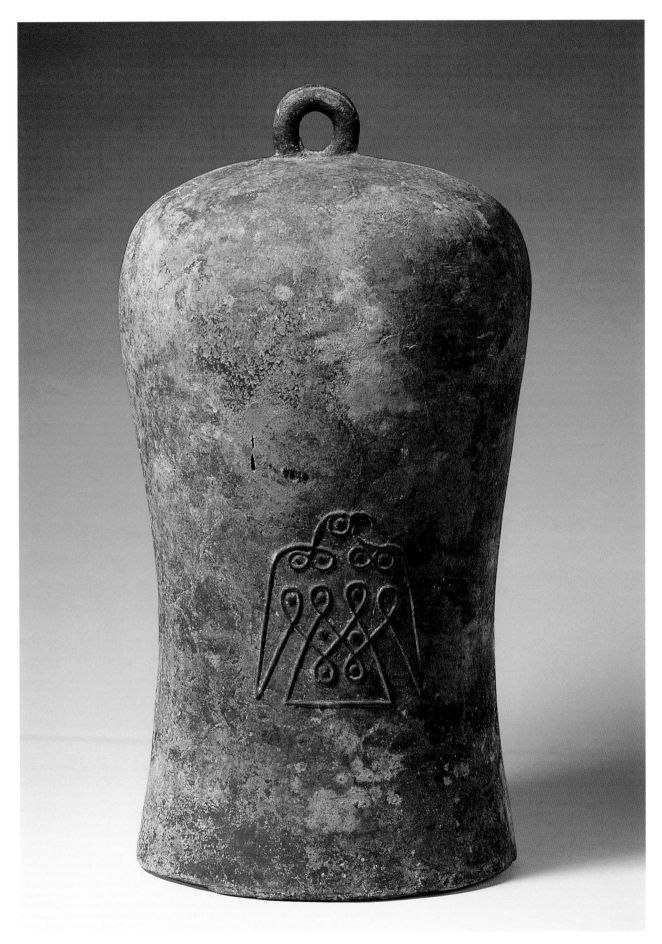

48

circles and diamonds, each filled with a boss.[1] The bird's body is a trapezoidal shape, flat at the bottom with no indication of legs or talons. In sharp contrast with the smooth plain surface of the bell, the presence of this heraldic image of the bird becomes even more powerful.

The surface of the bell has acquired a blue green patina with touches of azurite and deeper blue lapis while the smooth interior displays a dazzling patina of deep blue lapis with splashes of azurite. Since there is no indication of the existence of a clapper inside, the bell was most likely played by striking the exterior.

The Luozhuang tomb had a main chamber with two grave ramps descending into it and was surrounded by 36 burial pits (see Beningson, "Spiritual Geography," pp. 9–10). This single bell was found in Pit 14 along with a set of 19 bronze bells (*bianzhong*) and a set of stone chimes (*bianqing*) (see Beningson, "Spiritual Geography," fig. 4). The contents of Western Han tombs continued to reflect the feudal character of Shang through Zhou dynasties tombs, in particular those from the Warring States period. Just as the scale of a tomb and the number of objects buried indicated the rank and status of the deceased in these hierarchical societies, so too did the number, completeness, and quality of the instruments of music. One of the most famous excavations of musical instruments was from the Warring States tomb of Marquis Yi of Zeng in Suixian county, Hubei; the tomb contained a three-tiered L-shaped frame suspended with 65 bronze chime bells as well as a separate but smaller set of 32 chimes.[2]

This single bell does not belong to a set and comes closest to matching a type of bell known as the *chunyu*, a musical instrument that was generally used in combination with a drum (*gu*) and sometimes discovered in tombs along with the *zheng*, a hand held bell. From the Spring and Autumn period (770–476 BCE) through the Han dynasty, the *zheng* bell was used on the battlefield to sound the retreat of the troops, while the *gu* drum sounded the advance.[3] The single bell closest to the Luozhuang example came from a Spring and Autumn period tomb unearthed in Dantu county, Jiangsu. About the same size (43 cm tall), the Jiangsu bell also has a cylindrical form but it bends or tilts to one side and has an animal-shaped knob on top and an animal-shaped flange on the side as well as some small spirals and birds on the front; the surface is largely smooth and plain.[4]

Chunyu bells were associated with the Ba people from south China in the area known today as Sichuan, western Hunan, and eastern Guizhou. Apparently, the oldest examples of these bells were found in Shandong and Anhui and were associated with the Dong Yi people active in Shandong during the Western Zhou. Eventually the Dong Yi moved south where most of the bells have been found, pointing to cultural exchanges among various ethnic groups in north and south China.[5]

Ritual and music were essential supports to social regulation and government in the earlier Shang and Zhou dynasties; they accompanied the accession of rulers, enfeoffment of nobles and officers, state hunts, banquets, granting of titles, and other functions. Many of these rites were incorporated into the Han dynasty Music Bureau, which regulated the music performed during imperial ceremonies and sacrifices. Continuing archaeological discoveries have dramatically increased scholars' understanding of ancient Chinese music and its import for ancient societies.[6]

AJ

1. A similar kind of interlace, not in the form of a bird but instead embellishing a stylized eight-petaled flower, decorated what was either a wall or ceiling stone excavated from Eastern Han tombs in Songshan near Jiaxiang, Shandong. See Klaas Ruitenbeek, *Chinese Shadows* (Toronto: Royal Ontario Museum, 2002), p. 16, fig. 3 and Jining diqu wenwu zu and Jiaxiangxian wenguan suo, "Shandong Jiaxiang Songshan 1980 nian chutu de Han huaxiangshi" [Han dynasty stone reliefs unearthed in 1980 at Songshan in Jiaxiang county, Shandong province], *Wenwu*, no. 5 (1982), p. 65, figs. 6–13.
2. See Suixian Leigudun yihao mu kaogu fajuedui, "Hubei Suixian Zeng Houyi mu fajue jianbao" [A brief report on the excavation of the tomb of Marquis Yi of Zeng in Suixian, Hubei], *Wenwu*, no. 7 (1979), pp. 4, 16, and figs. 17 & 18; color plate 1; see also Chen Zhenyu, "Musical Instruments and Human Sacrifices in the Tomb of the Marquis Yi of Zeng," in *China Archaeology and Art Digest* 2, nos. 2–3 (December, 1999), pp.106–111.
3. Sun Ji, "Drum and Tocsin," *China Archaeology and Art Digest* 2, nos. 2–3 (December, 1999), p. 55.
4. See *Zhongguo wenwu jinghua* [Gems of China's Cultural Relics] (Beijing: Wenwu chubanshe, 1990), no. 58. Two somewhat smaller cylindrical bells—completely plain and undecorated, with a larger loop handle on top and an open bottom—were found in a Guangxi tomb along with a bell with what are described as "ram's horns" on top; Guangxi Zhuang zu zizhiqu wenwu gongzuodui, "Guangxi Guixian Luopowan yihao mu fajue jianbao" [Excavation of Tomb No. 1 at Luopowan in Guixian, Guangxi], *Wenwu*, no. 9 (1978), plate 4:2 and p. 27, fig. 3.
5. Wan Quanwen, "Ba ren yu zhunyu" [The Ba people and *chunyu*], *Wenwu tiandi*, no. 5 (1997), pp. 34–36.
6. See Lothar von Falkenhausen, *Suspended Music: Chime-bells in the Culture of Bronze Age China* (Berkeley: University of California Press, 1993), and the English summary of Liu Yu's original article in Chinese, "The 'Rites of Zhou' in Western Zhou bronze," *China Archaeology and Art Digest* 2, nos. 2–3 (December, 1999), pp. 128–37.

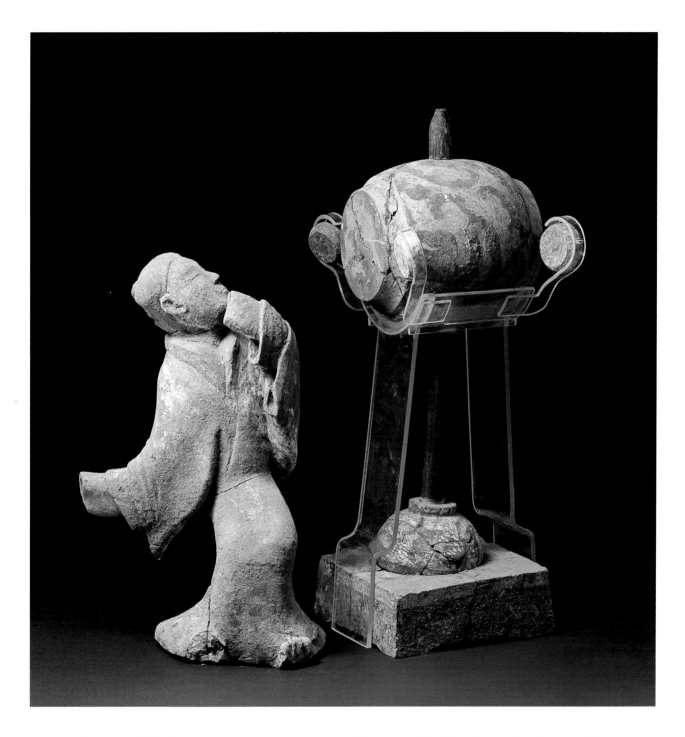

12. Musician and his drum

西漢　男舞俑及建鼓

Western Han dynasty (206 BCE–9 CE)

Clay with natural pigments
 (wooden pole is modern replacement)

Figure: H. 38.5 cm

Large drum: H. 18.5 cm, Diam. 16 cm

Small drum: Diam. 4.5 cm, Thickness 2 cm

Bottom of stand: H. 2 cm, W. 18 cm

Excavated 2002, Weishan, Zhangqiu Municipality

Collection of Zhangqiu Municipal Museum

The site at Weishan is considered one of the greatest archaeological discoveries of 2002.[1] Excavated from this site were this musician and his drum, as well as the cavalry officer (cat. no. 13) included in our exhibition. The musician and drum were found in Pit 1, three-quarters of the way back in the pit, directly behind Horse Drawn War Chariot No. 4. Behind the drum were standing infantry soldiers with shields raised, ready to move forward in battle.[2] Given the location of the drum in the pit, it is likely that the musician struck his drum to set the pace for a protective mission to guard the tomb occupant in the

afterlife. From the Spring and Autumn period through the Han dynasty, the beat of the drum would signal the army's advance as described in the *Weiliaozi*: "The drum beat signals the advance and the repeated drum beat means attack; the tocsin's clang signals a halt and a repeated clanging [of the bell] means retreat."[3] The drummer is leaning back with his weight shifted to his back leg and right hand poised to strike the drum.

This particular type of drum is called a *jiangu* (erected drum).[4] It is supported by a wooden pole that pierces the center of the cylindrical body and extends above it. The drumhead is perpendicular to the ground. This instrument can be found along with orchestras of chime and bell sets depicted on the side of Warring States bronzes.[5] The earliest excavated example of a *jiangu* is from the Eastern Zhou tomb of Marquis Yi of Zeng (433 BCE) at Leigudun, Suizhou, Hubei province. In that example, the base of the drum stand is formed by over sixteen large dragons clinging to or biting each other. It was made in twenty-four pieces cast separately and then soldered together.[6] Texts from the late Spring and Autumn period describe drums as having alligator skins.[7] *Jiangu* drums are also listed in the inventory from Tomb 3 at Mawangdui.[8] Ceramic models of such drums have been excavated from two famous tombs in Shandong province. A group of free-standing acrobats accompanied by musicians was found in a Warring States tomb in Zhangqiu, the same municipality as the Weishan site.[9] The group included two drummers, one with a large *jiangu* and the other with a smaller one, each holding two drumsticks as they beat their drums. Excavated from the Han dynasty tomb at Wuyingshan in 1969 was another equally elaborate tableau of entertainers and musicians attached to a square base.[10] Accompanying the Wuyingshan acrobats is a drummer playing a similar *jiangu* drum. The officials lined up along the far ends of the scene are wearing costume prescribed for rituals, similar to those of the figures standing on our bird (see cat. no. 3), underscoring the interrelationship between music, political authority, and cultural prestige in ancient China.

SLB

1. Guojia wenwu ju, ed., *Zhongguo zhongyao kaogu faxian 2002* [Major Archaeological Discoveries in China, 2002] (Beijing : Wenwu chuban she, 2003), pp. 81–86; Xie Zhixiu, ed., *Shandong zhongda kaogu xin faxian, 1990–2003* [Largest New Archaeological Discoveries in Shandong 1990–2003] (Beijing: Shandong wenhua yinxiang chubanshe, 2003), pp. 151–58.

2. Similar shields are used by figures of infantry soldiers from the Western Han tomb at Yangjiawan, Xianyang, now in the collection of the Shaanxi Historical Museum. *Chang'an guibao* [Treasures of Chang'an] (Hong Kong: Hong Kong Museum of Art and Cultural Bureau of Shaanxi, 1993), pp. 50–51, no. 1. Specific details about the Weishan tomb, the organization of the pit, as well as excavation photos showing the drum in situ are found in Beningson, "Spiritual Geography," pp. 10–12, and illustrated in figs. 9 and 10. For other site photos see figs. 11 and 12.

3. Sun Ji, "Drum and Tocsin," p. 55. The drum in a military setting might sometimes have feathered pennants flying atop its center pole. The *Guoyu* states that the *jiangu* drum is "attached to an upright column like a planted tree." The drum would be set up in either the commander's chariot or on his boat in battle. However, the *jiangu* drum occupied too much room in early war chariots and the general had "no room to stand," and so when attacking in battle, the change was eventually made to a smaller drum size. Ibid., pp. 55–58.

4. Further information on the history of drums can be found in Li Chunyi, *Zhongguo shanggu chutu yueqi zonglun* [Compendium of Ancient Chinese Excavated Musical Instruments] (Beijing: Wenwu chubanshe, 1996). See ibid., pp. 6–9, for a history of drum shapes from Shang dynasty examples to Warring States depictions of drums and chimes on bronzes and ibid., plate 3, for the Warring States period drum base excavated in Zeng Houyi's tomb. For depictions of Han dynasty drums, see ibid., p. 21, fig. 17:4 (from the Han tomb at Wuyingshan, Shandong province), and fig. 17:7 (from the Eastern Han or later tomb at Yinan, Shandong province). A drummer striking an oversized *jiangu* drum with two drumsticks is found on a wall painting in the Eastern Han tomb at Helinge in Inner Mongolia. The base of the drum is formed by two prancing animals whose heads face outwards, but who share one body. Attached to the top of the drum stand are most likely feathered pennants, which sometimes adorned the top of these drums (see Sun Ji, "Drum and Tocsin," p. 56). The drum is painted in red pigment with decorative swirls similar to those on ours. Jan Fontein and Wu Tung, *Han and T'ang Murals* (Boston: Museum of Fine Arts, 1976), p. 44, no. 22.

5. See Jenny F. So, *Music in the Age of Confucius* (Washington D.C.: Freer Gallery of Art and Arthur M. Sackler Gallery, 2000), p. 20, fig. 1.7, for a detail of the design on a 5th-century BCE bronze ritual *hu* vessel from Baihuatan, Chengdu, Sichuan province.

6. Ibid., p. 126, no. 5.

7. "Now their casting is completed, the (bell) rack has been fashioned, and the great bells have been suspended from it. The large jade chimestone and the alligator-skin drum (are also in place)." Falkenhausen, *Suspended Music*, p. 202.

8. The Mawangdui inventory mentions "one *jiangu* and two drummers who hold drumsticks." Sun Ji, *Handai wuzhi wenhua ziliao tushuo* [A Pictorial Handbook of Han Dynasty Material Culture] (Beijing: Wenwu chubanshe, 1990), p. 378.

9. Li Rixun, "Shandong Zhangqiu Nülangshan Zhanguo mu chutu yuewu taoyong ji youguan wenti" [Questions concerning the excavation of musical and dancing ceramic figures at the Warring States tomb at Nülangshan, Zhangqiu, Shandong], *Wenwu*, no. 3 (1993), pp. 1–6; p. 3, figs. 1 and 2 (line drawing of drummers); p. 4, fig. 5 (photo of musicians); plate 1:3 (photo of chime player); and plate 2 (entire tableau).

10. Jinan shi bowuguan, "Shitan Jinan Wuyingshan," pp. 19–23, figs. 2–5. This group of figures was attached to a square base, much like the ceramic bird with *ding* vessels on its wings (cat. no. 3). The Wuyingshan site also yielded the group of five ceramic horses pulling a chariot (cat. no. 2) in our exhibition.

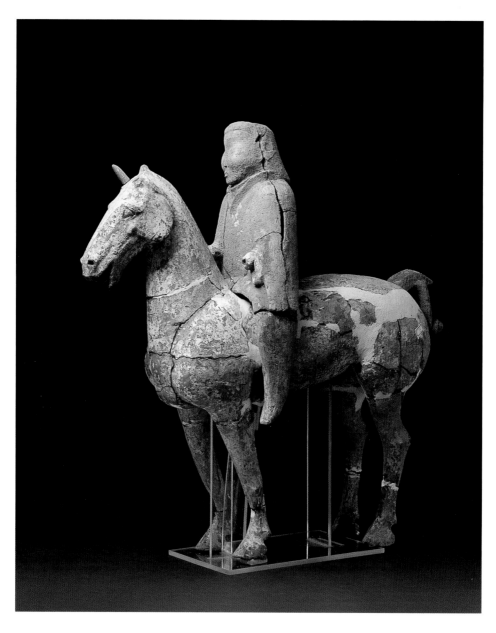

13. Equestrian figure

西漢　陶騎俑

Western Han dynasty (206 BCE–9 CE)
Clay with natural pigments
Figure: H. 45 cm, W. 21.5 cm
Horse: H. 59 cm, L. 68 cm
Excavated 2002, Weishan, Zhangqiu Municipality
Collection of Zhangqiu Municipal Museum

The rider sits astride his battle steed ready to protect the tomb occupant in the afterlife. Man and horse were each made in separate molds. After the clay was fired, they were painted with natural red pigments. The horse's tail was made separately and attached. The rider has a broad forehead, small mouth, and extremely wide and puffed out cheeks. His arms are raised to hold the reins of the horse. This equestrian figure was excavated from Pit 1 at the Weishan site. In the pit were a total of 172 ceramic figures including 55 ceramic horses, 4 chariots, more than 60 shields, and over 150 other objects including the musician and drummer in this exhibition (cat. no. 12).[1] At the very front of the pit was a row of five equestrian figures. Mounted figures were also found to the sides of some of the chariots in the pit. The exact battle formation within the pit is described in detail in my essay in this catalogue, where excavation photos of the cavalry in situ can also be found. Excavated near the site were also three kilns for making the chariots, horses, and figures found in the two pits excavated near the main tomb at Weishan.

Military cavalcades of such majesty are found in only very high-ranking burials. This figure might be part of a ceremonial guard positioned to protect the tomb occupant

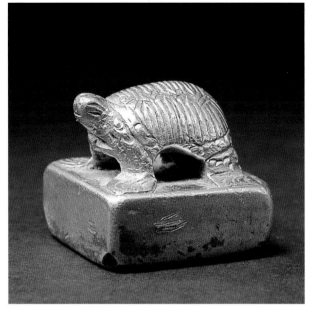

on his afterlife journey, as well as to serve as an indicator of his elite status in the temporal and celestial hierarchies. Models of cavalry and foot soldiers as military guards were excavated from the Han royal tomb (ca. 179–141 BCE) at Yangjiawan, Xianyang, in 1965. A larger group of military guards were excavated in 1990 at the joint tomb of the Han emperor Jingde and his wife, Empress Wang, south of Yangling. Their tomb was comprised of 24 pits containing over 40,000 clay figures, all one-third life size. They originally had movable arms and wore clothing of silk and hemp.

SLB

1. Guojia wenwu ju, ed., *Zhongguo zhongyao kaogu faxian 2002*, pp. 81–86.

14. Gold seal with a tortoise

西漢　關內侯金印
Western Han dynasty (206 BCE–9 CE)
Gold; H. 2.1 cm, L. 2.4 cm
Excavated 1976, Dongshicai, Xintai
Seal legend: *guan nei hou yin*
Collection of Shandong Provincial Museum

The tortoise stands foursquare on top of the gold seal, with his feet appearing to melt into the base of the seal platform. His facial features were cast into the gold as were the detailed markings of hexagons that adorn his shell. Cast in seal script on the reverse is *guan nei hou yin*, "the seal of *guan nei hou*." According to the *Hanshu,*

guan nei hou is the second highest of twenty aristocratic ranks.[1] In the temporal world, seals served to assert the rank and authority of the owner and were indicators of his position at the imperial court and his participation in the sphere of political and administration authority. The oldest surviving administrative handbook, *Han jiuli* (Old Statutes of the Han Dynasty), clarifies the use of gold seals with tortoises or turtles on their knobs.

> The seals of the imperial princes are made of gold, the knob is shaped like a camel, the inscription takes "*xi*" as the designation for "seal." The barons also bear a golden seal, the knob is shaped like a tortoise, the inscription is called "*yin*." The prime minister and generals-in-chief both have a golden seal with a knob formed like a tortoise, but the inscriptions of their seals is called "*zhang*."[2]

The rare examples of extant gold seals such as the two shown in our exhibition (cat. no. 15) bespeak the official rank of our tomb occupants and assert their preeminence in the hierarchy of the afterlife. Texts such as *Words of Strong Admonition* by Yang Xiong (53 BCE–18 CE) attest to the association of official seals with an official's high social standing: "If I could only wear a red sash and if I could let a golden seal hang from my girdle, I would feel unlimited joy."[3] One can imagine the gold seal hanging from such a red sash on the robes of the officials behind the head of the bird in our exhibition (cat. no. 3) as they performed their ritual activities. Two square gold seals with tortoises on top were excavated in 1983 from the Western Han tomb of the king of Nanyue in Guangdong,[4]

and one was excavated in 1981 from Eastern Han Tomb 2 at Ganquanzhen in Hanjiang county, Jiangsu province.[5] This shape of seal, square topped with a tortoise, in gold is well known from the Western Han through the Sixteen Kingdoms (304–439) period.[6]

SLB

1. Michael Loewe, "The Orders of Aristocratic Rank of Han China," *T'oung Pao* 48, no. 1–3 (1960), p. 99. Loewe discusses the privileges associated with the rank of *guan nei hou* on pp. 150–54.
2. Lothar Wagner, "Chinese Seals," in *7000 Years of Seals*, ed. Dominique Collon (London: British Museum Press, 1997), pp. 209–210.
3. Ibid., p. 212. Wagner also cites an example of the opposite feeling in the Tang dynasty as shown in the poetry of Du Fu (712–770): "With grief you looked at your large golden seal, For you looked for the pure and calm life of a hermit."
4. *Zhongguo meishu quanji: Gongyi meishu bian*, vol. 10, *Jin yin boli falang qi* [Gold, Silver, Glass, Cloisonne] (Beijing: Wenwu chubanshe, 1988), p. 16, nos. 28–29; pp. 9–10.
5. Ibid., p. 19, nos. 37–39; p. 11.
6. There are eleven square gold seals with tortoises on top ranging from the Western Han through Sixteen Kingdoms period illustrated in *Zhongguo wenwu jinghua da cidian: jin yan yu shi juan* [Compendium of Archaeological Treasures of China: Gold, Silver, Jade, and Stone Volume], 2nd ed. (Shanghai: Shanghai cishu chubanshe, 1999), pp. 414–26, nos. 15, 20, 31, 32, 35, 36, 38, 44, 45, 48, 59. The tortoise seal with the shell most similar to our example is dated to the Three Kingdoms or Wei period. It is only slightly shorter (1.9 cm) than ours. The four-character legend in seal script reads, *guan zhong hou yin*. It was excavated in 1951 at Nanyang in Henan province and is now in the collection of the Henan Provincial Museum. The markings on the tortoise's shell, as well as the outline of the shell's rim, are similar fashion to those of the Shandong seal. However, the eyes of the Henan tortoise are rendered as recessed circles on the sides of his head, whereas our tortoise's eyes are recessed dots in the front of his head. Ibid., p. 422, no. 44.

15. Gold seal with a tortoise belonging to Marquis Shi Luo

西漢　石洛侯金印

Western Han dynasty (206 BCE–9 CE)
Gold; H. 1.5 cm, L. (seal face) 2.3 cm
Seal legend: Shi Luo Hou *yin*
Collection of Shandong Provincial Museum

This gold seal in the shape of a tortoise is unique. Its carapace, which is engraved with hexagons, is a flat sheet that mirrors the exact shape of its base; its squat legs form columns at the rounded corners. His tiny head juts forward beyond the perimeter of the base. The underside of the seal is cast with a four-character legend in seal script, Shi Luo Hou *yin*, pronouncing its owner to be Marquis Shi Luo. A commentary to the *Hou Hanshu* (History of the Later Han Dynasty) states that "princes and nobles should use gold seals, with tortoise handles and red ink."[1] In Chinese cosmology, the shell of the tortoise is often compared to the vault of heaven and its underside to the flat disc of earth. The hexagons on the shell are associated with the divine ancestor Fu Xi and the origins of writing.[2] As early as the Shang dynasty, oracle bones using tortoise plastrons were used to record royal divinations; these records comprise the earliest body of writing known in China. The tortoise is one of the four sacred animals, *sil-ing*, in the *Liji*, or Book of Rites. The tortoise symbolized permanence and longevity (see cat. no. 49). It was most likely for these reasons that stone stelae with epitaphs and inscriptions are often supported on the backs of tortoise-shaped bases. In addition, the tortoise combined

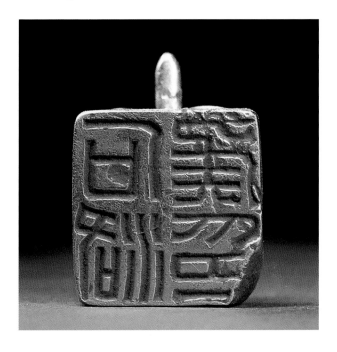

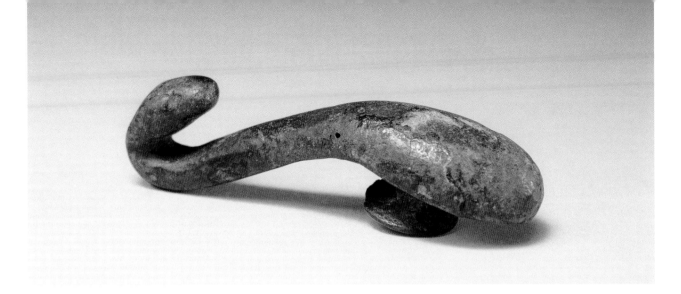

with a snake becomes the symbol of the Dark Warrior of the North, one of the spirits that preside over the Four Directions or the Four Quarters of the Universe.

SLB

1. Carol Michaelson, *Gilded Dragons: Buried Treasures from China's Golden Ages* (London: British Museum Press, 1999), p. 54.
2. For more details about the relationship between hexagrams and the origins of writing, see Cary Liu's discussion of a Han dynasty ceramic inkstone in the shape of a tortoise with hexagrams and a shell similar to that of the tortoise-shaped seal in this exhibition. Liu et al., *Recarving China's Past*, cat. no. 54.

16. Belt-hook with auspicious symbol
漢　昌壽帶鉤銅印
Han dynasty (206 BCE–220 CE)
Bronze; L. (belt-hook) 6.2 cm, L. (seal) 1.5 cm
Seal legend: *chang shou*
Collection of Shandong Provincial Museum

This bronze belt-hook is in the shape of an animal, perhaps a dragon. Its small head, cast with indentations to indicate the eyes, forms the hook, while its body forms a raised arc with a rounded end. Garment hooks of this shape are well known from the Eastern Zhou dynasty onward. They are often found in precious materials such as jade or gold, or in bronze and iron with jade, gold, or silver inlay.[1] The underside of this bronze belt-hook has the unusual feature of a projecting stud that serves as a seal. The circular seal is cast with the two characters *chang shou* in seal script calligraphy. *Chang* means prosperous and abundant as well as to make prosperous and glorify. It can also be translated as "light" or "brightness." *Shou* means longevity, here referring to the perpetuation of the soul and reputation of the deceased beyond death, as well as the desire for lineage longevity.[2] The

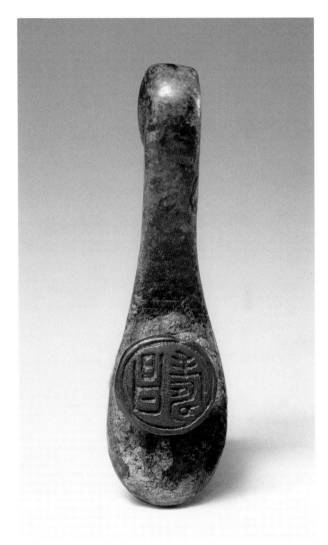

inscription could also be an allusion to the brightness of the ancestors and the "brilliant artifacts" within the tomb.[3] Metal also played a role in the Han vision of the afterlife, the material itself signifying longevity and immortality.[4] An inscription from a Han bronze mirror states: "May you have joy, wealth, and prosperity. Long life be yours, exceeding that of metal and stone, as is fit

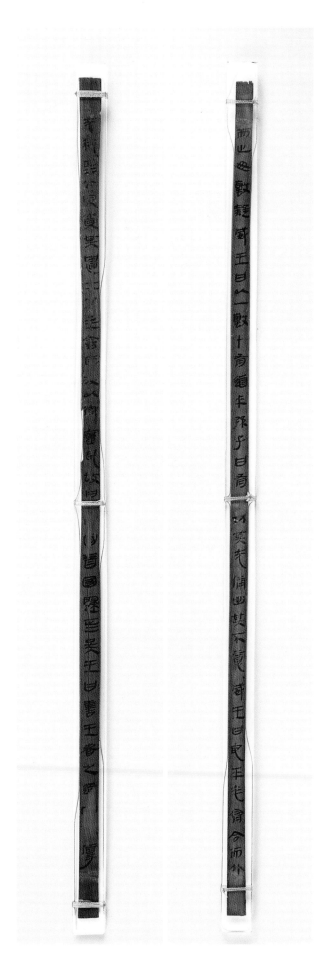

for nobleman or king."[5] From the Warring States period onward it was quite common to have seals made with auspicious meanings.[6] This belt-hook might have been used in life by the deceased and then buried with him as a treasured object. It might also have been made solely for the mortuary context as we see many references to longevity for both the tomb occupant and the tomb itself on objects and in texts buried with the deceased.[7]

SLB

1. The Western Han tomb of the king of Nanyue in Guangdong yielded an iron belt-hook of similar shape inlaid with jade. For more details on Eastern Zhou belt-hooks in animal forms see Rawson, *Chinese Jade from the Neolithic to the Qing*, pp. 303–307.
2. For a discussion of the concept of *shou* in the Han funerary context see K. E. Brashier, "Longevity Like Metal and Stone: The Role of the Mirror in Han Burials," *T'oung Pao* 81, no. 4–5 (1995), pp. 214–15.
3. David N. Keightley explains the lack of eternally burning lamps in China before the Eastern Zhou with the view that the dead themselves were *ming*, or "bright," and that "the spirits of the ancestors were thought to live in a world of light." Keightley, *The Ancestral Landscape: Time, Space, and Community in late Shang China (ca. 1200–1045 BC)*, China Research Monograph 53 (Berkeley: University of California, 2000), p. 25 n. 25. For the concept of *mingqi*, see also Cary Liu's essay, "Embodying the Harmony of the Sun and the Moon: The Concept of 'Brilliant Artifacts' in Han Dynasty Burial Objects and Funerary Architecture," in this catalogue.
4. Brashier, "Longevity Like Metal and Stone," pp. 217–21.
5. Loewe, *Ways to Paradise*, p. 196, C2102.
6. Wagner, "Chinese Seals," p. 208.
7. The term *shou* "longevity" was also applied to the coffin itself as well as to the tomb. The term *shouqi* was used for the coffin of the mother of Emperor Huan (r. 146–68). A tomb tile with an inscription dated 113 CE from Sichuan identifies the tomb as a "ten-thousand harvests, lengthened years, and increased longevity vault." See Brashier, "Longevity Like Metal and Stone," pp. 216–17.

17-1. Bamboo Strip of the "King Wei's Questions" Chapter of *Sun Bin's Art of War*

西漢　銀雀山漢墓竹簡"孫臏兵法·威王問"

Western Han period, 2nd century BCE
Bamboo; L. 27 cm
Excavated 1972, Yinqueshan, Linyi
Collection of Shandong Provincial Museum

17-2. Bamboo Strip of the "Questions of Wu" Chapter of *Sunzi's Art of War*

西漢　銀雀山漢墓竹簡"孫子兵法·吳問"

Western Han period, 2nd century BCE
Bamboo; L. 27 cm
Excavated 1972, Yinqueshan, Linyi
Collection of Shandong Provincial Museum

The burial items placed within a Han tomb might include written texts as well as jade, ceramics, and lacquer. Inscribed on silk, wood, or bamboo, such texts reflected the interests or professional responsibilities of the tomb's occupant and, when recovered and painstakingly reassembled by archaeologists, shed new light on the intellectual world of early China and the state of such diverse fields as medicine, law, and cartography. One of the most important textual finds of the last fifty years comes from the two Western Han tombs at Yinqueshan (Silver Sparrow Mountain) south of Linyi, Shandong, which were discovered and excavated in the spring of 1972. Yinqueshan Tomb 1 yielded 4,942 inscribed bamboo strips and strip fragments that have proved to be of tremendous value for the study of early Chinese military thought. When pieced together, some of them corresponded to portions of several extant books, including *Sunzi's Art of War* (*Sunzi bingfa*), the *Six Strategies* (*Liu tao*), the *Weiliaozi*, and *Guanzi*. Others seem to belong to lost chapters of some of these same works, and still others represent hitherto unknown materials. While some of the texts found in the tomb deal with divination and even canine physiognomy, the majority are clearly works of military theory. This, and the fact that the tomb contained no weapons, has led to speculation that its occupant was a military administrator rather than a general. An inscription on a lacquer cup suggests that he may have been surnamed Sima, and coins found in the tomb indicate that the burial took place between 140 and 118 BCE.

The texts themselves must have been copied somewhat earlier, most likely during the first half of the 2nd century BCE. The characters are in the clerical script (*lishu*) mandated by the Qin dynasty and inherited by Han, but still show the influence of the earlier seal script (*zhuanshu*). The individual bamboo strips, each bearing a line of text, were arranged side by side and joined with cords to form a chapter or sequence of chapters that could be rolled up for storage with the inscribed side facing inward. The chapter title was often written on the reverse (outward-facing side) of the outermost strip for easy reference, and the bundle was unrolled from right to left as it was read. Although the Yinqueshan bamboo strips were in disarray and had suffered considerable damage by the time of their discovery in 1972, such that it has not been possible to reconstruct any of the books in its entirety, their publication has contributed enormously to our understanding of China's early military thought. The recovery of significant portions of the *Six Strategies* and *Weiliaozi* from Tomb 1 has, for example, demonstrated

those books' antiquity and laid to rest the suspicions expressed by many scholars since the Northern Song period that the received editions included in the *Seven Military Classics* (*Wujing qishu*) collection are later forgeries. The recovery of portions of the thirteen chapters of *Sunzi's Art of War* has not only made it possible to resolve some discrepancies between the different editions in circulation today, but has also demonstrated that the contents of the thirteen chapters have changed very little since the Western Han period (although the order of the chapters was different then).

Perhaps the single most exciting aspect of the Yinqueshan find was the discovery of several hundred bamboo strips and fragments belonging to the lost *Sun Bin's Art of War*, whose existence was last attested in a catalogue of the Han imperial library compiled in the first century. One of the two bamboo strips (cat. no. 17-1) in this exhibition is assigned to the reconstructed "King Wei's Questions" chapter, which takes the form of a dialogue between the book's putative author, the fourth-century BCE strategist Sun Bin, and his master, the ruler of the state of Qi. In the passage written on this strip the subject of discussion is one of the perennial concerns of Chinese strategy, the means by which to defeat a more powerful or numerous adversary. King Wei asks whether there is a way of attacking an enemy whose strength is ten times that of one's own force, and Sun Bin replies that there is, if one attacks where the enemy is unprepared and travels by an unexpected route. Both the concept and the language echo *Sunzi's Art of War*, pointing to the strong element of continuity in early Chinese military thought.

The other bamboo strip (cat. no. 17-2) comes from "Questions of Wu," one of five lost chapters of *Sunzi's Art of War* found in Tomb 1 at Yinqueshan. This chapter is presented as a dialogue between the ruler of the southeastern state of Wu and the great strategist Sun Wu (or Sunzi), who, according to Sima Qian's *Historical Records* (*Shiji*), was active in the service of Wu around 500 BCE. The topic is the politics of the state of Jin, which has fallen into the hands of the leaders of six great families. The king of Wu asks which of these families will perish and which survive, and Sunzi bases his answer on their economic policies. On this particular strip, the strategist predicts that the Zhao family will be the last one left standing because its light taxation and restraint in government spending would win the people's loyalty by making them prosperous. The dialogue format of this chapter sets it apart from the core thirteen chapters of *Sunzi's Art of War*, raising the possibility that it was written some-

what later than the thirteen chapters (which some scholars place as early as the first half of the fifth century BCE). Its ideas, resonating with Confucian writings such as those of the philosopher Mencius, underscore the point that Chinese military theory is not limited to the conduct of battles and campaigns but has always concerned itself with statecraft in the broadest sense.

DG

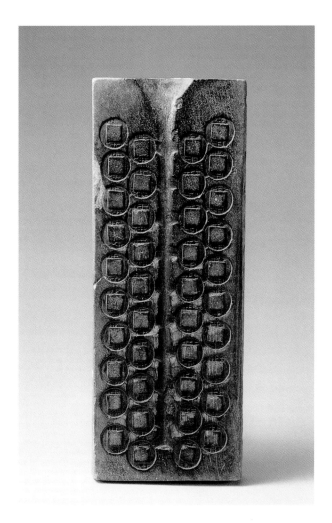

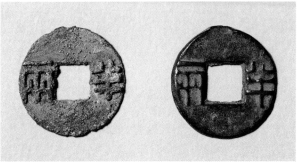

18. Mold for *banliang* coins (four *zhu*)

漢　四銖半兩錢石範
Han dynasty (206 BCE–220 CE)
Stone; H. 7.3 cm, W. 10.8 cm, D. 2.4 cm
Excavated from Linqu
Collection of Shandong Provincial Museum

Banliang coins

四銖半兩錢
Han dynasty (206 BCE–220 CE)
Bronze; Diam. (average) 2.3 cm
Collection of Shandong Provincial Museum

A variety of different coinage was in use in ancient China until the First Emperor of China unified the currency during the Qin dynasty with the *banliang* ("half-ounce" or four *zhu*) coin, which was round with a central square hole. This standardization of coinage was part of a broader plan to consolidate political and administrative power that included standardizing weights and measures (see cat. nos. 20, 21) as well as axle widths to make countrywide communication more effective. The *banliang* coins typically weigh between ten and six grams. In 118 BCE a new coin type, the *wuzhu* (five *zhu*) coin (cat. no. 19), was introduced by the Han emperor Wudi (r. 141–87 BCE). The *wuzhu* coin weighed on average 3.5 grams and remained in circulation for over seven hundred years. In contrast to Western coinage, which was most often stamped and where the intrinsic value of the metal content generally created the value of the currency, Chinese coins were cast with metal of little value. Value was imparted by a fiduciary relationship between issuer and user, the inscription on the coin in effect transforming the object into one of value. Although the bronze and, later, copper metal of coins had little intrinsic value, bronze was itself a signifier of importance in ancient Chinese rituals, as seen in such ritual bronze vessels as the *ding* (cat. no. 4) in our exhibition. During the Warring States period and continuing through the Han dynasty, replicas of money produced in clay as well as miniature coins began to be placed in tombs.

To make coins like those in our exhibition, ceramic master molds would have been used to make the secondary molds—usually of ceramic, stone, or metal, as we see here. Molten bronze was poured into the upper channel of this secondary mold and would then flow into the offshoots of this casting tree.[1] The mold would then be broken open and the resulting "coin tree" removed. The connecting metal would be broken off,

filed down, and reused, and the coins put into circulation. During the Eastern Han dynasty the repertoire of financial resources within a tomb expanded with the introduction of bronze money trees whose branches were laden with *wuzhu* coins. It is thought that the idea for creating them came as a result of seeing coin trees during the casting process. This mold in our exhibition would have cast forty *banliang* coins, and our other coin mold (cat. no. 19) would have cast twelve *wuzhu* coins.

SLB

1. Metal molds, such as for our *wuzhu* coins (cat. no. 19), would have been backed with a disposable earthenware mold, which aided in gas absorption, and the two would have been secured with iron clamps along the two brackets on the back of the secondary mold. The mold in the exhibition, however, does not have brackets. For more details on the technology of coin mold casting see Anthony Barbieri-Low's discussion in Liu et al., *Recarving China's Past*, nos. 60–63. For more information on money trees during the Eastern Han dynasty, see Susan N. Erickson's essay in the same publication, as well as Susan N. Erickson, "Money Trees of the Eastern Han Dynasty," *Bulletin of the Museum of Far Eastern Antiquities* 66 (1994), pp. 1–116.

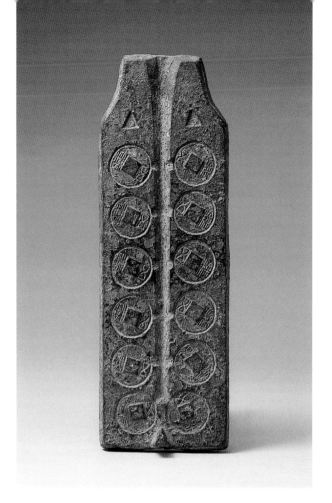

19. Mold for *wuzhu* coins
漢　五銖錢銅範
Han dynasty (206 BCE–220 CE)
Bronze; H. 22.7 cm, W. 7.7cm, D. 0.9 cm
Excavated from Cangshan
Collection of Shandong Provincial Museum

Wuzhu coins
五銖錢
Han dynasty (206 BCE–220 CE)
Bronze; Diam. (average) 2.6 cm
Collection of Shandong Provincial Museum

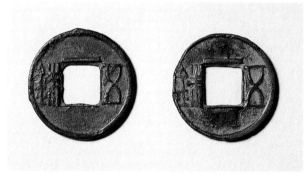

In tombs of the Han dynasty, we often find either real or imitation coinage.[1] Clearly the purpose of these coins was cosmological as well as monetary.[2] Round coins with a square center hole are viewed as cosmic maps, imaging the relationship between the round heaven and the square earth, whereby the deceased could ascend to paradise. For this reason, bronze trees laden with *wuzhu* coins are sometimes called *shengxianshu*, "immortal ascension trees," rather than *yaoqianshu*, "money trees."[3] Impressions of *wuzhu* coins are often found in clay tomb tiles such as our directional tiles (cat. nos. 46–50), which came from the walls of an Eastern Han tomb at Linyi. *Wuzhu* coins are also depicted in the center and corners

of the *liubo* game in our exhibition (cat. no. 7), again linking this coin with immortality as well as with divination. The name *wuzhu* itself indicates why there is an abundance of such coins in tombs.[4] From a more practical point of view, the *wuzhu* coins had another function. As the bureaucracy of the afterlife began to replicate that of the mundane world, coins in tombs enabled the deceased to pay taxes to the underworld government without causing misfortune to their living relatives.[5] In ancient China, even if you could avoid death and achieve immortality, you still had to pay taxes.

SLB

1. Mawangdui Tomb 1 yielded two types of clay imitation coinage: *banliang* coins and Chu *yingcheng* ingots. There were 300 imitation *yingcheng* ingots and 40 containers of imitation *banliang* coins, each

container holding approximately 2500–3000 coins. All the imitation coins were called *tuqian* (dirt cash) on the tomb inventory records. Hunan sheng bowuguan et al., *Changsha Mawangdui yihao mu*, vol. 1, p. 126; and ibid., vol. 2, p. 198, plate 226 (*banliang*); p. 220, plate 254 (*banliang*); p. 197, plate 227 (*yingcheng*); and p. 220, plate 255 (*yingcheng*).

2. In the 123 years after 118 BCE, when *wuzhu* coins first came into use, more than twenty-eight billion coins were cast. Lien-sheng Yang, *Money and Credit in China: A Short History*, Harvard-Yenching Institute Monograph Series 12 (1952; repr. Cambridge: Harvard University Press, 1971).

3. Zhang Maohua, "Money Trees Explained," *China Archaeology and Art Digest* 4, no. 4 (April-May 2002), pp. 20–21.

4. Susan Erickson discusses the term *wuzhu* in the context of a cosmic pillar that acts as a conduit to heaven. On the long side of a stone coffin excavated from Eastern Han Tomb 3 at Guitoushan, Jianyang county, Sichuan province, there are depictions of creatures associated with heaven, such as a dragon (see cat. nos. 43, 44), *liubo* players (see cat. no. 7), and the deities of the sun and moon. Below the sun and moon, there is a small tree and an inscription that reads *zhushu*. The *zhu* is a vertical support or pillar mentioned in the "Tian wen" of the *Chuci*, where the question is asked: "Where did the eight pillars (*zhu*) meet the sky?" Similarly in the *Shanhaijing* it is noted that the *zhu* (trunk) of the *fusang* tree is 300 *li* tall. The *fusang* tree is an auspicious symbol associated with the journey to immortal realms. The character *shu* is a measure of weight, but it is also pronounced *zhu* and is used in the word for *wuzhu* coin. Erickson extrapolates that since this tomb also contained a branch of a money tree with a *wuzhu* coin, that this image of a tree below the sun and moon may refer to pillars like the money tree that act as conduits to heaven. Erickson, "Money Trees of the Eastern Han Dynasty," pp. 31–32.

5. Mu-chou Poo, *In Search of Personal Welfare: A View of Ancient Chinese Religion* (Albany: SUNY Press, 1998), p. 170. Also see Anna Seidel, "Tokens of Immortality in Han Graves," *Numen* 29 (1982), p. 111.

20. Measure with edict of the First Emperor of China, 221 BCE

秦　秦詔陶量

Qin dynasty (221–207 BCE)
Clay; H. 9.2 cm, Diam. (mouth) 20.5 cm
Excavated 1963 from the old city at Zhuguo, Zoucheng County
Collection of Shandong Provincial Museum

In the year 221 BCE, after many years of subjugating competing kingdoms, Qin Shihuangdi succeeded in uniting China and proclaimed himself the First Emperor. As part of his political consolidation, Qin Shihuangdi unified the language, making the small seal script of his former kingdom of Qin the standard for the empire. According to the *Shiji*, the First Emperor collected all the weapons of his enemies and melted them down to make bells. He also embarked upon a series of sacred processions throughout his empire,[1] ascending the sacred mountain peaks of his newly conquered subjects and erecting stone stelae which pronounced his political and spiritual claim to the throne in the newly adopted Qin seal script.[2] The first five of seven stelae were erected on sacred mountains in what is present-day Shandong province. On Mount Langye near the east coast of Shandong, his stelae inscription reads:

Everywhere under vast heaven
He [Qin Shihuang] unifies the minds and integrates the wills.
Vessels and implements have their identical measures,
One uniformly writes the refined characters.[3]

The standardization of weights and measures, as well as of axle widths, and the redefinition of pitch standards for musical instruments were acts of the First Emperor's economic, political, and social integration of the empire through its communication and bureaucratic tools.[4]

This ceramic measure was made according to the new regulations of the First Emperor. Stamped on the side of the measure is an edict dated to the twenty-sixth year of Qin Shihuang, 221 BCE, the year he unified China. The entire edict is mentioned in the historical chronicles. Here, the forty-character inscription is in twenty columns. It proclaims that the First Emperor makes measures for all the lords under the heavens to create great peace, and furthermore, pronounces the standardization of measures. The measure holds one peck.[5] On the base is stamped the location of the workshop where it was made, Zou, which is today's Zoucheng county. The sacred Mount Yi is also located in Zoucheng in southern Shandong, and the First Emperor made his political pilgrimage there in 219 BCE to erect one of his stelae.

SLB

1. The tour of inspection was an ancient rite whereby a new king tested the acceptance of his sovereignty throughout the county. Through this rite, a part of the emperor's consolidation of power and a mark of his legitimacy, Heaven, ancestors (past generations), and all people (current and perhaps also future generations) acknowledged him as ruler. The First Emperor was embarking on this tour to establish himself as the legitimate successor to the sage rulers of antiquity.
2. Mark Edward Lewis states that "In placing these inscriptions in the newly conquered eastern states, the First Emperor completed his conquest by inscribing the reality of his power, in the newly created imperial script, into the sacred landscape of his new subjects." Mark Edward Lewis, *Writing and Authority in Early China* (Albany: State University of New York Press, 1999), p. 339.
3. Martin Kern, *The Stele Inscriptions of Ch'in Shih-huang: Text and Ritual in Early Chinese Imperial Representation*, American Oriental Series 85 (New Haven: American Oriental Society, 2000), p. 27.
4. These three standardizations as well as the unification of the language were all undertaken in the same year. The adoption of the small script characters of the state of Qin, began the process of standardization of the language which continues into this century.
5. Qiu Guangming, *Zhongguo lidai duliang hengkao* [History of China's Weights and Measures](Beijing: Kexue chubanshe, 1992), pp. 200–201, no. 103.

21. Edict of Second Emperor of China, 210 BCE

秦　秦二世元年詔版
Qin dynasty (221–207 BCE)
Bronze; L. 9.9 cm, W. 7 cm
Excavated in Jinan in front of the
 Shandong Provincial Library
Collection of Shandong Provincial Museum

The First Emperor of China, Qin Shihuangdi (r. 221–210 BCE), died in 210 BCE after unifying the country in 221 BCE and consolidating his power. His son ascended the throne at age twenty-one and ruled briefly (r. 210–207 BCE) until Liu Bang, later known as the founding emperor Gaodi, helped defeat the Qin and established the Han dynasty, which was to remain in power for over four hundred years. In 209 BCE, the Second Emperor tried to emulate his father by making a royal pilgrimage to climb the same peaks as his father and thereby link their names for eternity (see cat. no. 20). He traveled to all the stelae erected by his father and had their sides inscribed with supplementary records, in particular naming the officials who had originally accompanied the founding emperor.[1] The *Shiji* relates how at Mount Kuaiji he added inscriptions to the stele that the First Emperor had earlier set up. The inscription reads:

> The emperor said: "These inscriptions on metal and stone were all made by the First Emperor. Now we have succeeded to the title of emperor, but since the inscriptions of metal and stone do not contain the words 'First Emperor,' there is a danger that after a long time has passed it may appear as though the inscriptions were made not by the First Emperor but by one of his later heirs, and this will not serve to praise his merits and accomplishments and his outstanding virtue."[2]

The bronze in our exhibition is cast with an edict from the first year of the Second Emperor's reign and exemplifies his attempts to enhance his own power and authority by association with the political hegemony of his father. The inscription, which is seven columns long, states that the Second Emperor decreed the standardization of measures following the actions of the First Emperor to reinforce the administrative and political unification of the country (*fa duliang jin* Shihuangdi *wei zhi*). It is one of the most important artifacts to shed light on the administrative controls and processes of the Qin government.

This plaque, now missing the top left section, was discovered during the construction of the Shandong Provincial Library in the capital city of Jinan. It has three extant extensions at the corners to attach it to another object. There is a very similar bronze of the same shape, but in a slightly larger size, in the collection of the Royal Ontario Museum. It is cast with the same edict and similar calligraphy, but with a different division of characters in the vertical columns.[3] The ROM bronze is slightly convex and has similar extensions at the four corners.[4]

SLB

1. Kern, *The Stele Inscriptions of Ch'in Shih-huang*, p. 4.

2. Sima Qian, *Records of the Grand Historian: Qin Dynasty*, translated by Burton Watson (New York: Renditions/Columbia University Press, 1993), pp. 64–65.

3. The ROM bronze is in the Bishop White Collection, no. 931.13.195. Its dimensions are 10.6 x 8.1 x 0.25 cm. Its four extensions at the corners measure 1.7 cm wide and 0.6 cm high, and the perforations measure 0.45 cm in diameter at the front and 0.1–0.2 cm at the back. The object is convex with the highest point raised about 0.9 cm. Its text is identical but the division into vertical columns different: 7 columns of on average 9 characters, except the last column, which has 6 characters. The ROM bronze is not missing the top left section as in the bronze from Shandong. My appreciation to Klaas Ruitenbeek, Curator, Asian Art, ROM, for providing me with the above information.

4. The archaeological metals conservator at ROM has studied their piece and believes that it was attached to an iron object. Iron corrodes preferentially, thus protecting the bronze and explaining why the ROM bronze is in pristine condition.

22. Green-glazed dog

東漢　綠釉陶狗

Eastern Han dynasty (25–220 CE)
Clay with green glaze
H. 40.2 cm, L. 40 cm
Excavated from Donggu River, Gaotang
Collection of Shandong Provincial Museum

The green-glazed ceramic dog stands, ferocious, with his toes poised for movement and his legs bent. Head and ears alert, he appears to strain forward either to hear his master's command or to protect his master's tomb from disturbance. His eyes are deep-set with large eye sockets extending down to his jowls. He bares his fangs menacingly. His harness is twisted behind his neck and wraps around the body behind his front legs. His large, upturned tail coils inward. There is a similarly posed green-glazed dog with bared fangs and open mouth in the collection of the Palace Museum, Beijing, but it is smaller, stands flat-footed, and has a tiny tail and ears curved forward. Its disposition is much less animated and its body less articulated than the dog in our exhibition.[1]

The association of dogs with heavenly prognostications is found in one of the silk manuscripts excavated from Tomb 3 at Mawangdui (ca. 168 BCE). Entries on the manuscript concern the oracles of the clouds, and they relate specific animals to military augurs. Next to a depiction of a cloud in the shape of a dog it states: "if this appears over the city wall it will not be taken."[2]

The apotropaic properties of the dog in Chinese religion, with regard to burials, go back to the Shang dynasty. In cross-shaped Shang tombs, a dog was often buried in the central hole at the bottom of the pit. This dog has been compared to the Manchurian psychopomp dog who guides souls to the Mountain, dwelling place of the ancestors.[3] The dog as vatic icon is confirmed in texts such as the *Fengsu tongyi*, in which Ying Shao describes the custom of anointing

doorways with the blood of a white dog to ward off evil.[4] The *Zhouli* documents that when the ruler was in mourning, a dog-skin carpet was placed on the funerary chariot. The dog's role as guide for the deceased and guardian of the tomb is given in the famous text excavated from the late Warring States or Early Qin dynasty tomb at Fangmatan near Tianshui, Gansu province.[5] According to the bamboo slip manuscripts excavated from Tomb 1, a man named Dan killed himself after stabbing a man in Yuanyong Village; he was buried and three years later (297 BCE) was released from his tomb by the underworld authorities to return to the world of the living. Dan's patron in the living world, Xi Wu was convinced that Dan "was not yet fated to die" and initiated legal proceedings on his behalf, seeking Dan's return to life. The declaration was made to the underworld magistrate Scribe of the Director of the Life-mandate, Gongsun Qiang, who then had a white dog dig up the pit to let Dan out. Dan stood

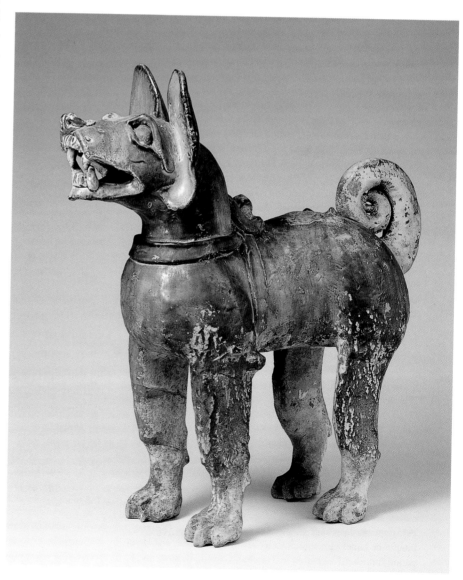

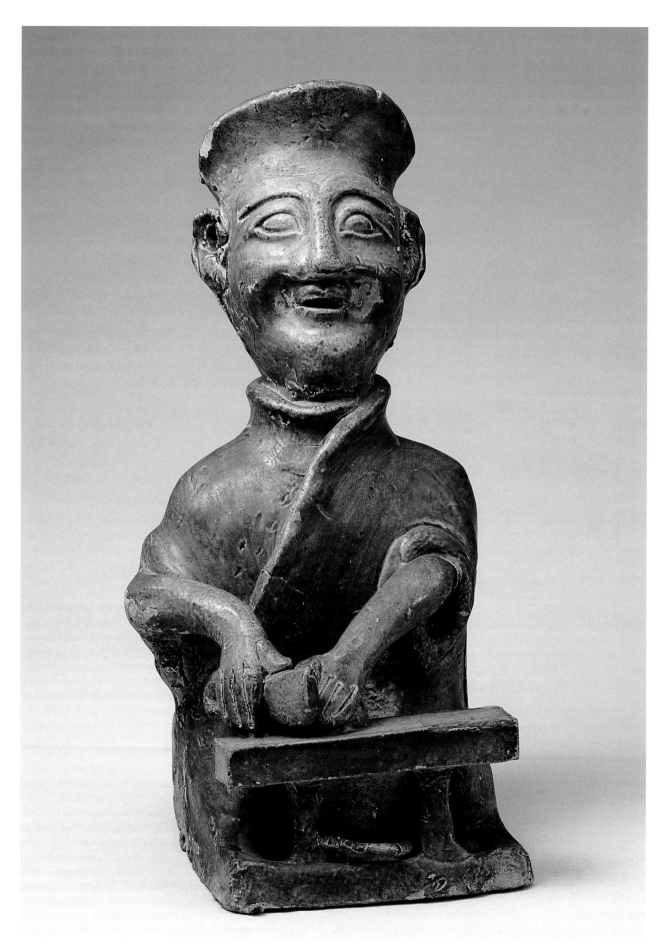

25. Green-glazed stove
東漢　綠釉陶灶
Eastern Han dynasty (25–220 CE)
Clay with green glaze; H. 38 cm, L. 39 cm, W. 30 cm
Excavated from Donggu River, Gaotang
Collection of Shandong Provincial Museum

Models of stoves, both in bronze and ceramic, were popular during the Han dynasty but became rare in later periods. Our stove is quite unusual for its large size. A rectangular opening, surrounded by incised decoration, was placed on the side of the stove for inserting the fuel. The body serves as a firebox and the smoke would have vented through the long, curving chimney opposite the opening.[1] On the top surface of the stove body are three circular openings covered by vessels. The two shallow pans would have held food for cooking. The deep basin typically would have had a grating so the upper section could be used as a steamer. Some models of stoves are also accompanied in the tomb by figures of chefs, as is the case in our exhibition (cat. no. 24).[2]

The ceramic stove in our exhibition would have been used by the model chef to prepare the delicacies most favored by our tomb occupant in the afterlife. Our knowledge of food preparation in the Han dynasty is quite rich. An actual stove would have risen to waist height.[3] The "Neize" chapter (Guide to the Domestic Virtues) of the *Liji*, written in the first century BCE, provides details of the ingredients, preparation, and presentation of the cuisines of the elite.[4] Tombs 1 and 3 at Mawangdui provide archaeological evidence for the text. These tombs, which date from 186 to 168 BCE during the early Western Han dynasty, were excavated in Changsha, Hunan province. Tomb 1, belonging to the matriarch of an aristocratic family, Lady Dai, was particularly well preserved because it had been lined with clay. Her body was also in good condition; it was revealed that she had died at the age of fifty with back problems and perhaps gastric ailments, as melon seeds were found in her stomach. Tomb 1 contained forty-eight bamboo baskets of prepared meats and fruit, and fifty-one ceramic containers, mostly filled with food, as well as sacks of cereals, vegetables, and rice. The preferred meal of Lady Dai was laid out on lacquered dishes with chopsticks ready to be consumed, with bamboo slips identifying each dish. Comparable information was also found in Tomb 3, which was occupied by her son.

SLB

1. This stove is similar in form to known examples of bronze stoves in the shape of turtles. In those stoves, the body of the creature represented the firebox, and the curving neck, head, and mouth formed a chimney to vent the smoke. For an example of a bronze stove in the shape of a turtle see, Liu et al, *Recarving China's Past*, cat. no. 19.

2. The same ceramic group of chef, stove, dog, and chicken were excavated from Tomb 1 located in Hebei province at Yujia Village in Qianan District. Qianan District Cultural Protection Institute, "Hebei Qianan Yujiacun yihao Hanmu qingli" [Summary of no. 1 Han tomb at Yujia village, Qianan district, Hebei province], *Wenwu*, no. 10 (1996), p. 36, fig. 19, nos. 3 (chef), 8 (stove), 10 (chicken), and 11 (dog), also shown in pp. 37–39. Also found in the same tomb were a ceramic well and a ceramic incense burner (*boshanlu*).

3 . Colin Mackenzie in Annette Juliano and Judith Lerner, *Monks and Merchants: Silk Road Treasures from Northwest China* (New York: Harry N. Abrams, Inc. with The Asia Society, 2001), p. 85, no. 19a.

4 . Michele Pirazzoli-t'Serstevens, *The Han Dynasty* (New York: Rizzoli, 1982), pp. 50–52. For more information on the tomb of Lady Dai see Hunan sheng bowuguan et al., *Changsha Mawangdui yihao Hanmu*. In addition to the food found in her tomb, there were also bamboo cases filled with garments and silk fabrics, eight containers of herbal medicine, and musical instruments, some of which have markings indicating their tone scales.

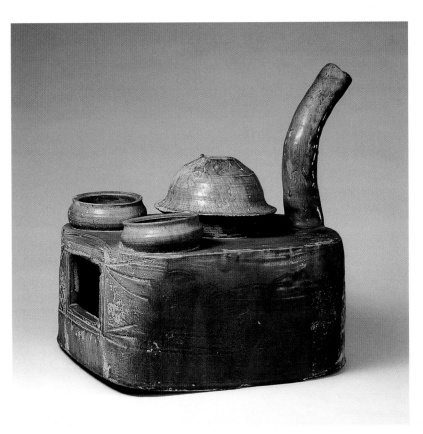

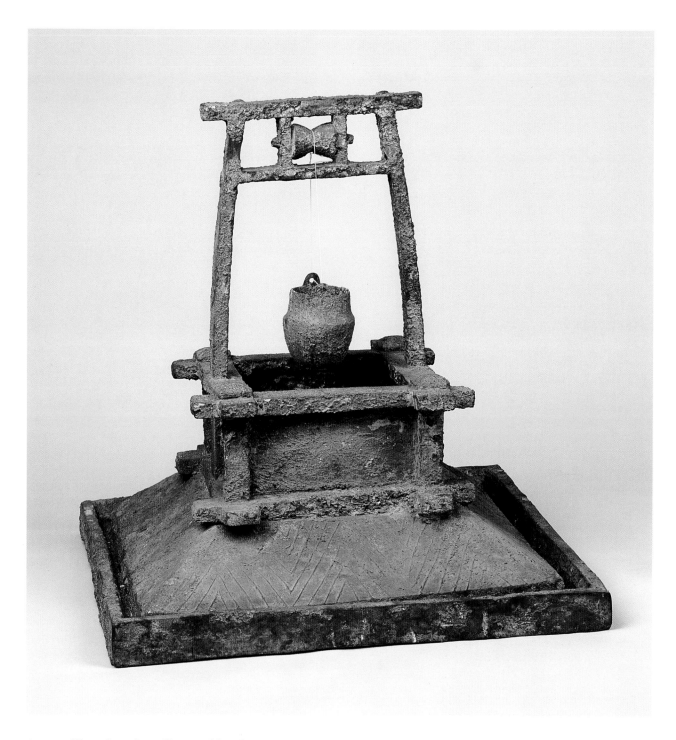

26. Wellhead with pulley and bucket

東漢　銅水井（附水桶）
Eastern Han dynasty (25–220 CE)
Bronze; H. 49.5 cm; W. (square base) 48 cm
Unearthed 1969, Jining City Park
Collection Shandong Provincial Museum, Jinan

By the Eastern Han dynasty, tomb contents reflected the importance of agriculture to the economy and preserved for the next world the routines of daily life in an agrarian land-owning society. Tomb chambers often contain clay models of pigsties, pigs, goat pens, goats, chickens, dogs, lamps, farmhouses, watchtowers, granaries, grain mills, stoves, and wellheads. Clay models of wellheads were both popular and varied during the Han. There were two basic types. The first, probably the most common, consisted of a rectangular base with stamped decoration on four sides; it usually had a wooden superstructure, lost over time, which once supported a clay gabled roof and was sometimes mounted with a pulley system for raising and lowering a bucket. The second type was a cylindrical wellhead with a superstructure to support a circular roof and pulley system, and an occasional rooster standing on top.[1] Inventive and lively vari-

ations of decorative subjects and elements, such as a toad sitting on the rim of a well, occurred within these two categories.

This is a very rare cast bronze model of a wellhead, complete with an elaborate base. The square wellhead sits on a pyramid-shaped platform with a trough between the sloping sides and the outer rim of the square base; thin raised lines create a zigzag pattern on the sides of the platform. Although square, the wellhead has the basic form of a typical Han rectangular clay wellhead that has been translated into bronze. At each corner of the wellhead, the rims intersect and extend outward beyond the square of the well, creating a cross; the intersection is marked by the raised square top of the vertical post; the bottom edge of the well also has extended intersecting flat beams.[2] The four recessed outside walls of the well are undecorated. The superstructure supports a winch or pulley that would hoist the bucket; the surviving bucket has a deep, rounded form and an indented rim with two handles pierced with holes for a rope.

The construction of this bronze model, as well as the clay examples, suggests that the actual wellheads were originally constructed of wood. To date, no other bronze wellhead of this size and weight has been found.

AJ

1. A number of publications and catalogues about the Han dynasty and clay *mingqi* are available. Certainly, the pioneering analysis of clay *mingqi* was done by Ezekiel Schloss in *Art of the Han* (New York: China House Gallery, 1979) and in his major work, *Ancient Chinese Ceramic Sculpture from Han Through Tang*, 2 vols. (Stamford, Ct.: Castle Publishing Co., Ltd., 1977). Rectangular wellheads are illustrated in Schloss, *Art of the Han*, pp. 36–37 and a cylindrical one on p. 38. For an example of a rectangular wellhead with modern wooden posts to support the clay roof see *Kaikodo Journal 9* (Hong Kong: Kaikodo, 1998), pp. 136–37, no. 50; see also Schloss, *Ancient Chinese Ceramic Sculpture*, p. 233, for examples of wellheads that were painted in late Han and early Six Dynasties (5th century) tomb walls.
2. For a clay example with crosses at the corners of the wellhead on the top rim but not at the bottom, see Schloss, *Art of the Han*, p. 36, no. 12.

27. Lady with vessel on her head
西漢　彩繪頂水罐女陶俑
Western Han dynasty (206 BCE–9 CE)
Clay with pigments; H. 22.3 cm
Excavated 1978 from Jinqueshan, Linyi Municipality
Collection of Linyi Municipal Museum

The lady stands slightly bent, with her hands discreetly tucked in the sleeves of her robe. On her head she balances a yellow water vessel whose base is the same size as the top of her head. Neither her face nor body are well articulated, but she has a pleasing demeanor with dark

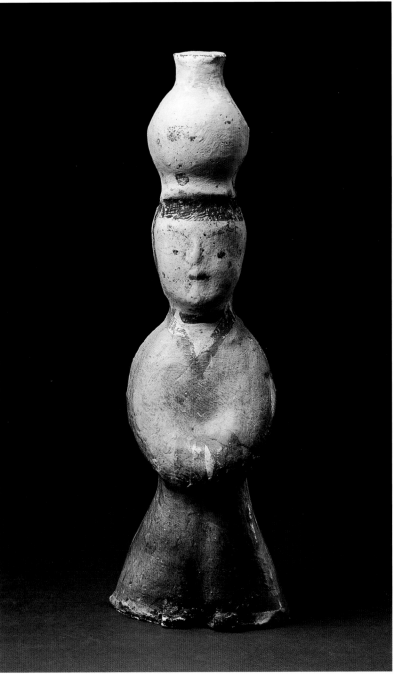

pupils to indicate her eyes, wide nose, and broad eyebrows drawn high on her forehead. Her small mouth is painted red-brown and echoes the shape of her nose. Her double chin contours the base of her chubby face. She wears a necklace of the same color as her lips. Her blue robe, the fronts lapped left over right across the chest, drapes over her ample form and hangs down to the floor with her black shoes peeking out from below the bottom hem. This is a rare example of a tomb figure carrying a water vessel in this manner.

SLB

28. Chariot fitting—yoke saddle ornament, *ejiao*

西漢　鎏金銅軛角（三號車）
Western Han dynasty (206 BCE–9 CE)
Gilt bronze; H. 4.4 cm, L. 8.5 cm,
Excavated 1996, No. 3 chariot, Shuangrushan,
　　Changqing County
Collection of Changqing County Museum

During the Han dynasty, processions of chariots shaded by parasols or occasionally by canopies were among the most popular subjects painted, stamped, or carved on the walls of tombs and shrines.[1] Often accompanied by riders on horseback, chariots with parasols in particular seem to gallop across the walls of tombs housing high-ranking nobles and officials. Although the rise of cavalry in the fourth century BCE reduced their role in warfare, chariots retained their importance as indicators of rank and wealth.[2] A third-century BCE poetic description of the affluent early Chinese metropolis of Linzi in Shandong

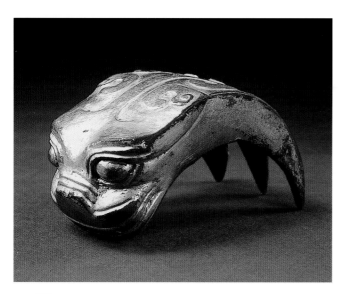

characterizes the populace as enjoying the luxuries not only of chariots, but also of musical instruments, fighting cocks, and games of dice and soccer; the streets of Linzi were "so choked with chariots that the hubcaps struck against one another."[3]

Life-size chariots and their horses were often buried with the dead of noble or royal rank, thus continuing to confer status after death; this practice began in the Shang and continued through the Han dynasty. Chariots shaded with parasols appeared in graves as early as the Western Zhou but became more prevalent around the late sixth to early fifth century BCE and were increasingly popular in the Qin (221–206 BCE) and Han (206 BCE–220 CE) dynasties. These were the most lavishly embellished vehicles, with elegant fittings of gilt bronze (cat. nos. 28, 31, 39–44) and gold and silver inlay (cat. nos. 29, 30).[4] Unmistakable symbols of wealth and status, these chariots not only maintained the luxurious lifestyle of the deceased but were also thought to carry him on his final journey to the land of the immortals.

Examples of chariot fittings as well as other grave goods from at least two Western Han rock-cut royal tomb sites in Shandong, one at Shuangrushan, Changqing county (see p. 1, fig. 1), and the other at Jiulongshan in Qufu county, are included in this exhibition.[5] Shuangrushan Tomb 1 remained undisturbed until its excavation, preserving over 2,000 burial items, including life-size one-two-and four-horse chariots along with a half-size chariot and a miniature one. The following four gilt bronze and inlaid chariot fittings, catalogue nos. 28 through 31, come from the surviving chariot burials at Shuangrushan. At Jiulongshan the four royal tombs contained some twelve life-size chariots and the remains of fifty horses as well as several miniature chariots. The site yielded four of the gilt bronze chariot fittings in the exhibition (cat. nos. 39–44).

This small gilt bronze ornamental fitting is shaped like a fantastic arched animal. At the front, its head has a flat pig-like snout with two raised ridges across the top and two bulging eyes accentuated by two raised ridges: one forms an eyebrow and the other, the edges of the eyelids. This second ridge continues along the side to the top of the head, where it is transformed into low-relief bands that become curled horns. Another band runs between the horns, along the animal's arched back, and ends in a T-shape. The body ends in a tail shaped as three large saw-teeth.

Called an *ejiao*, literally "yoke horn," this ornamental fitting was placed at the curved ends of the yoke saddle that was fitted around the horse's neck (for diagram

of chariot parts, see appendix 1).[6] The head of this fantastic creature resonates with the same energy as the heads on the bronze lamp- or iron-stand (cat. no. 10) and on the large stone striding *bixie* that guarded the spirit roads approaching tombs. Fittings and stone sculpture alike were invested with apotropaic power to protect the deceased and to ward off evil. A very similar fitting was excavated from the late second-century BCE Western Han tombs of Prince Liu Sheng and Lady Dou Wan at Mancheng, Hebei.[7] A slightly different gilt bronze *ejiao*, with an open loop in the center and no saw-tooth tail, was excavated from the Western Han tombs at Jiulong-shan, Qufu county (cat. no. 40).

AJ

1 . There seem to be two major styles of chariots visible on the walls of the Wu family shrines. One has a parasol or umbrella covering the driver and occupant. The second has what is perhaps technically a canopy because it is anchored to the chariot box by four poles; sometimes this type of canopy occurs with a chariot that has a three-sided enclosure for the occupants. See Wu Hung, *The Wu Liang Shrine: The Ideology of Early Chinese Pictorial Art* (Stanford, Calif.: Stanford University Press, 1989), p. 57, fig. 30, and the complete set of rubbings of the Wu Family Shrines in the catalogue by Liu et al., *Recarving China's Past* (forthcoming). Ceremonial processions of chariots and riders on horseback form an important and integral part of the imagery carved on the stone slabs of the Wu family shrines in Shandong. See also the detail of a chariot procession in a tomb painting from Anping county, Hebei province, published as a copy in Wong, *Treasures from the Han*, p. 13. These are among the many representations of chariot processions in Han tombs.

2. See Anthony J. Barbieri-Low, "Wheeled Vehicles in the Chinese Bronze Age (c. 2000–741 B.C.)," *Sino-Platonic Papers* 99 (February, 2000), pp. 1–98, 8 color plates, for a thorough and valuable discussion of the development of chariots in Bronze Age China.

3. See Lawton, *Chinese Art of the Warring States Period*, p. 15.

4. Apparently, the impression of a wooden parasol survived in an early Western Zhou chariot pit at Liulihe in Beijing, but evidence of cast bronze parasol or canopy fittings did not appear until the Eastern Zhou dynasty. Parasols were not necessarily fixed permanently to the chariot; they could be removed or hand-held. See Colin MacKenzie, "From Diversity to Synthesis: New Roles of Metalwork and Decorative Styles during the Warring States and Han Periods," in *Inlaid Bronze and Related Material from pre-Tang China* (London: Eskenazi, Ltd., 1991), p. 10. See also Jenny F. So's entry discussing the bronze cylinder fitting for a chariot canopy inlaid with gold and silver in *Miho Museum, South Wing* (Shiga: The Miho Museum Catalogue), no. 108, p. 212.

5. For the tombs and chariot burials excavated from Shuangrushan, Changqing county, see three articles in *Kaogu*, no. 3 (1997), pp. 1–9, 26, 4 plates; pp. 10–15; and pp. 16–26. *China Archaeology and Art Digest* 2, no. 1 (Jan.–March, 1997), contains a summary of the *Kaogu* article (pp. 16–26), mentioned previously, which focuses on the restoration and study of a chariot from Tomb 1. The excavation report of the Jiulongshan tombs in Qufu county was published in Shandong sheng bowuguan, "Qufu Jiulongshan Hanmu fajue jianbao" [Brief excavation report of the Han tomb at Jiulongshan, Qufu],

Wenwu, no. 5 (1972), pp. 39–54; and after p. 64, back cover, figs. 1–6.

6. See Barbieri-Low, "Wheeled Vehicles," Table 2: Translation of Key Technical Terms for Chinese Chariotry, p. 86.

7. Zhongguo shehui kexueyuan kaogu yanjiu suo and Hebei sheng wenwu guanli chu,*Mancheng Hanmu fajue baogao* [Report of the Han Tombs Excavated at Mancheng] (Beijing: Wenwu chubanshe, 1980), vol. 2, plate 223:3.

29. Chariot fittings—four rings
西漢　鑲金銀銅環（一號車）
Western Han dynasty (206 BCE–9 CE)
Bronze with gold and silver inlay; Diam. (outside)
　3.5 cm, Diam. (inside) 1.8 cm
Excavated 1996, No. 1 Chariot, Shuangrushan,
　Changqing County
Collection of Changqing County Museum

As noted earlier, not all chariots were lavishly decorated. Only those with parasols or canopies, reserved for individuals of exalted rank, received fittings of gilt bronze and gold and silver inlay. Occurring in smaller numbers than open chariots, these richly ornamented vehicles appear mostly in tombs of rulers, nobles, and high-ranking officials, reinforcing the ceremonial function of the chariot as well as its role as an emblem of wealth and power.

These four small rings are associated with the chariot discovered at the southern end of the tomb ramp in Tomb 1 at Shuangrushan. Although the chariot was badly damaged, most of the basic components were still in place, and the original form of this chariot has been reconstructed.[1] However, it is not clear where these four exquisitely inlaid rings were originally positioned on the chariot. The four flat rings show a highly stylized undulating landscape scroll articulated in silver inlay and inhabited by a myriad of lively animals, both real and fantastic, including celestial cranes, deer, dogs, and rabbits; the landscape scrolls are reminiscent of Han cloud scrolls transformed by adding fringes of vegetation to indicate the tops of hills. The appearance of these real and fantastic animals in landscape was considered auspicious; such a depiction was believed to enhance the possibility of their appearing in actuality and also made reference to the fantastic realms of the immortals. This type of imagery, therefore, proliferated in the Han dynasty; it is found on the *boshanlu* (cat. no. 9) in this exhibition as well as on other chariot fittings, particularly the cylinder from the canopy of a chariot.[2]

The inlaid forms visible on these four small rings reflect the elegance and fluency of the brush. The dynamic

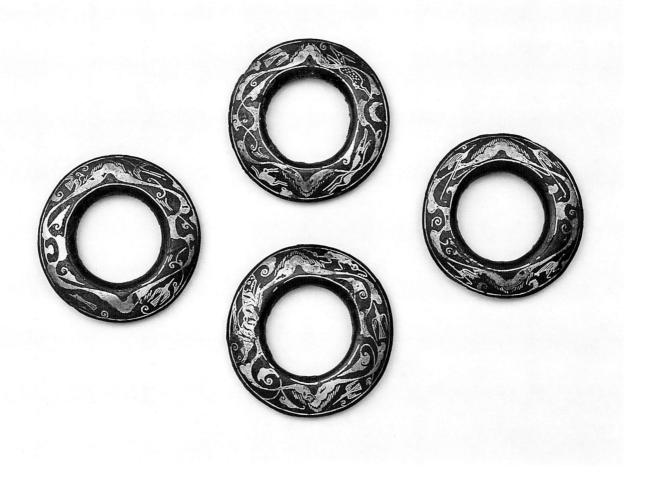

curvilinear forms of inlay developed in the late Warring States period, around the fourth to the third century BCE, were inspired by the popularity of the painted lacquers of south China.[3]

AJ

1. See Cui Dayong's discussion of the reconstruction in his article, "Shuangrushan yihao Hanmu yihao mache de fuyuan de yanjiu" [The restoration and study of the no. 1 chariot from the no. 1 Han tomb at Shuangru Hill], *Kaogu*, no. 3 (1997), pp. 16–26. For a short summary of the article, see *China Archaeology and Art Digest* 2, no. 1 (Jan.-Mar., 1997), pp. 64–65.
2. William Watson, *The Genius of China: An Exhibition of the Archaeological Finds of the People's Republic of China* (London: The Royal Academy, 1973), no. 173; *Miho Museum, South Wing*, p. 212. Another example of a cylinder with an elaborate landscape but without the original inlay is included in the 2005 exhibition at Princeton, *Recarving China's Past* (forthcoming).
3. See So, "The Inlaid Bronzes of the Warring States Period," pp. 305–320. A similar bronze ring with a repeated T-pattern and contrasting gold and silver inlay was published by Eskenazi, Ltd, *Inlaid Bronze and Related Materials from pre-Tang China* (London: Eskenazi, Ltd, 1991), no. 22, p. 66.

30. Chariot fitting—rein guide, *yi*

西漢　金銀鑲嵌銅軑
Western Han dynasty (206 BCE–9 CE)
Bronze with gold and silver inlay; Diam. (outside)
　　6 cm, Diam. (inside) 4 cm
Excavated 1996, No. 1 Chariot, Shuangrushan,
　　Changqing County
Collection of Changqing County Museum

This solid bronze ring, called a *yi*, has been flattened along one segment of its outer circumference, creating a flat oval base that allows the ring to be attached at a right angle to parts of the chariot to channel the reins from the horse to the driver in the chariot box.[1] These rings are usually positioned on the yoke bar at the base of the horse's neck and in the center of the support across the front of the chariot box (for diagram of chariot, see appendix 1). With these guides or channels, the reins can run from the horse's head to the yoke bar and chariot box without getting caught, obstructed, or tangled, permitting the driver to steer.

　　The ring, beautifully inlaid with gold and silver, shows fluent curvilinear designs combining tight spirals,

scrolls with whimsical animal-like attributes, and undulating bands with curled hooks. The design is arranged symmetrically as mirror images on either side of the ring with the center placed just opposite the flat base and marked by two curled bands and tight spirals. The spiral cluster repeats as the bands curl, uncurl, and overlap on the ring. These designs have the same painterly fluency, inspired by fourth- to third-century BCE painted lacquer patterns from south China, as the four inlaid rings (cat. no. 29) discussed earlier. [2]

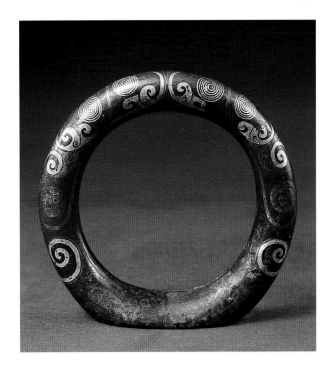

AJ

1. For the term *yi*, see Barbieri-Low, "Wheeled Vehicles," Table 2, p. 89.
2. Warring States mirrors from the 4th to 3rd century BCE also show similar painterly fluency. See Chou, *Circles of Reflection*, nos. 5–8, pp. 27–29.

31. Chariot fitting—parasol spoke ornament, *gaigong*

西漢　鎏金銅蓋弓

Western Han dynasty (206 BCE–9 CE)
Gilt bronze; L. 12.8 cm; D. 1.3 cm
Excavated 1996, No. 2 Chariot, Shuangrushan,
 Changqing County
Collection of Changqing County Museum

As discussed previously, chariots with parasols or canopies are powerful symbols of wealth and rank. Rulers, nobles, princes, and high-ranking officials used these vehicles in life and in death, choosing to have their chariots, complete with lavish fittings and horses, interred in their tombs. The twenty-two gilt bronze caps that had been preserved in the royal tombs excavated at Shuangrushan were used to cover and to embellish the end of the spokes that supported the parasol (see appendix 1). All twenty-two are identical.

Each small cap was designed as a four-petaled flower; a circle, which rises in the center, is inhabited by a seated bear articulated in relief. The four petals have been positioned directly

opposite each other, symbolically pointing north, south, east, and west, directions that are further emphasized by the pointed shape of each petal. The four cardinal directions plus the center position were fundamental to Chinese cosmology. Their role became more formalized by the end of the Han, when they were represented by fantastic and real animals—the Green Dragon of the East, the Red Bird of the South, the White Tiger of the West and the Black Warrior (Tortoise and Snake of the North)—as seen on the post-Han pottery tiles in the exhibition (cat. nos. 46–49). The interior of each petal is bifurcated by an incised line flanked on each side by a raised spiral. In contrast to the fantastic feline or leonine

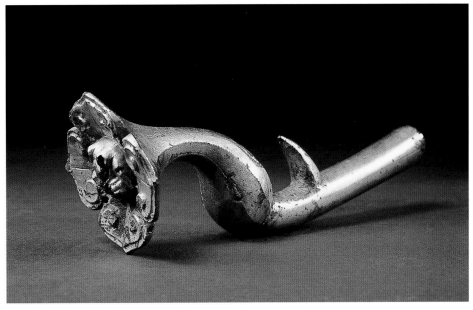

73

creatures depicted on the stand (cat. no. 10), chariot fitting or *ejiao* (cat. no. 28), and the crossbow fitting (cat. no. 32), this animal resembles a sitting or squatting bear, with a long tapered snout, pointed ears, furry head, round belly, and large claws. Similar animals ornament bronze objects found in the tombs of Liu Sheng and Dou Wan at Mancheng, Hebei.[1]

AJ

1. Zhongguo shehui kexueyuan, *Mancheng Hanmu fajue baogao*, vol. 2, plate 233:5, 6.

32. Crossbow fittings

西漢　鎏金銅承弓器

Western Han dynasty (206 BCE–9 CE)
Gilt bronze; H. 11.2 cm, L. 24.2 cm
Excavated 1996, near No. 2 Chariot,
　　Shuangrushan, Changqing County
Collection of Changqing County Museum

This is one of two pairs of crossbow fittings excavated from Tomb 1 at Shuangrushan.[1] The rectangular hollow sockets taper into the elegantly curving neck of a fantastic feline-like head. Raised ridges along the edges of the long neck enhance the transition and give the neck a stronger definition.

Until the 1972 discovery of a crossbow alongside a chariot in the Warring States horse pit at Zhongzhoulu at Luoyang in Henan, these fittings were commonly thought to belong to chariots.[2] It appears that these pairs of fittings may have "actually functioned as part of a crossbow and were meant to hold a bow."[3] Also inlaid with gold and silver, the pair found at Luoyang are similar in form to this pair but have more serpent-like heads.[4] Another two pairs of crossbow fittings were found, one inlaid and the other gilt bronze with inlaid stones, in the tombs of Liu Sheng and Dou Wan at Mancheng, Hebei. They are very similar in shape, including their feline-like animal heads, to this pair from Shuangrushan.[5] Variants of this kind of feline or leonine head, clearly belonging to auspicious and protective creatures, become ubiquitous in the Han dynasty, appearing on the large stone *bixie* that guard tombs and on smaller objects such as jade belt hooks, bronze lamp supports (cat. no. 10), and a jade pillow from Shuangrushan (cat. no. 35).[6]

AJ

1. See Susan Beningson's essay "Spiritual Geography" in this catalogue for a discussion of the Shuangrushan site as well as two other Western Han sites.
2. See Luoyang bowuguan, "Luoyang Zhongzhoulu Zhanguo chemakeng chutu tongqi" [The chariot pit found at Zhongzhoulu, Luoyang], *Kaogu*, no. 3 (1974), pp. 171–78.
3. See Lawton, *Chinese Art of the Warring States Period*, pp. 65–67 for an extended discussion of the crossbow and its origins, as well as the paired fittings.
4. Luoyang bowuguan, "Luoyang Zhongzhoulu," plate 3:4. Another similar pair was found in a Warring States tomb, 4th or 3rd century BCE, at Yongji, Shanxi; Watson, *The Genius of China*, no. 127, pp. 94–95.
5. Zhongguo shehui kexueyuan, *Mancheng Hanmu fajue baogao*, vol. 2, plates 135, 136.
6. See the feline head on the end of the pillow published in the Shuangrushan brief excavation report, Shandong daxue kaogu xi et al., "Shandong Changqing xian," plate 2:3.

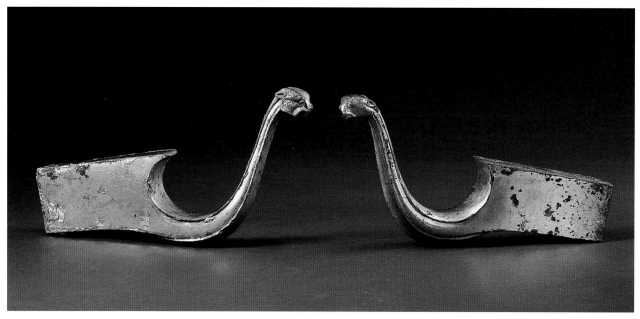

33. Gold ingots

西漢　金餅（齊王銘）

Western Han dynasty (206 BCE–9 CE)
Gold; Diam. 6.3 cm and 3.2 cm
Excavated 1996, Shuangrushan, Changqing County
Inscription (larger ingot): *ji wang*
Collection of Changqing County Museum

These two gold ingots (*jin bing*) of different size were among the twenty found in the royal tomb of Liu Kuan (r. 97–87 BCE), the last ruler of the Jibei Kingdom (Jibei *guo*) during the Western Han dynasty (reign of Emperor Wudi). Its capital city, Lu, was thought to be five kilometers north of the tomb at today's Luchengwa. Of the twenty gold ingots found in the tomb, nineteen were of the larger dimension. A gold button, the only other gold object found in the tomb, was located at the waist of the interred, while the gold ingots were found placed next to his head on the jade pillow (cat. no. 35). The exact location of the gold ingots in the tomb can be seen in Beningson, "Spiritual Geography," fig. 2, in this catalogue. On the reverse side of the larger of the two ingots included in this exhibition is incised the two characters *ji wang*, "king of Ji," indicating that the deceased was the king of the Jibei Kingdom, or perhaps a marquis per the excavation report. Seven other of the large ingots have the character *wang*, and the remaining have no inscriptions. Large button-ingots like these were worth 10,000 cash in the Han period.[1] A small number of bronze *wuzhu* coins, similar to those in our exhibition (see cat. no. 19) were also found in the tomb. The twenty gold ingots weigh more than 4260 grams, and although fewer in number, their total weight exceeds that of the coins found in two lavish tombs located at Dingxian and Lingshan at Mancheng in Hebei province.[2]

Similar gold *bing* ingots were also excavated in 1961 from the Western Han tomb at Dongtaibao village near Taiyuan, Shanxi province. That tomb dates from the second year of the reign of the emperor Han Wudi (95 BCE). Some of those gold discs were inscribed with the character for "good fortune" (*ji*) and more than ten other characters.[3]

Recent excavations have revealed that gold *bing* ingots circulated in the Qin state during the Eastern Zhou dynasty.[4] After Qin Shihuang unified China in 221 BCE, gold was legal tender in the newly established empire. Ingots like these were sometimes cut into pieces and circulated during the Western Han dynasty. Gold currency was also cast in the form of horses and unicorn (*qilin*) hooves (see cat. no. 50). During the Eastern Han dynasty, gold *bing* ingots were hoarded and gold rarely circulated. In addition, the rise of Buddhism saw gold primarily used to cast religious statues and to prepare sutras.

SLB

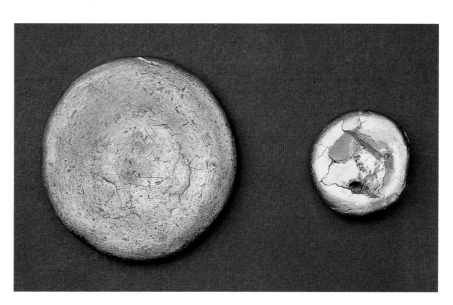

1. Ren Xianghong, "Shuangrushan yihao mu muzhu kaolue," p. 12.
2. *Ibid*. The tomb at Mancheng had 40 gold ingots (*jin bing*). See Zhongguo shehui kexueyuan, *Mancheng Hanmu fajue baogao*, vol. 1, p. 207 and vol. 2, fig. 159.
3. There were five gold ingots (sometimes called "biscuits") found in the Dongtaibao tomb; the three smallest measure 5 cm each, the next two largest measure the same as our ingot, 6.3 cm, and the largest measures 6.4 cm. The weight of the five gold ingots totaled 245 grams. They are all the same shape as our gold ingots, except that the outer rim on those is more pronounced than on ours. All have sunken depressions in the center. Song Fusheng, *Shanxi sheng bowuguan cang wenwu jinghua* [Masterworks of the Shanxi Provincial Museum Collection] (Taiyuan: Shanxi People's Publishing House, 1999), p. 201, no. 360. These same gold ingots are also published in *Zhongguo wenwu jinghua da cidian*, p. 246, no. 19. The Shaanxi Provincial Museum in Xi'an also had a large group of gold ingots on display in June 2004. Their label stated that they comprised the largest group of these ingots yet found.
4. Li Zude, "A Preliminary Study of Qin and Han Gold Currency," English summary, *China Archaeology and Art Digest* 2, no. 1 (January-March 1997), pp. 146–47. The original Chinese article appeared in *Zhongguo shi yanjiu* [Journal of Chinese Historical Studies] (issued by History Institute, Chinese Academy of Social Sciences, Beijing), no. 1 (1997), pp. 52–61.

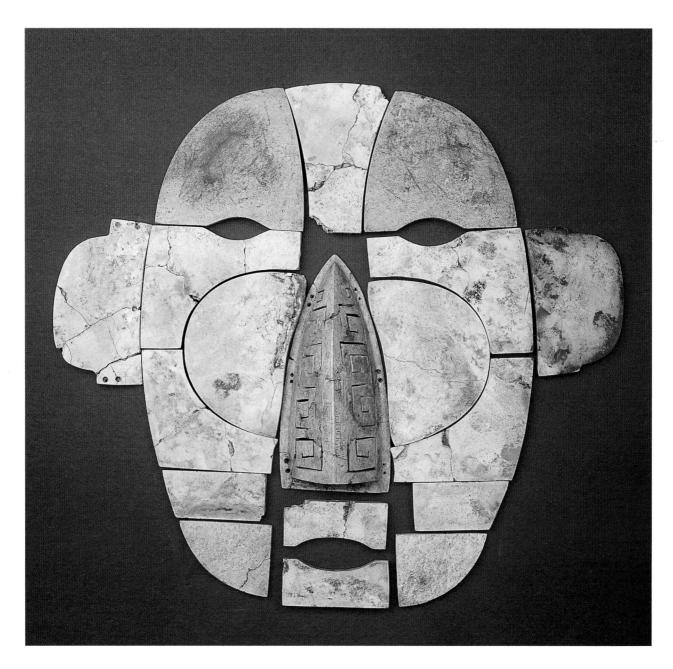

34. Face-cover

西漢　玉面罩

Western Han dynasty (206 BCE–9 CE)
Jade (nephrite); H. 20 cm, W. 23 cm
Excavated 1996, Shuangrushan, Changqing County
Collection of Changqing County Museum

This face-cover is made of eighteen small parts: three for the forehead, six for the cheeks, six for the chin and mouth, two for the ears, and one for the nose. Unlike other known examples, the eyes and mouth are not represented by individual pieces but instead by openings created by the curving sides of two adjacent pieces. The most unusual piece is the nose, which is carved from a triangular block of jade, hollowed out on the underside and decorated with openwork spirals. Two small holes are drilled into the

lower end to indicate the nostrils. The back and side-edges of each jade are pierced with small holes, by which they would have been sewn on a piece of fabric.

Jade face-covers appeared in China in the middle Western Zhou period. Among the jades excavated from a tenth-century BCE tomb at Zhangjiapo, Chang'an, Shaanxi province, archaeologists were able to identify the parts for the eye, eyebrow, and ear.[1] These jades also have small holes pierced on the back and side edges.

Archaeological finds suggest that the use of face-covers had become an established practice by late Western Zhou times. Examples from this period often have a large number of smaller pieces assembled around the edge of the cover, in addition to such essential components as eyes, nose, mouth, and ears. They were almost all made, either completely or partially, by recycling older

pieces, and in some cases, the eyes, nose, and mouth were made from jade ornaments that have corresponding shapes. Fragments with carved patterns on the surface were also used.

The use of face-covers seems to have become more extensive in the Eastern Zhou period, when stone was also used as substitutes for jade in burials of lesser significance.[2] During the Western Han period, face-covers appear to have been in decline but not completely discontinued, even after use of the jade suit grew to be the norm in burials of the elite class. Especially noteworthy among recent finds is a face-cover from Houloushan, Xuzhou, Jiangsu province, which is composed of 30 jade pieces, mostly rectangular and pentagonal in shape.[3] They are neatly fitted into five rows, forming a complete sheet of jade, resembling the head cover of a jade suit.

The custom of covering the face of the dead was not limited to early Chinese civilization; it has been found in many ancient cultures from Central Asia to the Mediterranean. The use of jade for the face-covers, however, was an exclusive Chinese practice that had to do with the esteem reserved for this special stone and the belief in its protective power.

ZS

1. Zhongguo shehui kexueyuan kaogu yanjiusuo, "Chang'an Zhang-jiapo Xi Zhou Jing Shu mu fajue baogao" [Excavation of the tomb of Jing Shu from the Western Zhou at Zhangjiapo, Chang'an], *Kaogu*, no.1 (1986), pp. 22–27.
2. Zhongguo kexueyuan kaogu yanjiusuo, *Luoyang Zhongzhoulu (Xigongduan)* (Beijing: Kexue chubanshe, 1959).
3. Li Yinde, "Xuzhou chutu Xi Han yu mianzhao de fuyuan yanjiu" [Study and restoration of the Western Han jade face-cover excavated in Xuzhou], *Wenwu*, no. 4 (1993), pp. 47–48.

35. Pillow

西漢　玉枕

Western Han dynasty (206 BCE–9 CE)
Jade (nephrite); H. 10.4 cm, W. 42 cm
Excavated 1996, Shuangrushan, Changqing County
Collection of Changqing County Museum

This pillow remained largely at its original location during excavation, thus allowing archaeologists to restore it without much difficulty. It is composed of fourteen jade pieces and a bamboo core. The upper section comprises eight small pieces and a large panel with engraved patterns and the lower section an undecorated baseboard. Between the two is a rectangular bamboo core. From each end of the pillow extends a large animal face with a broad nose, round eyes, and small ears. It is probably the face of a bear, a popular motif of the Han period. The pillow is supported on two short feet that are decorated with engraved scrolls.

To date all early examples of pillows are from the Han period, the earliest being that from a Western Han tomb

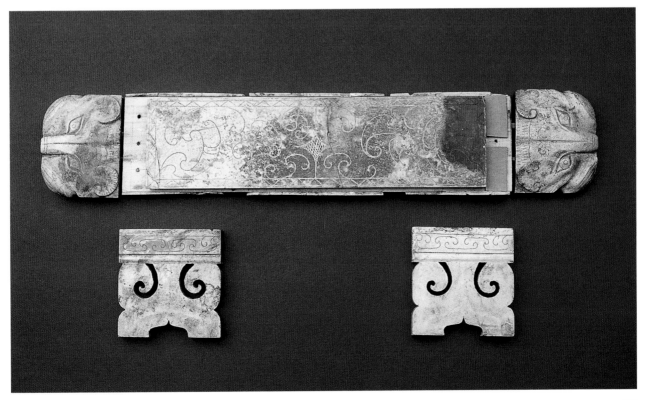

at Houloushan, Xuzhou, Jiangsu province.[1] This pillow, formed by four writhing dragons in gilt bronze, is the most ornate and most structurally complex among them. The upper side and the two ends are inlaid with jade dragons outlined with gold foil. A similar example, also made of gilt bronze and carved jade, was found in the tomb of Liu Sheng, king of the Zhongshan state of Western Han, at Mancheng, Hebei province.[2] Another well-known pillow is from the tomb of Liu Yan, a king of Zhongshan state in the Eastern Han dynasty, at Dingzhou, Hebei.[3] It is carved from a large block of green jade and densely covered with incised scrolls. The archaeological finds in general suggest that pillows were common in the burials of the Han dynasty and continued into later times. The use of jade in the pillows had to do perhaps not only with the display of the wealth and status of the deceased but also with the belief in the protective power of the stone.

ZS

1. Xuzhou bowuguan, "Xuzhou Houloushan Xi Han mu fajue bao-gao" [Excavation report for the Western Han tomb at Houloushan, Xuzhou], *Wenwu*, no. 4 (1993), pp. 40–43.
2. Zhongguo shehui kexueyuan, *Mancheng Hanmu fajue baogao*, vol. 1, pp. 78, 80–81.
3. Hebei sheng wenhuaju wenwu gongzuodui, "Hebei Dingxian Beizhuang Han mu fajue baogao" [Excavation report of the Han tomb from Beizhuang, Dingxian, Hebei province], *Kaogu xuebao*, no. 2 (1964), p. 143.

36. Two pigs
西漢　玉握
Western Han dynasty (206 BCE–9 CE)
Jade (nephrite); L. 10.4 cm, W. 2 cm
Excavated 1996, Shuangrushan, Changqing County
Collection of Changqing County Museum

This pair of reclining pigs are carved out of a rectangular block of jade. While the bulky bodies largely retain the shape of the stone, the carefully modeled snouts and gently dished ears have a realistic look. Deeply beveled cuts combined with light engraved lines describe their legs and trotters. The undersides of the pigs are completely flat.

Jade pigs were one of the most common tomb furnishings of the Han (206 BCE–220 CE) through Six Dynasties (265–589) period, their representation ranging from naturalistically descriptive to completely abstract. They are often called "hand warmers" since many were found in the hands of tomb occupants. In fact, their placement in hands did not become a general practice until the Eastern Han period, and they are also believed to be weights.[1] The meaning of such a tradition remains unknown, but because pigs were regarded as a symbol of wealth, it was probably desirable for the dead to hold them as they stepped into the afterlife.

ZS

1. Rawson, *Chinese Jade from the Neolithic to Qing*, pp. 319–20.

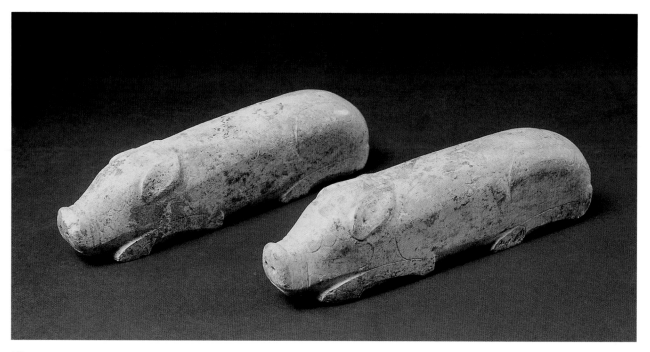

37. Plugs, cicada, and ring
西漢　玉九竅塞—耳塞，鼻塞，
　　　肛塞，口唅和陰罩
Western Han dynasty (206 BCE–9 CE)
Jade (nephrite)
Plugs a–e: L. 1.5–7 cm
Cicada: H. 3.8 cm
Ring: Diam. 7.4 cm
Excavated 1996, Shuangrushan, Changqing County
Collection of Changqing County Museum

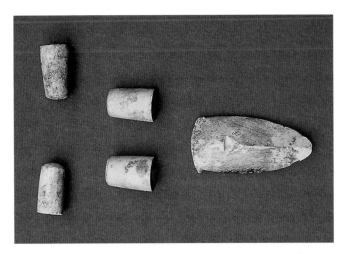

Small plugs that were used to seal the nose, ears, and anus of the dead are common among burial jades in the Han dynasty. They are in the shape of short cylinders gently tapering toward one end and usually undecorated. Two small cylindrical jades with simple carvings, in the British Museum collection, are likely the only known decorated examples,[1] but supporting evidence from archaeology has yet to be found.

The practice of placing small jades in the mouth of the deceased dates from the late Neolithic period. Jades used for this purpose include beads, rings or even small fragments that are apparently broken off from larger pieces. By the Han dynasty, the practice had become standard among elite burials and jade cicadas the most favored type for the purpose. Their representations range from fairly naturalistic to simply abstract. The present example is carved in a highly abstract style, with beveled sides forming the wings and two small projections suggesting the eyes. This reductionist approach is typical of the style of the time, which is also seen in many other jades.

Burial jades used also include eye and genital covers. Eye covers are usually flat pieces in the shape of an almond and with a small hole in the center. Genital covers do not seem to have a particular shape. The examples found in archaeology are of various shapes but were almost all made from older pieces. This ring, used as the genital cover in the Shuangrushan tomb, resembles closely those of prehistoric and early Bronze Age cultures and is likely to have survived from that period.

ZS

1. Rawson, *Chinese Jade from the Neolithic to Qing*, p. 318, no. 24.4.

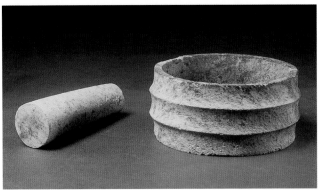

38. Disc (*bi*)
西漢　玉璧
Western Han dynasty (206 BCE–9 CE)
Jade (nephrite); Diam. 19 cm
Excavated 1996, Shuangrushan, Changqing County
Collection of Changqing County Museum

Large discs with relatively small holes in the center, commonly known as *bi*, are one of the principal jade types that had their origin in prehistoric China. The earliest ones were found in lavishly furnished tombs of the Liangzhu culture (ca. 3200–2000 BCE) in southern China. Their function in this Neolithic culture remains unknown, although given the rarity of the material and the tremendous amount of labor invested in their manufacture it is conjectured that they were probably symbols of wealth or objects used in rituals.

The discs seem to have gone into decline in the early Bronze Age: few examples have been found in tombs of the Shang and Western Zhou periods. An exception is the tomb of Fu Hao, a consort of a Shang king, which yielded a fairly large number of discs. But many of these discs were Neolithic rather than Shang in date. Of course, large jade discs were probably not meant to be buried. They were too valuable and were not necessarily personal possessions or adornments.[1]

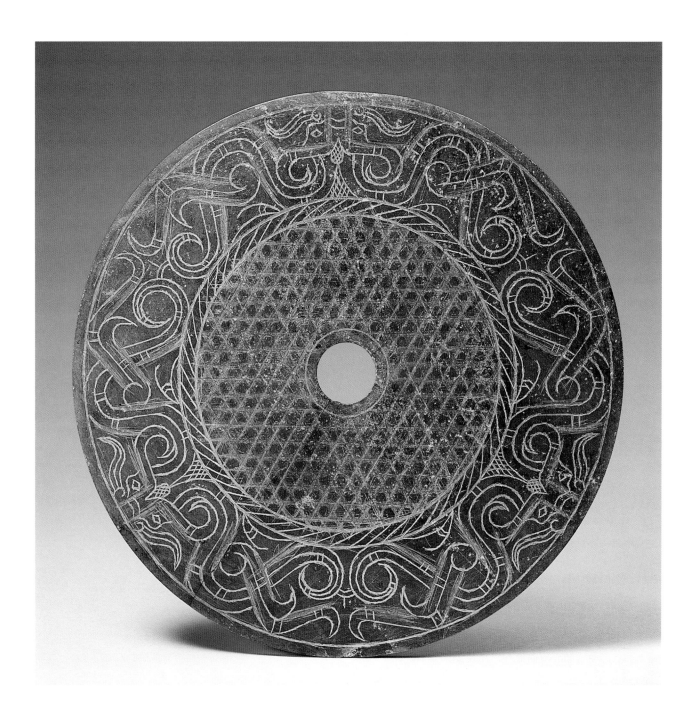

A revival of jade discs occurred in the late Eastern Zhou period, when they were placed on the chest and under the back of the deceased, suggesting that they were thought to have the power to protect the dead. At the same time a dramatic change in the decoration of the discs took place. Their surface was no longer plain but embellished with raised and engraved patterns. The most prevalent decorative motif of that period is the small curl in low relief, which in time developed into a pattern of small hexagons that continued into the following Han period.

The present example represents another distinctive style, which also developed in the late Eastern Zhou and became most popular in the Western Han period. It is decorated at the center with a pattern of small hexagons

arranged in horizontal and diagonal rows; this zone is encircled by an intertwined pattern formed by three animal heads and long scrolls. The decoration is executed in bold and dynamic cuts, affording the animal faces a strong sense of vigor. This design was ultimately derived from gold and bronze work of the Jin and Qin states in northwestern China, where the Chinese had their early contact with Central and West Asia through their nomadic neighbors.[2]

ZS

1. Rawson, *Chinese Jade from the Neolithic to Qing*, p. 248.
2. Ibid., pp. 60–69.

39. Chariot fitting—draught pole ornament, *yuan shou shi*

西漢　鎏金銅轅首飾

Western Han dynasty (206 BCE–9 CE)
Gilt bronze: H. 11cm, L. 17 cm, Thickness 11.5 cm
Excavated 1970, chariot and horse burial in
　Tomb 4, Jiulongshan, Qufu County
Collection of Shandong Provincial Museum

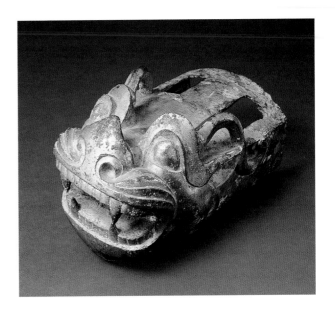

One of the most important parts of the chariot was the draught pole that connected the yoke bar at the base of the horse's neck to the axle of the chariot box. This fantastic, feline-like horned creature probably embellished the end of the draught pole near the horse's neck (see appendix 1). The partially hollow cylinder, open at one end, is pierced by two rectangular holes that probably helped secure this gilt bronze ornament to the draught pole; the other end is in the shape of a powerfully modeled, open-mouthed animal baring teeth and fangs. The feline monster's face is dominated by a large triangular flat nose, defined by two deeply set spiral nostrils and flanked by a ridged moustache, and two bulging eyes with thick stand-up eyebrows. Behind each eye, a horn forms an open loop, arching back, curving down to the side of the cylinder, and ending in a curl. This fierce bronze monster served to effectively repulse evil. A familiar creature in the Han dynasty, it is visible on many chariot ornaments in the exhibition (see cat. nos. 28, 40–42).

　Four royal rock-cut tombs of a smaller scale than Shuangrushan were found at Jiulongshan, or Nine Dragon Mount, in Qufu county, Shandong.[1] The four tombs contained a total of twelve chariots, each with a team of four horses, totaling 48 horses. Since the horses were buried alive as a sacrificial offering, the chariots sustained such severe damage that it was impossible to reconstruct them from the fittings and parts recovered.[2]

AJ

1. The short excavation report has been published by Shandong sheng bowuguan, "Qufu Jiulongshan Hanmu fajue jianbao," pp. 39–44, inside back cover.
2. Shandong sheng bowuguan, "Qufu Jiulongshan," p. 41.

40. Chariot fitting—yoke saddle ornament, *ejiao*

西漢　鎏金銅軛角

Western Han dynasty (206 BCE – 9 CE)
Gilt bronze; H. 4.4 cm, L. 8.5 cm
Excavated 1970, chariot and horse burial in
　Tomb 4, Jiulongshan, Qufu County
Collection of Shandong Provincial Museum

Echoing the *ejiao* from Shuangrushan (cat. no. 28), this yoke saddle ornament is in the shape of an arched animal with the same bulging eyes, flat nose, and horns. But this example has in addition a loop ring on the top of its head and does not have a saw-toothed tail. The hollow-cast ornament was placed over the curved ends of the

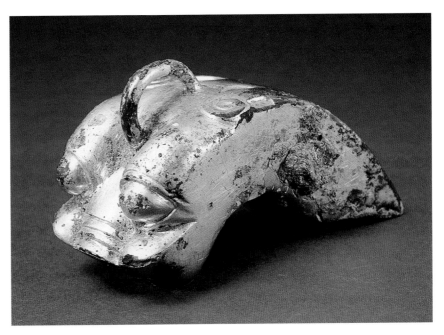

yoke saddle that fit over the horse's neck and supported the yoke bar (see appendix 1). A number of similar yoke saddle ornaments, both with and without rings, have been excavated from the tombs of Liu Sheng and Dou Wan at Mancheng, Hebei.[1]

The fantastic feline-like beast form appears on a number of objects in the exhibition and clearly was believed to be an exceptionally fierce guardian (see also cat. nos. 28, 35, 38, 39).

AJ

1. Zhongguo shehui kexueyuan, *Mancheng Hanmu fajue baogao*, vol. 2, plate 126:1, 2, 3.

41. Chariot fitting—axle ornament

西漢　鎏金獸面銅車飾
Western Han dynasty (206 BCE–9 CE)
Gilt bronze; L. 12.4 cm, Thickness 6.4 cm
Excavated 1970, chariot and horse burial in
　　Tomb 4, Jiulongshan, Qufu County
Collection of Shandong Provincial Museum

This plaque, articulated in high relief, depicts the typical Han apotropaic feline-like animal with a flat pig snout, deeply recessed curled nostrils, and a ridged moustache just above the teeth and fangs, where a horizontal line suggests clenched upper and lower teeth. Its two round bulging eyes seem to stare intently. A flat, plain rectangular piece of bronze without gilding, usually pierced with a small hole and found at the top between the ears, has been broken off.

Complete examples of this type of axle (*zhou*) ornament have been excavated from the tombs of Liu Sheng and Dou Wan at Mancheng, Hebei.[1]

AJ

1. Zhongguo shehui kexueyuan, *Mancheng Hanmu fajue baogao*, vol. 2, plate 226:1

42. Chariot fitting—yoke cross-bar ornament, *hengtong*

西漢　鎏金銅衡筩
Western Han dynasty (206 BCE–9 CE)
Gilt bronze; H. 8 cm, D. 4.5 cm
Excavated 1970, chariot and horse burial in
　　Tomb 4, Jiulongshan, Qufu County
Collection of Shandong Provincial Museum

A yoke saddle is placed over the horse's neck and connected to a horizontal cross-bar, called a yoke. The ornament *hengtong*, or *hengmo*, literally a yoke tube or tip, embellishes each end of the yoke bar.[1] This gilt bronze hollow cylinder has one open end that fits over the end of the yoke cross-bar (see appendix 1). At the closed end is a

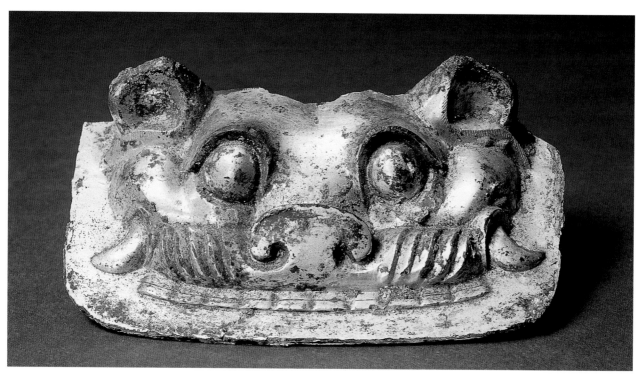

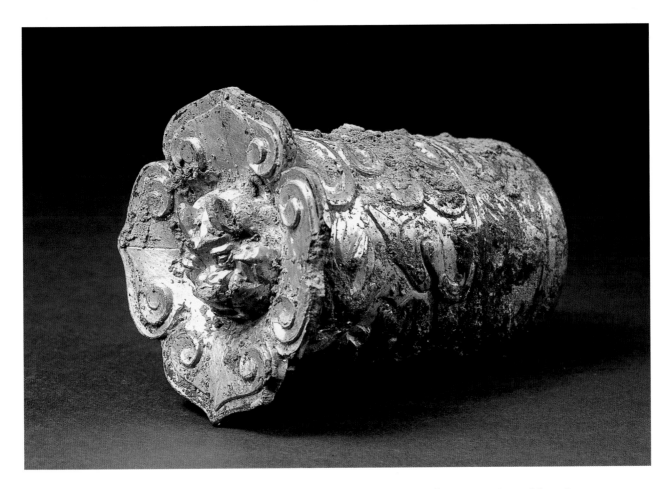

four pointed-petal flower oriented in the four directions; each petal is bifurcated by a line flanked by raised spirals. The radiating petals frame and emphasize a fierce bear-like creature articulated in higher relief on the raised circular center. The floral configuration of this yoke ornament is almost identical to that of the parasol spoke ornaments from Shuangrushan (cat. no.31). Crusted corrosion and patina covering the surface of the cylinder makes the relief decoration difficult to decipher. It is possible to see fragmentary parts of what seem to be sinuous body forms that the excavation report describes as a combination of *chi* dragons and floral patterns.[2] A *chi* is described as either a dragon-like creature that is yellow in color or a dragon that has not developed horns yet. Its body has feline characteristics, and the creature is sometimes referred to by its popular name, *chihu*, or "tiger."[3]

AJ

1. Barbieri-Low, "Wheeled Vehicles," Table 2, pp. 86–87.
2. Shandong sheng bowuguan, "Qufu Jiulongshan," p. 42.
3. See *Kangxi zidian, bantian* ed. (Hong Kong: Huaqiao cidian chubanshe, n.d.), shenjizhong, chongbu, shiyi hua, p. 17; and S. Howard Hansford, *A Glossary of Chinese Art and Archaeology* (London: The China Society, 1954), p. 15.

43. Chariot fitting—rein guide, *yi*

西漢　鎏金銅車軎
Western Han dynasty (206 BCE–9 CE)
Gilt bronze; H. 11.3 cm
Excavated 1970, Jiulongshan, Qufu County
Collection of Shandong Provincial Museum

Two dragons confront each other with their heads everted as they climb among the crevasses of a celestial mountain at the top of a U-shaped chariot fitting. Their sinuous S-shaped bodies weave over and under the luxuriant scroll of clouds and mountain peaks, ending at the base of the plaque. This fitting would have been mounted to the chariot's front, the reins passing through it in a fascicle.[1] The mountain might be a representation of Mount Kunlun (see cat. no. 44), and, as such, acts as a cosmic pillar to help the rider of this heaven-bound chariot reach the land of the immortals. The dragons' heads tilt upward as they raise their long hooked snouts menacingly into the air, their snouts resembling the mountain peaks. Their gaping mouths expose two fangs on top and bottom, and small beards accent their jawline. Their ears become part of the tall peak of the central mountain. A bear, clinging to the dragons between their necks, faces the viewer's

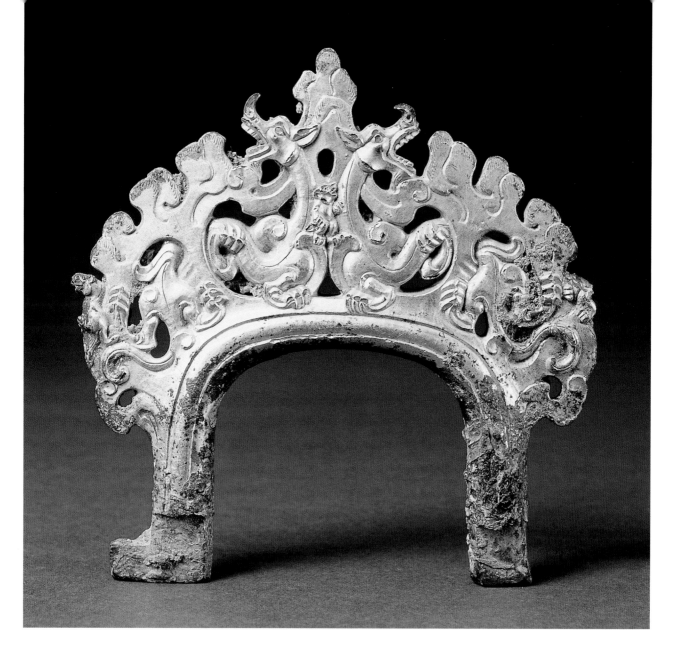

right. On the reverse side of the object, the imagery is identical except that the bear, located in the same position, is facing the viewer. The gilt bronze fitting is cast as a flat plaque with deep relief and an openwork design that animates the body of the dragons as they writhe through the mountain landscape. There are indentations where inlay may have been placed: on the dragons' claws as well as on the knuckles of the bear. Just as dragons are associated with the land of the immortals, so too are bears.[2]

The dragons on our chariot fitting resemble those on the lower section of a painting on silk that was placed on top of the coffin in Tomb 9 at Jinqueshan (Golden Sparrow Mountain), Linyi, Shandong.[3] Although the bottom of the Linyi banner is so damaged that we only see the dragons above the neck, they appear to have entwined bodies similar to those on the banner from Tomb 1 at Mawangdui. The Linyi dragons have their heads raised in the same position; their teeth and fangs are like those

on our chariot fitting, but their horn-like ears and extended tongues are more flame-like. Some undefined creature with horn-like protrusions on its head and a mouth like that of our bear scampers in the U-shaped well formed by the backs of the ears and arched heads of the dragons. On the Mawangdui banner the scaly bodies of the two entwined dragons unite the bottom sections of the composition, where the realm of the underworld is surmounted by the funeral of Lady Dai, with the upper section, where her portrait is painted before the gates to heaven. The dragons' bodies are tied together with a jade *bi* disc, while references to both jades and ritual bronzes punctuate the composition. Both the Mawangdui banner and the Linyi banner are thought to be cosmic diagrams, a map for the deceased to follow to heaven, with road markings en route. On our chariot fitting from Jiulongshan (Nine Dragon Mountain), the paired dragons intermingle with cloud essence (*yunqi*) to help the deceased on his

passage to eternity. Among the attributes of the dragon is its command over clouds, wind, and rain, a concern for which is integral to an agrarian society. A dragon chariot was the vehicle used to carry the King Father of the East (Dongwanggong) to the land of the immortals. More than just symbols of rank and status in both this world and the afterlife, the imagery on this gilt bronze reflects the intentions of the owner to be successful in his journey to Mount Kunlun.

SLB

1. Sun Ji discusses the rein guide in our exhibition in the context of the evolution of the shape of *yi* ornaments in chariots. During the Spring and Autumn period the *yi* was comprised of two O-shaped parts attached to the yoke bar for channeling reins. During the Warring States, this became a single round U shape. In the Western Han dynasty, the U shape became more square. Our *yi* is one of the more famous and elaborate chariot fittings. Sun Ji, *Zhongguo gu yu fu luncong* [Essays on Ancient Chinese Vehicles and Garments], rev. ed. (Beijing: Wenwu chubanshe, 2001), p. 47, fig. 3-20:6.

2. Bears are not very common in the pre-Han era, but from the time of Han Wudi through the rest of the dynasty they are often depicted on the sides of hill jars, incense burners, and other mortuary objects. They are often found in pictorial stone carvings in tombs and shrines including those from the Wu family cemetery in Jiaxiang county, Shandong province. Bears, as well as other exotic animals and plants, were gathered to create vast imperial hunting parks, which were microcosms of the universe. These hunting parks were mentioned in literature, including Sima Xiangru's rhapsodies, celebrating the glory and power of both the Han emperor and empire. During the Eastern Han dynasty, when the Great Exorcism ceremony was held at the imperial court, the chief exorcist of state performed the rites clothed in a bearskin with four eyes meant to ensure his all-round vision. The object of the ceremony was the expulsion of evil demons from home, court, and palace. For more on the Great Exorcism, see Loewe, *Divination, Mythology and Monarchy in Han China*, p. 45, and Derk Bodde, *Festivals in Classical China: New Year and other annual observances during the Han Dynasty* (Princeton: Princeton University Press, 1975), pp. 77–78, 81.

3. For more on the Linyi tomb see the excavation report: Linyi Jinqueshan Han mu fajue zu, "Shandong Linyi Jincuishan jiuhao hanmu fajue jianbao" [Brief excavation report of Han tomb no. 9 at Jinqueshan, Linyi county, Shandong province], *Wenwu*, no. 11 (1977), pp. 24–27. For more on the Linyi banner see Liu Jiaji and Liu Bingsen, "Jinqueshan Xi-Han bohua linmo hougan" [Later thoughts and copy of the Western Han cloth painting at Jinqueshan], *Wenwu*, no. 11 (1977), pp. 28–31, diagram 1 and line drawing 2. The line drawing is reproduced in Cary Liu's essay, "Embodying the Harmony of the Sun and the Moon," fig. 8.

44. Chariot fitting in the shape of a dragon
西漢　鎏金雕龍銅衡末飾
Western Han dynasty (206 BCE–9 CE)
Gilt bronze; H. 13.8 cm
Excavated 1970, Jiulongshan, Qufu County
Collection of Shandong Provincial Museum

This chariot fitting would have embellished one end of a yoke. It is in the shape of a roaring dragon, his head thrust back, prominent snout held high in the air, and mouth open with bared fangs and teeth. His body morphs into a celestial mountain with clouds, his legs and arms curling into the peaks and crevasses. The scrolling curvature of the mountain itself defines the contours of the dragon's body. Perhaps this is a representation of Mount Tai, in Shandong province, which was viewed as one of the main

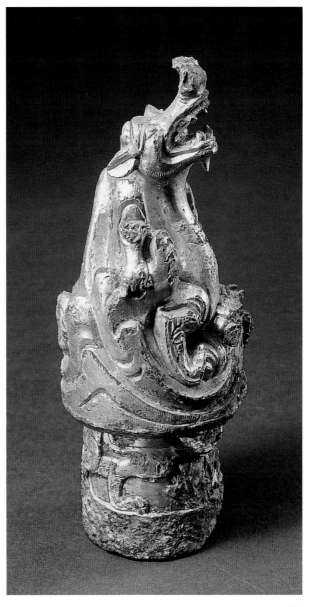

access routes to the spirit world of the immortals. It might also be Mount Kunlun, another peak with access to the heavens; this particular mountain acts as a cosmic pillar joining the earth to the heavens.[1] On one of the pillars in the late Eastern Han tomb at Yinan in Shandong, the peaks of Mount Kunlun are depicted as resting on the back of a dragon.[2] The imagery on this fitting as well as the chariot itself are embodied images (*tixiang*) which enhance the efficacy of celestial chariots to aid the deceased in his journey to the afterlife. This could also be a reference to dragon chariots which carry people to the land of immortals. One of the most important Han rhapsodies (*fu*) in the *Chuci* (Elegies of Chu) describes the magical journal of the emperor Han Wudi into the world of gods, spirits, and immortals. In the "Great Man Rhapsody" Sima Xiangru writes that a team of writhing, undulating dragons pulls his carriage across the sky:

> Winged dragons, inching and creeping along,
> 　　pull His ivory chariot;
> At the traces are red and black dragons, twist-
> 　　ing and turning.
> Flying low and high, they expand and contract,
> 　　proud and haughty;
> Bending and bowing, they leap up in a continu-
> 　　ous spiral...
> Riding the void, He rises into the distance;
> He transcends Non-being to subsist alone.[3]

SLB

1 . For more information on mountains as cosmic pillars see Erickson, "Boshanlu Mountain Censers," p. 16; Munakata, *Sacred Mountains in Chinese Art*, pp. 20–34; and Major, *Heaven and Earth*, pp. 154–60.
2. See my essay, in Liu et al., *Recarving China's Past*, cat. no. 29, for a discussion of tomb pillars as one form of *axis mundi* in tomb architecture. I discuss this in the context of a tubular chariot fitting which functions in similar fashion.
3. David R. Knechtges, "A Journey to Morality: Chang Heng's 'The Rhapsody on Pondering the Mystery'," in *Court Culture and Literature in Early China*, Variorum Collected Studies Series (Burlington, Vt.: Ashgate Publishing Company, 2002), pp. 169–71.

45. Pair of bridle ornaments (*jieyue*)

西漢　金鷹節約
Western Han dynasty (206 BCE–9 CE)
Gold; (1) H. 3.7 cm, L. 4.8 cm; (2) H. 3.5 cm, L. 4.7 cm
Excavated 1999, Luozhuang, Zhangqiu County, Jinan
Collection of the Jinan Municipal Museum

Each member of this remarkable pair of boldly modeled bridle ornaments from Luozhuang depicts a large raptor head with ears and a crest composed of three smaller raptor heads. Rows of short parallel lines incised on top of the large raptor head, inside the ear and under the eye, convey the texture of fur, hair, or feathers. The horse frontlet (cat. no.1, *danglu*) from the same tomb shows a fantastic horse with a mane that transforms into comparable eared raptor heads. This distinctive artistic vocabulary of eared raptor heads defines a style that appeared abruptly in western Inner Mongolia and northwest China

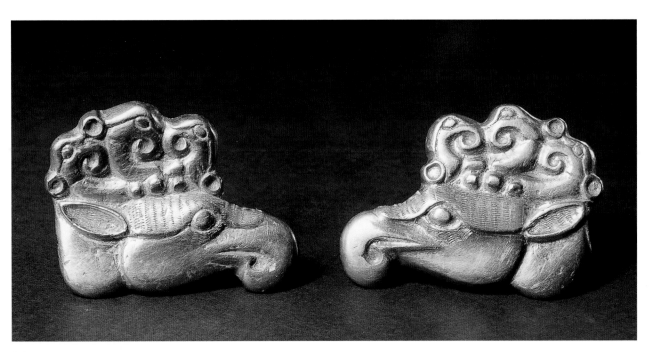

in the late fourth century BCE.[1] It is a new style associated with major horse-riding nomadic tribes of Indo-European heritage related to the Saka of Central Asia and the Scythians in southeastern Europe and carried to the far west by the Yuezhi or a subtribe called the Rouzhi. Reaching Gansu in the Ordos region in northwest China, this imported vocabulary came to adorn a new range of artifacts crafted from gold and silver, including riding bridle ornaments and chariot yoke ornaments.[2]

The establishment of the Han dynasty in 206 BCE also saw the rise of the Xiongnu nomadic confederacy, which conquered all the northern tribes including the Yuezhi/Rouzhi and created a steppe empire stretching along China's northern borders. The distinctive raptor-headed animals eventually lost favor as the visual symbolism shifted to the taste of the ruling Xiongnu, emphasizing greater naturalism and depicting real animals and human activities as well as a sinuous dragon-like animal. These gold bridle ornaments as well as the horse frontlet (*danglu*) could represent the continuation of this fantastic raptor-headed style into the late third century BCE. The other gold bridle ornament found at the Luozhuang site shows an eared raptor head in the slightly more naturalistic approach characteristic of the Western Han period but retaining the curved beak.[3] Whatever their dating, the bridle ornaments and frontlet probably came to Shandong as a result of the lucrative trade in luxury goods, largely gold and silver artifacts, between China and its northern neighbors. This trade actively began in the late fourth century BCE and continued through the Han dynasty.[4]

AJ

1. See Rawson and Bunker, *Ancient Chinese and Ordos Bronzes*, pp. 298–301, and Jenny F. So and Emma C. Bunker, *Traders and Raiders on China's Northern Frontier* (Seattle and London: Arthur M. Sackler Gallery, Smithsonian Institution and the University of Washington Press, 1995), pp. 57–59.
2. So and Bunker, *Traders and Raiders*, p. 58. Dating from the late fourth century BCE, one of the most stunning examples of this new vocabulary is the gold headdress shaped as a standing ungulate with antler tines and a tail that ends in eared raptor heads excavated from Nalin'gaotu, Shenmu county, Shaanxi. See Dai Yingxin and Sun Jiaxiang, "Shaanxi Shenmu xian chutu Xiongnu wenwu" [Relics of the Xiongnu excavated in Shenmu county, Shaanxi], *Wenwu*, no. 12 (1983), plate 4:1, and So and Bunker, *Traders and Raiders*, p. 56, fig. 20. Emma Bunker points out the similarity between this fantastic creature and the designs tattooed on the male body from Kurgan 2 at Pazyryk.
3. Guojia wenwu ju, ed., *Zhongguo zhongyao kaogu faxian 1999*, p. 77.
4. Ibid., p. 78. As Emma Bunker pointed out, many of these pieces found in Ordos graves were probably imports from China or cast by Chinese

metalworkers in local employ; So and Bunker, *Traders and Raiders*, pp. 58–59. As a result of this active trade, a gold belt plaque with eared raptor heads embellished with curved parallel ridges (similar to the frontlet) was found in eastern China in a third century BCE tomb in Hebei; see Li Xueqin, *Eastern Zhou and Qin Civilizations*, translated by K.C. Chang, (New Haven: Yale University Press, 1985), p. 334, fig. 15; and So and Bunker, *Traders and Raiders*, p. 58, fig. 24.

46. Directional tomb tile with Green Dragon of the East
東漢　四神陶磚之青龍
Eastern Han dynasty (25–220 CE) or later
Clay; L. 33.7 cm, W. 17 cm, D. 6 cm
Excavated 1988, Jinqueshan, Linyi Municipality
Collection of Linyi Municipal Museum

The sinuous, undulating body of the Green Dragon (*qinglong*) moves forward as he raises his rear haunches and springs into action.[1] His elongated jaw and open mouth end in fork-shaped lips. His horns or ears are perked back into curls. The clawed feet of three legs seem to shovel the air forward in frenetic motion while his uppermost leg reaches toward his mouth. The striped band under the throat runs down its neck to accentuate the curvature of his front chest and then continues under his trunk and along the tight reflex curves of his flicking S-shaped tail, which ends in a flame-like tip.

Known as the *siling*, or "four spirits," the Green Dragon of the East, White Tiger of the West, Red Bird of the South, and Dark Warrior of the North are the animals of the four directions.[2] The concept of gods of the four directions harkens back to Shang dynasty oracle bones. An early representation of animals associated with the directions is seen in a mirror of the seventh century BCE bearing two tigers, a stag, and a bird.[3] During the Qin and Han dynasties, four directional animals were used to decorate tiles and bricks in palaces and tombs. By the early Western Han, these animals decorated both coffins and tombs. In Tomb 1 at Mawangdui, the *siling*, comprised at that time of the dragon, tiger, phoenix, and deer, are illustrated on the inner coffin of Lady Dai (d. 186 BCE). In 130 BCE the emperor Han Wudi formally adopted a correspondence between the directions and their symbolic animals, known as the *sishen*, or "four deities." Some of the earliest large tomb bricks decorated with the four animals are found in his tomb at Maoling.[4]

Our four directional tiles, decorated with their four corresponding animals, were excavated from the tomb at Jinqueshan (Golden Sparrow Mountain) in Linyi. The

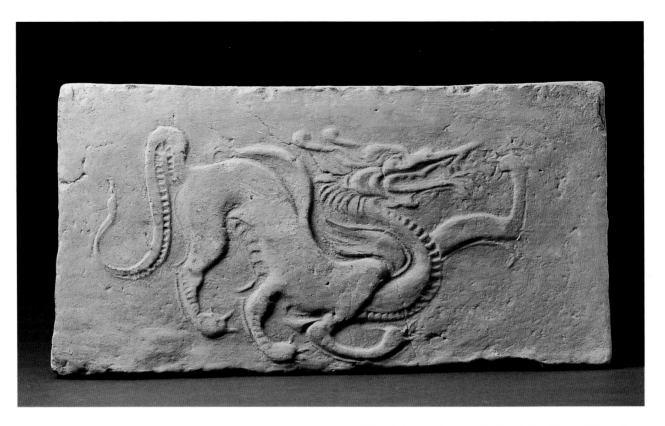

design of each animal was impressed into the wet gray clay of the hollow tile, and the finished tile was then inserted into the wall of the tomb.[5] In addition to the four directional animals, this tomb also yielded a hollow brick tile with a unicorn (*qilin*) (cat. no. 50) as well as the handprints of perhaps the artisan who made the tiles (cat. no. 51). All seven tiles were stamped on the side with the character *zhang*, the name of either the artisan or the tomb occupant. The tomb also contained two hollow tiles bearing images of horses, two tiles with differing lotus designs, a tile with a female figure, and a tile with the impression of a *wuzhu* coin (see cat. no. 19).[6] The four directional animals are an integral part of the cosmology of the Han dynasty and transform the tomb into a cosmic diagram of the afterlife, providing protection in all directions.

SLB

1. For a discussion of the cosmological associations of dragons, see cat. nos. 43 and 44.
2. According to Robert Campany, the Green Dragon (*qinglong*) is also the name of the position occupied by the six *jia* in the signs denoting segments of time. Campany quotes Stephen R. Bokenkamp to explain that "The 'six *jia*' and 'six *ding*' are spirits derived from the diviner's cosmological compass (or a table derived from it) according to a method known as *dunjia*...*jia* was designated yang, and *ding* designated yin...These became the gendered *jia* and *ding* spirits of Daoism." Robert Ford Campany, *To Live as Long as Heaven and Earth:*

A Translation and Study of Ge Hong's Traditions of Divine Transcendents (Berkeley: University of California Press, 2002), pp. 73–74. The *jia* spirits are sometimes solicited for martial protection and concealment. The six *jia* are invoked in tandem with the practice of "breaking azure (*qing*) dragon grass" with the purpose of allowing people to remain invisible to humans, animal, and spirits when entering mountains. This is from Ge Hong's Daoist text dating to 283–343. Ibid., p. 74.
3. Jessica Rawson, *Chinese Ornament: The Dragon and the Lotus* (London: The British Museum, 1984), pp. 90–92.
4. Wang Zhijie and Zhu Jieyuan, "Han Maoling ji qi peizang zhong fujin xin fajue de zhongyao wenwu" [Important relics unearthed in the vicinity of Maoling and its satellite tombs of the Western Han dynasty], *Wenwu*, no. 7 (1976), pp. 51–55.
5. For more details on how these tiles were made and the use of hollow tomb tiles in tomb architecture, see Susan L. Beningson in Liu et al., *Recarving China's Past*, cat. no. 9.
6. Linyi shi bowuguan, "Shandong Linyi Jinqueshan huaxiang zhuan mu" [The tomb with pictorial hollow bricks at Jinqueshan, Linyi, Shandong province], *Wenwu*, no. 6 (1995), pp. 72–78. In the excavation report there is a question as to whether this tomb dates to the late Eastern Han or the Western Jin dynasty. The placement of the four animals does not correspond to their exact directions, but as they are all there it is meant to symbolize protection in all directions and the order of the cosmos: the Green Dragon and White Tiger were on the north wall; the Red Bird, *qilin*, and horses were on the west wall; and the Dark Warrior was on the north wall. The tomb was robbed quite early in its existence, so there are few grave goods to be found. Zheng Yan dates the tomb to the post-Han era, saying that the pictorial hollow bricks have many of the characteristics of the Southern Dynasties. Zheng Yan, *Wei Jin Nanbeichao bihua mu yanjiu* [Research on Tomb Painting of the Wei, Jin, and Northern and Southern Dynasties] (Beijing: Wenwu chubanshe, 2002), p. 129.

47. Directional tomb tile with White Tiger of the West

東漢　四神陶磚之白虎

Eastern Han dynasty (25–220 CE) or later
Clay; L. 32 cm, W. 16.4 cm, D. 6 cm
Excavated 1988, Jinqueshan, Linyi Municipality
Collection of Linyi Municipal Museum

The White Tiger (*baihu*) turns its neck backwards and roars with bared fangs. Its elongated body prances forward, with legs in mid-stride and long tail curving up into a bottom-heavy loop. The shoulders are muscular and well articulated, underscoring the tiger's physical power and ferocity. Atop its body are three scaly horn-like projections that may be wings. A raised, ribbed band articulates the curvature of its neck and runs along the flat underside of its torso, continuing to the tip of the tail. This band defines the structure of the tail giving it the effect of chain link armor.

Tigers have long occupied an important position in the hierarchy of cosmological animals. They were represented in Shang dynasty bone inscriptions and depicted on bronzes of the Zhou dynasty. Their protective role is demonstrated on two Han dynasty painted bricks from Sichuan on which fierce stalking tigers were depicted next to the inscriptions "to avoid evil" (*bixie*) and "to remove

evil" (*chuxiong*).[1] During the Han dynasty, under the emperor Wudi, a correspondence was formalized between the directions and their related animals, as well as the seasons, elements, and colors. Formal poems recited at ceremonies placed the directional animals at the same level as Taiyi, the Supreme Unity:

> The chariot of the divinity is made of clouds.
> It is drawn by winged dragons; innumerable are its
> feathered pennants.
> The divinity descends as though carried by chargers
> of the wind;
> To the left, the Green Dragon, to the right, the White
> Tiger.[2]

During the Han dynasty, both tigers and the color white were associated with immortality. Immortals such as the legendary Pengzu, who lived eight hundred years, attracted the presence of tigers.[3] Sima Qian and Ban Gu's descriptions of the islands of immortality state that they were inhabited by "creatures, birds, and beasts completely white."[4] Tigers also had an apotropaic role at tomb sites. According to the *Zhouli*, the chief exorcist (*fangxiang*) would lead the funeral procession and upon reaching the tomb, would descend into the burial pit to drive out the spectral denizens of the ground.[5] In the

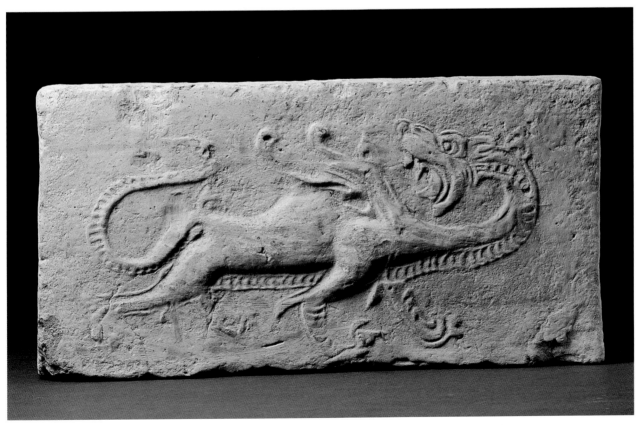

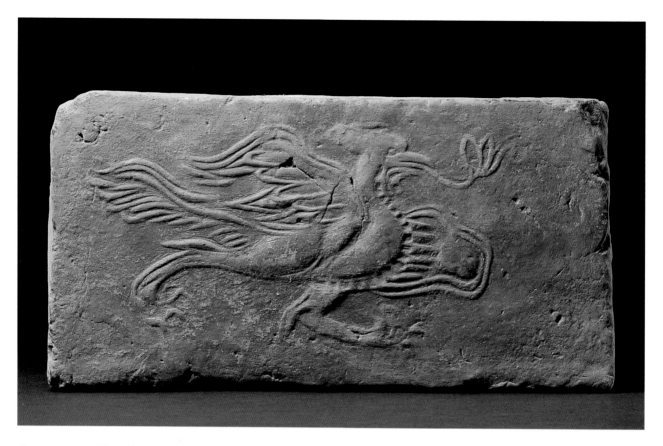

Fengsu tongyi, Ying Shao (ca. 140–206) cites this *Zhouli* passage as an explanation for the custom of planting a thuja tree on the tomb and placing a stone tiger at the head of the path to the tomb. The tiger and thuja combat the predatory spirits in the tomb and act as magical prophylactics to create a safe environment for the deceased.

SLB

1. Annette L. Juliano, *Teng-Hsien: An Important Six Dynasties Tomb* (Ascona, Switzerland: Artibus Asiae, 1980), p. 40.

2. From the *Hanshu*, as described in Rawson, *Chinese Ornament: The Lotus and the Dragon*, p. 91.

3. Roel Sterckx, *The Animal and the Daemon in Early China* (Albany: State University of New York Press, 2002), p. 152.

4. Sterckx cites the *Hanshu*, 25A.1204 and *Shiji*, 28.1370, as well as Liezi, 5.4b. Ibid., p. 152 and n. 147.

5. Donald Harper, "A Chinese Demonography of the Third Century B.C.," in *Harvard Journal of Asiatic Studies* 45, no. 2 (December 1985), p. 482.

48. Directional tomb tile with Red Bird of the South

東漢　四神陶磚之朱雀
Eastern Han dynasty (25–220 CE) or later
Clay; L. 32.5 cm, W. 16.5 cm, D. 6 cm
Excavated 1988, Jinqueshan, Linyi Municipality
Collection of Linyi Municipal Museum

The Red Bird (*zhuque*) flutters across the surface of the tomb tile. His outspread wings, filigreed with delicate linear patterning, seem ready for flight. A flower with three petals is held in the bird's elongated beak. The back thigh, modeled in the highest relief, accentuates the curvature of the four layers of wing feathers as they pulsate behind him. A double-ridged line describes the contours of the left wing and the leading edge of the right wing, and a striped band runs from his neck down his chest to his legs.

Birds are important decorative elements on Shang and Western Zhou ritual bronze vessels. In the southern kingdom of Chu, elegant sculptures of birds with wings made of antlers acted as guardians in tombs, where they were placed in front of coffins, their feet sometimes entangled with snakes.[1] It has been argued that these guardian birds possibly provided the model for the Red Bird, which was adopted as the symbol of the south in the Han dynasty. Red birds were also associated with good omens

(*xiangrui*) and became auspicious symbols for the empire. The depiction of the Red Bird is sometimes confused with the depiction of the phoenix (*fenghuang*), which later became the symbol of the empress, and in many cases there are no distinctions in the iconography of the two birds. By the Tang dynasty, two of the four directional animals, the Tiger of the West and the Dark Warrior of the North, diminished in importance, and the remaining Green Dragon and Red Bird assumed even greater roles as auspicious animals. Many important buildings and tombs in China were aligned from north to south with their entrances facing south, the most auspicious direction of all—the direction represented by the Red Bird.

Birds are also associated with the flight into the afterlife and the journey to immortality as can been seen on the ceramic bird with *ding* vessels on its wings in our exhibition (cat. no. 3). The posture of the bird, with outstretched wings, is also thought to be apotropaic.[2] Therapeutic exercises named the "bird stretch" (*niaoshen*), and the "bear ramble" (*xiongjing*) (see cat. no. 43 n. 2), are illustrated in three manuscripts from Mawangdui Tomb 3. These physical cultivation exercises imitate the movements of animals and have magico-religious significance. Just as a ruler adopted the ritually correct posture to bring order to his own person and to the world, so too might certain exercise postures restore health to any individual. In the Eastern Han, Hua Tuo taught a technique called the "disportment of the five creatures," modeled after the movements of the bird, bear, deer, gibbon, and tiger and intended to remove any sickness from the body. Because of their magical efficacy, feathered dancers performing avian movements were also included in the exorcistic performances during the New Year celebrations.

SLB

1. Rawson, *Chinese Ornament: the Lotus and the Dragon*, p. 99.
2. "A Chinese Demonography," pp. 483 & 487. Harper argues that the body itself can be exploited as a natural demonifuge even without additional magical devices, as in the common belief that spitting was effective against demons. Ibid., p. 483 n. 72.

49. Directional tomb tile with Dark Warrior of the North

東漢　四神陶磚之玄武

Eastern Han dynasty (25–220 CE) or later
Clay; L. 32.4 cm, W. 16.8 cm, D. 6 cm
Excavated 1988, Jinqueshan, Linyi Municipality
Collection of Linyi Municipal Museum

Of the four directional animals, only the Dark or Black Warrior (*xuanwu*) is in fact comprised of two animals, the

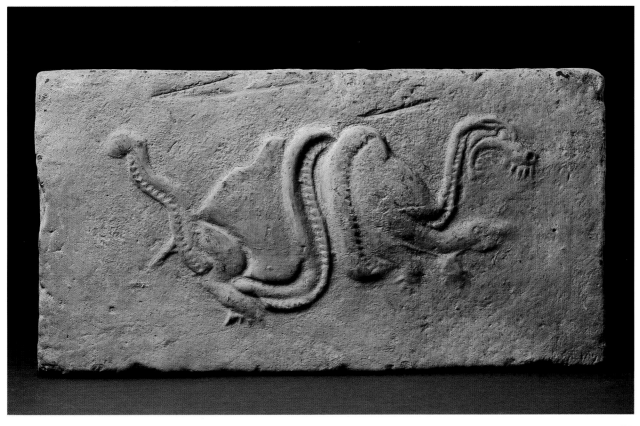

snake entwined around the tortoise. The tortoise is viewed as a microcosm of the universe, its carapace representing heaven and its underbelly, the earth(see cat. nos. 14, 15). It is also associated with longevity, stability, and immortality. Its allusion to immortality harkens to the "Tangwen" chapter of the *Liezi*, which describes the five islands that lay in the eastern seas including the island of Penglai, the dwelling place of immortals. The islands were said to have lacked roots to keep them in place, and they therefore floated at the mercy of tide and wind. The immortals complained to the supreme power Di, who worried that they might be deprived of their homes. Di commanded Yu Jiang to dispatch fifteen giant tortoises to raise their heads and hold the islands in place. The tortoises in turn formed themselves into three teams, which rotated every 60,000 years.[1] In Chinese cosmology, tortoises are always female and must mate with snakes in order to procreate. By extension, their union represents the forces of the male *yin* and the female *yang*. This meaning of the Dark Warrior is supported by inscriptions on Han dynasty mirrors:

> The fine copper which the Han dynasty possesses and which is drawn from Danyang and has been mixed with (silver and tin) and the mirror is pure and bright. The Dragon on the left and the Tiger on the right forfend all evil and keep the four quarters in order; the Scarlet Bird and the Dark Warrior accord with Yin and Yang.[2]

On our tomb tile, the snake weaves its sinuous body around that of the tortoise and appears ready to strike. Its underbelly is detailed with delicate ribbing, similar to that found on the other three directional animals shown in our exhibition, that highlights the curvature of its coiling form. The Dark Warrior continued to be used as a powerful cosmological symbol in tombs throughout the Six Dynasties period.[3]

SLB

1. This description of the *Liezi* passage is taken from Loewe, *Ways to Paradise*, pp. 40, 42. It is thought that this association with longevity, as well as stability and immortality, are the reasons why tortoises are often used as bases for stone stele with epitaphs and inscriptions. There are also two tortoises with owls on their backs in the bottom section of the Mawangdui banner. Loewe argues that their purpose there most probably relates to this story in the *Liezi*.
2. Ibid., p. 196. The description of the Dragon and Tiger is taken from both inscriptions C2102 and C2203.
3. For a further description of the Dark Warrior and other directional animals in the Six Dynasties period, see Juliano, *Teng-Hsien: An Important Six Dynasties Tomb*, pp. 35–44.

50. Tomb tile with a *qilin*

東漢　麒麟陶磚

Clay; L. 32.5 cm, W. 17 cm, D. 6 cm
Eastern Han dynasty (25–220 CE) or later
Excavated 1988, Jinqueshan, Linyi Municipality
Collection of Linyi Municipal Museum

Most likely, the animal impressed on this tomb tile is a *qilin*—a mythological composite animal with cosmological merit—rather than a lion as listed in the excavation report. In tombs, the *qilin* is often found in combination with the four directional animals. The *qilin* shown here has a craggy face like a bulldog, a body like a dog, a tail like a bird, and claws on his feet like a turtle. His face is shown in full frontal view with a broad smiling mouth, high cheeks, and small triangular ears, while his springing body is shown in profile. His long feather-like tail juts out behind him as he prances, acting as a counterbalance to the raised lines forming the whiskers around his face.

The *qilin* is often depicted with a horn jutting from his forehead like a unicorn.[1] In ancient Chinese literature, this creature is invariably linked to Confucius. The capture of a *qilin* is credited as the immediate impetus for Confucius' composition of the *Chunqiu* (Spring and Autumn Annals).[2] The mythic potency of the *qilin* during the Han dynasty was derived from its ability to portend either good government or the birth of a virtuous ruler. Such numinous animals were used as auspicious omens (*xiangrui*) to augur the virtuous and corrupt cycles implicit in imperial rule and dynastic change.[3] In 95 BCE, the Han emperor Wudi issued an edict that gold ingots were henceforth to be made in the shape of horse or *qilin* hoofs as a reward to the nobility.[4] A gold *qilin* hoof is in the collection of the Hebei Provincial Cultural Research Institute.[5] The *qilin* retained its status as an auspicious animal through the Qing dynasty when its image decorated First Rank mandarin squares on the robes of military officials.

SLB

1. In Gansu province, unicorns were found in a Han dynasty tomb at Mocuizi, Wuwei, and in a Wei-Jin dynasty tomb at Xiaheqing, Jiuquan. The bronze qilin from Tomb 18 at Xiaheqing was not found with the other grave goods in the back chamber, but rather stood alone in the middle of the front room with its head facing the tomb entrance. Another bronze unicorn, found in a late Han tomb at Leitai near Wuwei, was positioned just outside the tomb door. In the Eastern Han dynasty tomb at Gunzhuang, Mizhi county in Shaanxi, the pictorial images of two charging unicorns were carved at the bottom of the stone doors to protect the tomb entrance and to ward off

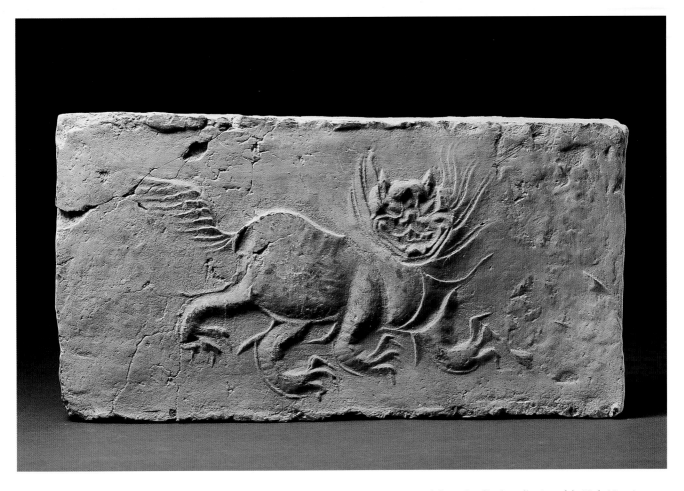

intruders. See Juliano, *Monks and Merchants*, p. 44, fig. B; pp. 45–46. Both bronze and wood sculptures of unicorns are in the collection of the Gansu Provincial Museum, and there is another bronze unicorn in the Changcheng (Great Wall) Museum located in Jiayuguan, Gansu province. A goat-like creature with a horn, thought to be a *qilin*, is incised in the limestone panels of a late Eastern Han tomb at Yinan, Shandong. See *Yinan gu huaxiangshi mu fajue baogao* [Report of the Excavation of Ancient Stone Pictorial Carvings at Yinan Tomb] (Beijing: Wenwubu wenwu guanliju, 1956), plate 29:8.

2. In the *Lunyu* as cited by Lewis, *Writing and Authority in Early China*, p. 235. Lewis further explains that Confucius collected and edited the works of earlier rulers, and himself composed the *Chunqiu* in order to "complete the Way of the King" and preserve it for the future. Ibid., p. 234.

3. Wu Hung, "A Sanpan Shan Chariot Ornament and the Xiangrui Design in Western Han Art," *Archives of Asian Art* 37 (1984), p. 39.

4. The edict says: "We captured a white unicorn and used it as an offering in the imperial ancestral temple. The Wuwa river produced a heavenly horse, and actual gold was discovered on Mount Tai [hence] it is proper that we should change [some] former appellation. Now [we] change [the shape for ingots of] actual gold to that of unicorns' feet and fine horses' hooves, in order to accord with these auspicious presages and use them to distribute among the vassal kings as grants to them." After H. H. Dubs, *The History of the Former Han Dynasty by Pan Ku* (Baltimore, 1944), vol. 2, p. 110, as cited in Michaelson, *Gilded Dragons*, pp. 56–57.

5. For more on a gold horse hoof unearthed in 1974 in Xi'an and now in the collection of the Shaanxi Provincial Historical Museum, see Wong, *Treasures from the Han*, p. 31. For gold horse hoofs, all dating to the Western Han, see *Zhongguo wenwu jinghua da cidian*, p.

245, no. 15 (single horse hoof in the collection of the Hubei Provincial Cultural Research Institute); no. 16 (Henan Provincial Museum); and no. 17 (this is the only pair in the Nanjing Museum, the rest are single hooves). See ibid., no. 18, for a gold ingot in the shape of a *qilin* hoof, dating from the Western Han and excavated in 1973, now in the collection of the Hebei Provincial Cultural Research Institute. The hoof is gold and hollow; set on its top is white glass with a gold band surrounding the rim. No. 15 has green glass inserted in the top and a similar band of gold at the rim. The other gold hooves are all empty.

51. Tomb tiles with pair of handprints

東漢　手印陶磚

Eastern Han dynasty (25–220 CE) or later
Clay; L. 33.5 cm, W. 16 cm, D. 6 cm
Excavated 1988, Jinqueshan, Linyi Municipality
Collection of Linyi Municipal Museum

The maker of the tomb might have impressed his left hand in the wet clay of these two hollow tiles, before they were inserted in the wall, to leave his physical mark in the tomb he created, the same tomb that yielded the four tiles with directional animals (cat. nos. 46–49) and the *qilin* tile (cat. no. 50). On the side of each of these tiles is stamped one character, *zhang*, which according to the

excavation report is the name of either the deceased or of the maker of the tomb.[1] There has also been speculation that this might be the name of the man who owned the workshop where the tomb tiles were made.[2] It is more likely that this is an extremely rare example of the architect of the tomb literally leaving his mark on the wall of his construction. One of the only other known examples of handprints on hollow bricks comes from a palace in Heilongjiang province and dates much later, to the Jin dynasty.[3] The tomb at Linyi dates to the third century, in either the late Eastern Han or post-Han period.

SLB

1. Linyi shi bowuguan, "Shandong Linyi Jinqueshan huaxiang zhuanmu," pp. 76–77. According to the excavation report, the same character is stamped on all six tomb tiles (four directional animals, qilin, handprints) but is slightly different on some. So there must have been more than one stamp.

2. *Kandai osha no kagayaki* [The Splendor of Royal Chariots in the Han Dynasty] (Kyoto and Yamaguchi: Kyoto Cultural museum and Yamaguchi Prefectural Museum, 2001), p. 100.

3. Another example of handprints on hollow bricks, much later in date, were found by the Heilongjiang Provincial Archaeological Research Institute in 2002 at a large construction site in Liuxiutun, Acheng City. These handprints date to the early Jin dynasty and are impressed in the hollow bricks used in construction of an imperial palace. The excavation in 2002 revealed an area of 10,000 square meters and includes a main palace, corridors, and a rear palace. Guojia wenwu ju, ed., *Zhongguo zhongyao kaogu faxian 2002*, p. 146.

Appendix 1: Major Tomb Sites and Index of Objects

Site, Excavation Date 地點和發掘年代	Kingdom 王國	Prince 諸侯王	Exhibited Objects 展品
Shuangrushan, Changqing, 1995–96 長清雙乳山	Jibei *guo* 濟北國	Liu Kuan (?–85 BCE) 劉寬	Cat. nos. 6, 28, 29, 30, 31, 32, 33, 34, 35, 36, 37, 38
Luozhuang, Zhangqiu, 1999 章丘洛莊	Lü *guo* 呂國	Lü Tai (Prince Su) (?–181 BCE) 肅王呂台	Cat. nos. 1, 4, 11, 45
Weishan, Zhangqiu, 2002 章丘危山	Jinan *guo* 濟南國	Liu Biguang (?) (?–154 BCE) 劉辟光（？）	Cat. nos. 12, 13
Jiulongshan, Qufu, 1970 曲阜九龍山	Lu *guo* 魯國	King of Lu 魯王	Cat. nos. 39, 40, 41, 42, 43, 44

Jibei *guo* occupied roughly the area of Qin dynasty Jibei *jun* (prefecture); its capital was Boyang, present-day Tai'an. In the Western Han dynasty, there were four Jibei kingdoms with 6 princes (206–85 BCE), lasting 122 years.
濟北國約在秦代濟北郡範圍，以博陽（今泰安）為都。西漢一代四個濟北國共曆六王，歷時122年。

Lü *guo*, also known as **Jichuan *guo***, occupied Jinan jun, including the area east of Jinan and west of Binzhou and Zibo. Its capital was Pingling (located west of present-day Zhangqiu). It was named by the Queen Mother of Lü, and only existed for 7 years from 187 to 181 BCE with three Lü *guo* revivals and four kings.
呂國及濟川國，在濟南郡範圍，都平陵，今章丘市西。由呂太后命名，三國四王，歷時7年。

Jinan *guo* succeeded Lüguo. It continued to occupy the territory of Jinan *jun* and kept Pingling as its capital. It only existed for one generation from 164 to 154 BCE.
濟南國，繼呂國之後，仍延續濟南郡舊地，以平陵為都。一國一王，歷時11年。

Lu *guo* was centered around Qufu. The kingdom began with the prince Liu Yu, son of Emperor Jing (r. 163–143 BCE), and was ruled by six consecutive princes from 155 to 23 BCE, a total of 133 years.
魯國，以曲阜為中心，自景帝子劉餘開始，一國六王，歷時133年。

Research by Liu Boqin and Lu Wensheng, drawn from the Shiji *and* Hanshu.
此參考資料由劉伯勤和魯文生據《史記》和《漢書》提供。

Drawing of Chariot 1 from the royal tomb at Shuangrushan, Shandong Province. After *Tokubetsuten kandai "Ōsha" no kagayaki: Chūgoku Shantō-shō Sōnyūzan seihoku ōryō shutsudo bunbutsu* (Kyoto: Kyōto fu Kyōto bunka hakubutsukan, Yamaguchiken hagi bijutsukan, and Urakami kinenkan, 2001)

gai gong
蓋弓（檩）

gai gong mao
蓋弓帽

dang lu
當盧（錫）

jie yue
節約

e shou
軛首

yi
輢

yuan shi
轅飾

heng
衡

heng mo
衡末

pei
轡

shan han
扇汗

xian
銜

biao
鑣

jing da
頸靼

yang
鞅

e
軛

e jiao
軛角

xian
韅

yin
靷

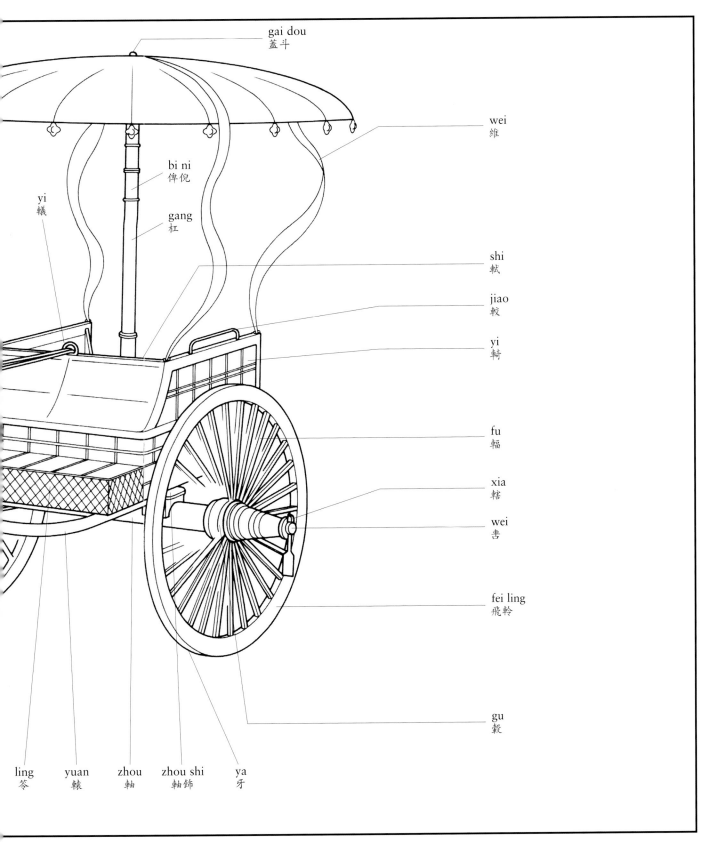

gai dou
蓋斗

wei
維

bi ni
俾倪

gang
杠

yi
檥

shi
軾

jiao
較

yi
輢

fu
輻

xia
轄

wei
軎

fei ling
飛軨

gu
轂

ling
笭

yuan
轅

zhou
軸

zhou shi
軸飾

ya
牙

APPENDIX 3: SELECTED CHINESE CHARACTERS
中文辭匯選錄

Ba	巴	*fang* (vase)	鈁
baihu	白虎	Fangmatan	放馬灘
Ban Gu	班固	*fangshi*	方士
banliang	半兩	*fangxiang*	方相
Baoshan	包山	*fantu*	犯土
bi	璧	*feiyi*	非衣
bianqing	編磬	*fenghuang*	鳳凰
bianzhong	編鐘	*Fengsu tongyi*	風俗通義
biqi	祕器	*fu*	賦
bixie	辟邪	Fu Hao	婦好
boju	博局	Fu Xi	伏羲
bosai	博塞	*fusang*	扶桑
boshanlu	博山爐	*gaigong*	蓋弓
Cang Jie	倉頡	Gaotang	高唐
Cangshan	蒼山	Gongsun Qiang	公孫強
Cao	曹	*gu* (drum)	鼓
chang shou	昌壽	*guan* (coffin)	棺
Changqing	長清	*guan* (jar)	罐
chi	螭	*guan nei hou yin*	關內侯印
chihu	螭虎	*Guanzi*	管子
chou	籌	*guiqi*	鬼器
Chuci	楚辭	*guo*	槨
chuling	芻靈	*Guoyu*	國語
Chunqiu	春秋	*Hanshu*	漢書
chunyu	錞于	Haoli	蒿裏
chuxiong	除凶	*he*	盒
dafu	大夫	*hengmo*	衡末
Dan	丹	*hengtong*	衡筒
danglu	當盧	*Hou Hanshu*	後漢書
dao	刀	Houloushan	後樓山
dasang	大喪	*hu* (shroud)	幠
Di	帝	*hu* (vessel)	壺
ding	鼎	Hua Tuo	華佗
ding (spirit)	丁	Huainanzi	淮南子
ding ding	定鼎	Huan Kuan	桓寬
Dixia hou	地下後	*huaxiangshi*	畫像石
Dong Yi	東夷	*hun*	魂
Dong yuan jiang	東園匠	*hunren*	閽人
Donggu (river)	東固河	*ji*	吉
Dongshicai	東石菜	*ji wang*	濟王
Dongwanggong	東王公	*jia*	甲
Dongzhifang	東芝房	Jia Gongyan	賈公彥
Dou Wan	竇綰	*jiangu*	建鼓
ejiao	軛角	Jibei *guo*	濟北國
fa duliang jin Shihuangdi *wei zhi*	法度量進始皇帝為之	*jietu*	解土

jifu	吉服	*mingshui*	明水
jin bing	金餅	*mingtang*	明堂
Jinan	濟南	*mingyi*	明衣
Jinan *guo*	濟南國	Mo Di	墨翟
Jining	濟寧	*Mozi*	墨子
Jinqueshan	金雀山	Muhuang shizhe	墓皇使者
jiqi (auspicious vessel)	吉器	Nanyue	南越
jiqi (sacrifice vessel)	祭器	Neize	內則
jiuding	九鼎	*niaoshen*	鳥伸
Jiulongshan	九龍山	*ou*	偶
Jiunüdun	九女墩	*pan*	盤
jiuqi	就器	Penghu	蓬壺
kan	龕	Penglai	蓬萊
Kong Yingda	孔穎達	Pengzu	彭祖
Kunlun	崑崙	*po*	魄
Lanling	蘭陵	*qilin*	麒麟
Liangzhu	良渚	*Qin Shihuangdi*	秦始皇帝
Liezi	列子	*qinglong*	青龍
Liji	禮記	Qufu	曲阜
Lilun	禮論	*renqi*	人器
Linqu	臨朐	*ri*	日
Linyi	臨沂	*ri yue yi ming*	日月以明
Linzi	臨淄	*saixi*	塞戲
lishu	隸書	*San buzu*	散不足
Liu Bang	劉邦	Shandong	山東
Liu Biguang	劉辟光	*Shanhaijing*	山海經
Liu Kuan	劉寬	Shaofu	少府
Liu Sheng	劉勝	*shen*	神
Liu tao	六韜	*sheng ren de jiu, si ren de wu*	生人得九，死人得五
liubo	陸博/六博	*shengqi*	生器
lü	律	*shengxianshu*	升仙樹
Lu (city)	盧	*shenming*	神明
Lu (kingdom)	魯	*shenyao*	神藥
Lu *guo*	魯國	*shi* (corpse)	屍
luanche	鸞車	*shi* (servicemen)	士
luanhe	鸞和	Shi Luo Hou *yin*	石洛侯印
Luchengwa	盧城窪	*Shiji*	史記
Lunheng	論衡	*Shijing*	詩經
Luozhuang	洛莊	*shou*	壽
Mancheng	滿城	Shuangrushan	雙乳山
Mawangdui	馬王堆	Shuangshan	雙山
mianguan	冕冠	*siling*	四靈
ming	明	Silu	司祿
mingde	明德	Sima Qian	司馬遷
mingqi	明器	Sima Xiangru	司馬相如

Barbieri-Low, Anthony J. "The Organization of Imperial Workshops during the Han Dynasty." Ph.D. diss., Princeton University, 2001.

———. "Wheeled Vehicles in the Chinese Bronze Age (c. 2000–741 B.C.)." *Sino-Platonic Papers* 99 (February, 2000), pp. 1–98.

Bodde, Derk. *Festivals in Classical China: New Year and Other Annual Observances during the Han Dynasty.* Princeton: Princeton University Press, 1975.

Brashier, K.E., "Han Thanatology and the Division of 'Souls.'" *Early China* 21 (1996), pp. 125–58.

———. "Longevity Like Metal and Stone: the Role of the Mirror in Han Burials." *T'oung Pao* 81, no. 4–5 (1995), pp. 201–29.

Cammann, Schuyler. "The 'TLV' Pattern on Cosmic Mirrors of the Han Dynasty." *Journal of the American Oriental Society* 68 (1948), pp. 159–67.

Campany, Robert Ford. *To Live as Long as Heaven and Earth: A Translation and Study of Ge Hong's Traditions of Divine Transcendents.* Berkeley: University of California Press, 2002.

———. "Return-from-Death Narratives in Early Medieval China." *Journal of Chinese Religions* 18 (1990), pp. 91–125.

Cao Zhezhi. *Zhongguo gu dai yong* [Ancient Burial Figures of China]. Shanghai: Shanghai wenhua chubanshe, 1996.

Cedzich, Ursula-Angelika. "Corpse Deliverance, Substitute Bodies, Name Change, and Feigned Death: Aspects of Metamorphosis and Immortality in Early Medieval China." In *Journal of Chinese Religions* 29 (2001), pp. 1–68.

———. "Ghosts and Demons, Law and Order: Grave Quelling Texts and Early Taoist Liturgy," *Taoist Resources* 4, no. 2 (1993), pp. 23–36.

Chang, Kwang-chih. "The Chinese Bronze Age: A Modern Synthesis." In *The Great Bronze Age of China*, edited by Wen Fong, pp. 35–50. New York: The Metropolitan Museum of Art, 1980.

Chang'an guibao [Treasures of Chang'an]. Hong Kong: Hong Kong Museum of Art and Cultural Bureau of Shaanxi, 1993.

Chang'an zhenbao [Treasures of Chang'an]. Beijing: Zhongguo sheying chubanshe, n.d.

Changjiang liuyu di er qi wenwu kaogu gongzuo renyuan xunlianban, "Hubei Jiangling Fenghuangshan Xi-Han mu fajue jianbao" [A brief report on the discovery of a Western Han tomb from Fenghuangshan in Jiangling, Hubei province]. *Wenwu*, no. 6 (1974), pp. 41–61.

Chee, Eng-Lee Seok. "Mingqi and other Tomb Furnishings as Reflections of Han Culture and Society." In *Spirit of Han*, pp. 30–40. Singapore: Southeast Asian Ceramic Society, 1991.

Chen Zhenyu. "Musical Instruments and Human Sacrifices in the Tomb of the Marquis Yi of Zeng." *China Archaeology and Art Digest* 2, nos. 2–3 (December, 1999), pp. 106–111.

Cheng Linquan and Han Guohe. "A Study of Gaming Board (TLV) Mirrors Unearthed in the Northern Suburbs of Xi'an." *China Archaeology and Art Digest* 4, no. 4 (April-May, 2002), pp. 97–110.

Chou, Ju-hsi. *Circles of Reflection: The Carter Collection of Chinese Bronze Mirrors.* Cleveland: The Cleveland Museum of Art, 2000.

Chūgoku sennin no furusato [China, Homeland of the Immortals]. Osaka: Ōsaka Furitsu Yayoi Bunka Hakubutsukan [Museum of Yayoi Culture], 1996.

Couvreur, Séraphin. *Li Ki ou Mémoires sur les bienséances et les cérémonies.* 2nd ed. Ho Kien Fou: Imprimerie de la Mission Catholique, 1913.

Cui Dayong. "Shuangrushan yihao Han mu yihao mache de fuyuan yu yanjiu" [Study and restoration of Chariot 1 in the Han dynasty Tomb 1 at Shuangrushan]. *Kaogu*, no. 3 (1997), pp. 16–26.

Dai Yingxin and Sun Jiaxiang. "Shaanxi Shenmu xian chutu Xiongnu wenwu" [Relics of the Xiongnu excavated in Shenmu county, Shaanxi]. *Wenwu*, no. 12 (1983), pp. 23–30.

DeWoskin, Kenneth J. "A Source Guide to the Lives and Techniques of Han and Six Dynasties Fang-shih." *Society for the Study of Chinese Religions Bulletin* 9 (Fall 1981), pp. 79–105.

Dien, Albert E., Jeffrey K. Riegel, and Nancy T. Price, eds. *Chinese Archaeological Abstracts, 3: Eastern Zhou to Han.* Los Angeles: The Institute of Archaeology, The University of California, 1985.

Dubs, H. H. *The History of the Former Han Dynasty by Pan Ku.* 3 vols. Baltimore, 1944.

Dunhuang Qijiawan: Xijin Shiliuguo muzang fajue baogao [Qijiawan, Dunhuang: Excavation report of Western Jin and Sixteen Kingdoms Tombs]. Beijing: Wenwu chubanshe, 1994.

Erickson, Susan N. "Boshanlu Mountain Censers of the Western Han Period: A Typological and Icono-logical Analysis." *Archives of Asian Art* 45 (Dec. 1992), pp. 6–28.

Erickson, Susan N. "Money Trees of the Eastern Han Dynasty." *Bulletin of the Museum of Far Eastern Antiquities* 66 (1994), pp. 1–116.

Falkenhausen, Lothar von. "Sources of Taoism: Reflections on Archaeological Indicators of Religious Change in Eastern Zhou China." *Taoist Resources* 5, no. 2 (1994), pp. 1–12.

Falkenhausen, Lothar von. *Suspended Music: Chime-Bells in the Culture of Bronze Age China.* Berke-ley: University of California Press, 1993.

Fang Penjun and Zhang Xunliao. "Shandong Cang-shan yuanjia yuannian huaxiangshi tiji de shidai he you guan wenti de taolun" [A discussion of the dating of the stone relief inscribed the first year of Yuanjia from Cangshan in Shandong province and related questions]. *Kaogu*, no. 3 (1980), pp. 271–78.

Finkel, Irving. "On Dice in Asia." *Orientations* 35, no. 6 (September, 2004), pp. 56–60.

Finkel, Irving, and Colin Mackenzie, eds. *Asian Games: The Art of Contest.* New York: The Asia Society and Museum, 2004.

Fontein, Jan, and Wu Tung. *Han and T'ang Murals.* Boston: Museum of Fine Arts, 1976.

Gansu sheng wenwu kaogu yanjiusuo and Tianshuishi Beidaoqu wenhuaguan. "Gansu Fangmatan Zhanguo Qin Han muqun de fajue" [Excavations of Warring States, Qin, and Han period tombs at Fangmatan in Tianshui, Gansu]. *Wenwu*, no. 2 (1989), pp. 1–11, 31.

Guangxi Zhuang zu zizhiqu wenwu gongzuodui, "Guangxi Guixian Luopowan yihao mu fajue jianbao" [Excavation of Tomb No. 1 at Luopowan in Guixian, Guangxi]. *Wenwu*, no. 9 (1978), pp. 25–42.

Guojia wenwu ju, ed. *Zhongguo zhongyao kaogu faxian 1999* [Major Archeological Discoveries in China in 1999]. Beijing: Wenwu chubanshe, 2001.

———, ed. *Zhongguo zhongyao kaogu faxian 2002* [Major Archaeological Discoveries in China, 2002]. Beijing: Wenwu chubanshe, 2003.

Hansen, Valerie. *Negotiating Daily Life in Traditional China: How Ordinary People Used Contracts, 600–1400.* New Haven: Yale University Press, 1995.

Hanshu [History of the Former Han]. Compiled by Ban Gu. Beijing: Zhonghu shuju, 1962.

Harper, Donald. "A Demonography of the Third Century B.C." *Harvard Journal of Asiatic Studies* 45, no. 2 (1985), pp. 459–98.

———. *Early Chinese Medical Literature: The Mawangdui Medical Manuscripts.* London: Royal Asiatic Society, 1996.

———. "Manuscripts related to Natural Philosophy." In Edward L. Shaughnessy, *New Sources of Early Chinese History: An Introduction to the Reading of Inscriptions and Manuscripts,* pp. 223–52. Berkeley: University of California and Society for the Study of Early China, 1997.

———. "Resurrection in Warring States Popular Reli-gion." *Taoist Resources* 5, no. 2 (1993), pp. 13–29.

He Shuangquan. "Tianshui Fangmatan Qin jian zhongshu" [A comprehensive survey of the Qin dynasty bamboo slips from Fangmatan at Tianshui]. *Wenwu*, no. 2 (1989), pp. 28–29.

Hebei chutu wenwu xuanji [Selection of Cultural Relics Excavated from Hebei Province]. Beijing: Wenwu chubanshe, 1980.

Hebei sheng wenhuaju wenwu gongzuodui. "Hebei Dingxian Beizhuang Han mu fajue baogao" [Excavation report of the Han tomb from Beizhuang, Dingxian, Hebei province]. *Kaogu xuebao*, no. 2 (1964), pp. 127–94.

Hentze, Carl. *Chinese Tomb Figures: A Study in the Beliefs and Folklore of Ancient China*. London: Edward Goldston, 1928.

Hu Siyong. *Jing shi Han Wang Ling*. Shandong: Jinan chubanshe, 2001.

Huang Zhanyue. "Handai Zhuhouwang mu lunshu" [Discussion of royal tombs of the Han period]. *Kaogu xuebao*, no. 1 (1998), pp. 11–34.

Hucker, Charles O. *A Dictionary of Official Titles in Imperial China*. Stanford: Stanford University Press, 1985.

Hunan sheng bowuguan and Zhongguo kexueyuan kaogu yanjiusuo, ed. *Changsha Mawangdui yihao Hanmu* [Han Tomb No. 1 at Mawangdui in Changsha]. 2 vol. Beijing: Wenwu chubanshe, 1973.

Ikeda, On. "Chūgoku rekidai bokenryakkō." *Tōyō bunka kenkyūjo kiyō* 86 (1981), pp. 193–278.

Jao Tsung-i [Rao Zongyi]. *Chinese Tomb Pottery Figures*. Exhibition catalogue. Hong Kong: Hong Kong University Press, 1953.

Jinan shi bowuguan. "Shitan Jinan Wuyingshan chutu de Xi-Han yuewu, zaji, yanyin taoyong" [Concerning the ceramic figures of dancers, acrobats, and entertainers excavated from the Western Han tomb at Wuyingshan, Jinan]. *Wenwu*, no. 5 (1972), pp. 19–23.

Jinan shi kaogu yanjiu suo, Shandong daxue kaogu xi, Shangdong sheng wenwu kaogu yanjiusuo, and Zhangqiu shi bowuguan. "Shandong Zhangqiu Luozhuang Hanmu peizang keng de qingli" [Summary report of the Han tomb and accompanying burial pits at Luozhuang, Zhangqiu, Shandong]. *Kaogu*, no. 8 (2004), pp. 3–16, color plates following p. 96.

Jining diqu wenwu zu and Jiaxiangxian wenguan suo. "Shandong Jiaxiang Songshan 1980 nian chutu de Han huaxiangshi" [Han dynasty stone reliefs unearthed in 1980 at Songshan in Jiaxiang county, Shandong province]. *Wenwu*, no. 5 (1982), pp. 60–70.

Juliano, Annette L. *Teng-Hsien: An Important Six Dynasties Tomb*. Ascona, Switzerland: Artibus Asiae, 1980.

Juliano, Annette L., and Judith Lerner. *Monks and Merchants: Silk Road Treasures from Northwest China*. New York: Harry N. Abrams, Inc. with The Asia Society, 2001.

Kandai osha no kagayaki. See *Tokubetsuten kandai "Ōsha" no kagayaki.*

Keightley, David N. *The Ancestral Landscape: Time, Space, and Community in late Shang China (ca. 1200–1045 BC)*. China Research Monograph 53. Berkeley: University of California, 2000.

Kern, Martin. *The Stele Inscriptions of Ch'in Shih-huang: Text and Ritual in Early Chinese Imperial Representation*. American Oriental Series 85. New Haven: American Oriental Society, 2000.

Kerr, Rose, ed. *Art and Design: The T.T. Tsui Gallery of Chinese Art*. London: Victoria and Albert Museum, 1991.

Kleeman, Terry. "Land Contracts and Related Documents." In *Chūgoku no shūkyō shisō to kagaku: Makio Ryōkai Hakushi shōju kinen ronshū* [Religion Thought and Science in China: A Festschrift in Honor of Professor Ryōkai Makio on his seventieth birthday], pp. 1–34. Tokyo: Kokusho Kankōkai, 1984.

Knechtges, David R. "The Emperor and Literature: Emperor Wu of the Han." In *Court Culture and Literature in Early China*, Variorum Collected Studies Series, pp. 51–76. Hampshire, England and Burlington, Vt.: Ashgate Publishing, 2002.

———. "A Journey to Morality: Chang Heng's 'The Rhapsody on Pondering the Mystery'." In *Court Culture and Literature in Early China*, Variorum Collected Studies Series, pp. 169–71. Burlington, Vt.: Ashgate Publishing Company, 2002.

Lawton, Thomas. *Chinese Art of the Warring States: Change and Continuity, 480–222 B.C.* Washington DC: Freer Gallery of Art and Indiana University Press, 1982.

Le Blanc, Charles. "Huai nan tzu." In Michael Loewe, ed., *Early Chinese Texts: A Bibliographical Guide*, Early China Special Monograph Series No. 2, pp. 189–95. Berkeley: Society for the Study of Early China and Institute of East Asian Studies, 1993.

Legge, James. *The Chinese Classics*. Reprint, Taibei: Southern Materials Center, Inc., 1985.

———. *The Li Ki*. The Sacred Books of the East, edited by F. Max Müller, vol. 28. Oxford: Clarendon Press, 1885.

Lewis, Candace J. "Pottery Towers of Han Dynasty China." Ph.D. diss., Institute of Fine Arts, New York University, 1999.

Lewis, Mark Edward. "Dicing and Divination in Early China." *Sino-Platonic Papers* 121 (July, 2002), pp. 1–22.

———. *Writing and Authority in Early China.* Albany: State University of New York Press, 1999.

Li Chunyi. *Zhongguo shanggu chutu yueqi zonglun* [Compendium of Ancient Chinese Excavated Musical Instruments]. Beijing: Wenwu chubanshe, 1996.

Li Jiemin. "'Yinwan Hanmu boju mudu shijie' zengbu" [Supplement to 'A tentative interpretation of the Han dynasty wooden slip from Yinwan bearing the *liubo* board divination']. *Wenwu*, no. 8 (2000), pp. 73–75.

Li Ling. "The Common Origins of Divination and Gaming." *China Archaeology and Art Digest* 4, no. 4 (April-May, 2002), pp. 49–52.

Li Rixun. "Shandong Zhangqiu Nülangshan Zhanguo mu chutu yuewu taoyong ji you guan wenti" [Questions concerning the excavation of musical and dancing ceramic figures at the Warring States tomb at Nülangshan, Zhangqiu, Shandong]. *Wenwu*, no. 3 (1993), pp. 1–6.

Li Xueqin. *Eastern Zhou and Qin Civilizations.* Translated by K.C. Chang. New Haven: Yale University Press, 1985.

———. "Fangmatan jian zhong de zhiguai gushi" [Stories recording strange occurrences in the bamboo slips from Fangmatan]. *Wenwu*, no. 4 (1990), pp. 43–47.

Li Yinde. "Xuzhou chutu Xi-Han yu mianzhao de fuyuan yanjiu" [Study and restoration of the Western Han jade face-cover excavated in Xuzhou]. *Wenwu*, no. 4 (1993), pp. 46–49.

Li Zude. "A Preliminary Study of Qin and Han Gold Currency." English summary. *China Archaeology and Art Digest* 2, no. 1 (January-March 1997), pp. 146–47. The original Chinese article appeared in *Zhongguo shi yanjiu* [Journal of Chinese Historical Studies] (issued by History Institute, Chinese Academy of Social Sciences, Beijing), no. 1 (1997), pp. 52–61.

Liji ji jie [*Rites Records* and Collected Explications]. Compiled by Sun Xidan. Beijing: Zhonghua shuju, 1989.

Lim, Lucy et al. *Stories from China's Past: Han Dynasty Pictorial Tomb Reliefs and Archeological Objects from Sichuan Province, People's Republic of China.* San Francisco: The Chinese Culture Foundation, 1987.

Linyi Jinqueshan Han mu fajue zu. "Shandong Linyi Jinqueshan jiuhao Han mu fajue jianbao" [Brief excavation report on the Han dynasty Tomb 9 at Jinqueshan, Linyi county, Shandong]. *Wenwu*, no. 11 (1977), pp. 24–27.

———. "Shandong Linyi Jincuishan jiuhao hanmu fajue jianbao" [Brief excavation report of Han tomb no. 9 at Jinqueshan, Linyi county, Shandong province]. *Wenwu*, no. 11 (1977), pp. 24–27.

Linyi shi bowuguan. "Shandong Linyi Jinqueshan huaxiang zhuan mu" [Pictorial brick tomb at Jinqueshan, Linyi county, Shandong]. *Wenwu*, no. 6 (1995), pp. 72–78.

———. "Shandong Linyi Jinqueshan jiuzuo Handai muzang" [Nine Han dynasty tombs at Jinquechan in Linyi, Shandong]. *Wenwu*, no. 1 (1989), pp. 21–47.

Liu, Cary Y. "Embodying Cosmic Patterns: Foundations of an Art of Calligraphy in China." *Oriental Art* 56, no. 5 (2000), pp. 2–9.

———. "The Yüan Dynasty Capital, Ta-tu: Imperial Building Program and Bureaucracy." *T'oung Pao* 78 (1992), pp. 264–301.

Liu, Cary Y., Michael Nylan, Anthony Barbieri-Low, et al. *Recarving China's Past: Art, Archaeology, and Architecture of the "Wu Family Shrines."* Princeton: Princeton University Art Museum, 2005.

Liu, James. "The Sung Emperors and the *ming-t'ang* or Hall of Enlightenment." In *Études Song in memoriam Étienne Balazs,* ed. Francoise Aubin, ser. 2, no. 1, pp. 45–58. Paris: Mouton, 1973.

Liu Jiaji and Liu Bingsen. "Jinqueshan Xi-Han bo hua linmo hou gan" [Later thoughts and copy of the Western Han cloth painting at Jinqueshan]. *Wenwu*, no. 11 (1977), pp. 28–31, front inside cover, and pl. 1.

Liu Ning. "'Tangren' xiaokao" [A short study on ironing stands]. *Liaohai wenwu xuekan*, no. 2 (1997), pp. 111–14.

Liu Shanyi. "Shuangrushan Xi-Han Jibei wangling" [Western Han Jibei kingdom royal mausoleum at Shuangrushan]. In *Tokubetsuten kandai "Ōsha" no kagayaki: Chūgoku Shantō-shō Sōnyūzan seihoku ōryō shutsudo bunbutsu*, pp. 18–23, 123–25. Exhibition catalogue. Kyoto: Kyōto fu Kyōto bunka hakubutsukan, Yamaguchiken hagi bijutsukan, and Urakami kinenkan, 2001.

Liu Yu. "The 'Rites of Zhou' in Western Zhou bronze." *China Archaeology and Art Digest* 2, nos. 2–3 (December, 1999), pp. 128–37.

Lobell, Jarrett A. "Warriors of Clay." *Archaeology* 56, no. 2 (2003), pp. 36–39.

Loewe, Michael. *A Biographical Dictionary of the Qin, Former Han and Xin Periods (221 B.C.–A.D. 24)*. Leiden: Brill, 2000.

———. *Chinese Ideas of Life and Death: Faith, Myth and Reason in the Han Period (202 BC–AD 220)*. London: George Allen & Unwin, 1982.

———, ed. *Early Chinese Texts: A Bibliographical Guide*. Berkeley: The Society for the Study of Early China and The Institute of East Asian Studies, University of California, Berkeley, 1993.

———. *Divination, Mythology and Monarchy in Han China*. London: Cambridge University Press, 1994.

———. "The Orders of Aristocratic Rank of Han China." *T'oung Pao* 48, no. 1-3 (1960), pp. 97–174.

———. "State Funerals of the Han Empire." *Bulletin of the Museum of Far Eastern Antiquities (Östasiatiska museet) Stockholm* 71 (1999), pp. 5–71.

———. *Ways to Paradise: The Chinese Quest for Immortality*. London: George Allen & Unwin, 1979.

Luo Zhenyu. *Gu mingqi tulu* [Illustrated Catalogue of Ancient Mingqi]. Shangyu: Luo shi, 1916.

Luoyang bowuguan. "Luoyang Zhongzhoulu Zhanguo chemakeng chutu tongqi" [The chariot pit found at Zhongzhoulu, Luoyang]. *Kaogu*, no. 3 (1974), pp. 171–78.

Ma Qianwei and Li Yong. "Changqing Jibei wangling fajue ji" [Record of the excavation of the Jibei kingdom royal mausoleum]. In *Jinan zhongda kaogu fajue jishi*, pp. 170–80. Jinan: Huanghe chubanshe, 2003.

MacKenzie, Colin. "From Diversity to Synthesis: New Roles of Metalwork and Decorative Styles during the Warring States and Han Periods." In *Inlaid Bronze and Related Material from pre-Tang China*, pp. 7–17. London: Eskenazi, Ltd., 1991.

———. "Games as Signifiers of Cultural Identity in Asia: *Weiqi* and Polo." *Orientations* 35, no. 6 (September, 2004), pp. 48–55.

Major, John. *Heaven and Earth in Early Han Thought: Chapters Three, Four and Five of the Huainanzi*. Albany: State University of New York Press, 1993.

Maspero, Henri. "Le Ming-Tang et la crise religieuse chinoise avant les Han." *Mélanges chinoises et bouddhiques*, 9 (1948–1951), pp. 1–71.

———. "Le mot *ming*." *Journal Asiatique* 223, no. 2 (1933), pp. 249–296.

Michaelson, Carol. *Gilded Dragons: Buried Treasures from China's Golden Ages*. London: British Museum Press, 1999.

Munakata, Kiyohiko. *Sacred Mountains in Chinese Art*. Urbana and Chicago: University of Illinois Press, 1991.

Nickerson, Peter. "The Great Petition for Sepulchral Plaints." In Stephen R. Bokenkamp, *Early Daoist Scriptures*, pp. 230–60. Berkeley: University of California Press, 1997.

———. "Shamans, Demons, Diviners and Taoists: Conflict and Assimilation in Medieval Chinese Ritual Practice (c. A.D. 100–1000)." *Taoist Resources* 5, no. 1 (1994), pp. 41–66.

Nylan, Michael. *The Five "Confucian" Classics*. New Haven: Yale University Press, 2001.

Peterson, Willard J. "Making Connections: 'Commentary on the Attached Verbalizations' of the *Book of Change*." *Harvard Journal of Asiatic Studies* 42, no. 1 (1982), pp. 67–116.

Pirazzoli-t'Serstevens, Michele. *The Han Dynasty*. New York: Rizzoli, 1982.

Poo, Mu-chou. *In Search of Personal Welfare: A View of Ancient Chinese Religion*. Albany: SUNY Press, 1998.

Qianan District Cultural Protection Institute. "Hebei Qianan Yujiacun yihao Hanmu qingli" [Summary of no. 1 Han tomb at Yujia village, Qianan district, Hebei province]. *Wenwu*, no. 10 (1996), pp. 30–42.

Qiu Guangming. *Zhongguo lidai duliang hengkao* [History of China's Weights and Measures]. Beijing: Kexue chubanshe, 1992.

Rawson, Jessica. *Chinese Bronzes, Art and Ritual*. London: The British Museum, 1987.

———. *Chinese Jade from the Neolithic to Qing*. London: The British Museum, 1995.

———. *Chinese Ornament: The Dragon and the Lotus*. London: The British Museum, 1984.

———. "Chu Influences on the Development of Han Bronze Vessels." *Arts Asiatiques* 44 (1989), pp. 84–99.

———. "The Eternal Palaces of the Western Han: A New View of the Universe." *Artibus Asiae* 59 (1999), pp. 5–58.

Rawson, Jessica, and Emma Bunker. *Ancient Chinese and Ordos Bronzes*. Hong Kong: Oriental Ceramic Society of Hong Kong and Hong Kong Art Museum, 1990.

Ren Xianghong. "Shuangrushan yihao mu muzhu kaolue" [Examination into the occupant of Tomb 1 at Shuangrushan]. *Kaogu*, no. 3 (1997), pp. 10–15.

———. "Zao shi liangda de Han wangling—Changqing Shuangrushan Xi-Han Jibei wangling" [Largest rock-cut Han royal tomb—the Western Han Jibei royal tomb at Shuangrushan, Changqing, Shandong]. In *Shandong zhongda kaogu xin faxian 1990–2003*, edited by Xie Zhixiu, pp. 113–31. Beijing: Shandong wenhua yinxiang chubanshe, 2003.

Ruitenbeek, Klaas. *Chinese Shadows: stone reliefs, rubbings and related works of art from the Han Dynasty (206 BC–AD 220) in the Royal Ontario Museum*. Toronto: Royal Ontario Museum, 2002.

Schloss, Ezekiel. *Ancient Chinese Ceramic Sculpture from Han Through Tang*. 2 vols. Stamford, Ct.: Castle Publishing Co., Ltd., 1977.

———. *Art of the Han*. New York: China House Gallery, 1979.

Seidel, Anna. "Buying One's Way to Heaven: The Celestial Treasury in Chinese Religions." *History of Religions* 17 (1978), pp. 419–32.

———. "Post-Mortem Immortality or: The Taoist Resurrection of the Body." In *Gilgul: Essays on the Transformation, Revolution and Permanence in the History of Religions*, edited by S. Shaked, D. Shulman, G.G. Stroumsa, pp. 223–37. Leiden and New York: E.J. Brill, 1987.

———. "Tokens of Immortality in Han Graves." *Numen* 29 (1982), pp. 79–122.

———. "Traces of Han Religion in Funeral Texts Found in Tombs." In *Dōkyō to shūkyō bunka*, edited by Akitsuki Kan'ei, pp. 21–57. Tokyo: Hirakawa, 1987.

Shandong daxue kaogu xi, Shandong sheng wenwu ju, and Changqing wenwu ju. "Shandong Changqing xian Shuangrushan yihao mu fajue jianbao" [Brief excavation report on Tomb 1 at Shuangrushan, Changqing county in Shandong]. *Kaogu*, no. 3 (1997), pp. 1–9, 26.

Shandong sheng bowuguan. "Linzi Langjiazhuang yihao Dong-Zhou xunren mu" [Excavation of Eastern Zhou Tomb 1 with human sacrifices at Langjiazhuang, Shandong]. *Kaogu xuebao*, no. 1 (1977), pp. 73–104.

———. "Qufu Jiulongshan Han mu fajue jianbao" [Brief excavation report of the Han tomb at Jiulongshan, Qufu]. *Wenwu*, no. 5 (1972), pp. 39–44, 54.

———. *Shandong sheng bowuguan cangping xuan* [Selections from Collection of the Shandong Provincial Museum]. Jinan: Shandong youyi shushe, 1991.

Shandong sheng bowuguan and Cangshan xian wenhua guan. "Shandong Cangshan yuanjia yuannian huaxiangshi mu" [The stone relief tomb of the first year of Yuanjia at Cangshan in Shandong]. *Kaogu*, no. 2 (1975), pp. 124–34.

Shandong sheng bowuguan and Linyi wenwu zu. "Linyi Yinqueshan sizuo Xi-Han mucang" [Four Western Han tombs at Yinqueshan, Linyi county]. *Kaogu*, no. 6 (1975), pp. 363–72, 351.

———. "Shandong Linyi Xi-Han mu faxian 'Sunzi Bingfa' he 'Sun Bin Bingfa' deng jujian de jianbao" [Brief report on the bamboo strips of "Sunzi

Bingfa" and "Sun Bin Bingfa" excavated from the Western Han tomb at Linyi Shandong]. *Wenwu*, no. 2 (1974), pp. 15–26.

Shandong wenwu shiye guanli ju, ed. *Shandong wenwu jingcui* [The Best Cultural Relics from Shandong]. Shandong: Meishu chubanshe, 1996.

Shandong wenwu xuanji [Archaeological Selections from Shandong]. Beijing: Wenwu chubanshe, 1959.

Shanghai shi fangzhi kexue yanjiu yuan wenwu yanjiu zu and Shanghai shi sichou gongye gongsi, eds. *Changsha Mawangdui yihao Hanmu: chutu fangzhipin de yanjiu* [Han Tomb Number One at Mawangdui in Changsha: Research on excavated woven silk textiles]. Beijing: Wenwu chubanshe, 1980.

Sima Qian. *Records of the Grand Historian: Han Dynasty*. 2 vols. Translated by Burton Watson. Rev. ed. New York: Renditions/Columbia University Press, 1993.

———. *Records of the Grand Historian: Qin Dynasty*. Translated by Burton Watson. New York: Renditions/Columbia University Press, 1993.

So, Jenny F. "The Inlaid Bronzes of the Warring States Period." In *The Great Bronze Age of China*, edited by Wen Fong, pp. 305–320. New York: The Metropolitan Museum of Art and Alfred A. Knopf, 1980.

———, ed. *Music in the Age of Confucius*. Washington D.C.: Freer Gallery of Art and Arthur M. Sackler Gallery, Smithsonian Institution, 2000.

So, Jenny F., and Emma C. Bunker. *Traders and Raiders on China's Northern Frontier*. Seattle and London: Arthur M. Sackler Gallery, Smithsonian Institution and the University of Washington Press, 1995.

Song Fusheng. *Shanxi sheng bowuguan cang wenwu jinghua* [Masterworks of the Shanxi Provincial Museum Collection]. Taiyuan: Shanxi People's Publishing House, 1999.

Soothill, William E. *The Hall of Light*. London: Lutterworth Press, 1951

Soper, Alexander C. "The Dome of Heaven." *The Art Bulletin* 29, no. 4 (December 1947), pp. 225–48.

Stein, Rolf A. "Religious Taoism and Popular Religion from the Second to Seventh Centuries." In Anna Seidel and Holmes Welch, eds., *Facets of Taoism*, pp. 53–81. New Haven: Yale University Press.

———. "Remarques sur les mouvements du Taoisme politico-religieux au IIème siècle ap. J.-C." *T'oung Pao* 50 (1963), pp. 1–78.

———. *The World in Miniature: Container Gardens and Dwellings in Far Eastern Religious Thought*. Translated by Phyllis Brooks. Stanford: Stanford University Press, 1990.

Steinhardt, Nancy Shatzman. "The Han Ritual Hall." In *Chinese Traditional Architecture*, pp. 69–77. New York: China Institute in America, 1984.

Sterckx, Roel. *The Animal and the Daemon in Early China*. Albany: State University of New York Press, 2002.

Suixian Leigudun yihao mu kaogu fajuedui. "Hubei Suixian Zeng Houyi mu fajue jianbao" [A brief report on the excavation of the tomb of Marquis Yi of Zeng in Suixian, Hubei]. *Wenwu*, no. 7 (1979), pp. 1–24.

Sun Ji. "Drum and Tocsin." *China Archaeology and Art Digest* 2, nos. 2–3 (December, 1999), pp. 55–60.

———. *Zhongguo gu yu fu luncong* [Essays on Ancient Chinese Vehicles and Garments]. Rev. ed. Beijing: Wenwu chubanshe, 2001.

Tang Jinyu. "Xi'an xi jiao Han dai jianzhu yizhi fajue baogao" [Excavation report on Han architectural relics in the western outskirts of Xi'an]. *Kaogu xuebao*, no. 2 (1959), pp. 45–55.

Thorp, Robert. "Mortuary Art and Architecture of Early Imperial China." Ph.D. diss., University of Kansas, 1979.

Tokubetsuten kandai "Ōsha" no kagayaki: Chūgoku Shantō-shō Sōnyūzan seihoku ōryō shutsudo bunbutsu [The Splendor of Royal Chariots in the Han Dynasty]. Exhibition catalogue. Kyoto: Kyōto fu Kyōto bunka hakubutsukan, Yamaguchiken hagi bijutsukan, and Urakami kinenkan, 2001.

Twitchett, Denis, and Michael Loewe, eds. *The Ch'in and Han Empires, 221 B.C.–A.D. 220*. Vol. 1 of *Cambridge History of China*. Cambridge: Cambridge University Press, 1986.

Wagner, Lothar. "Chinese Seals." In *7000 Years of Seals*, edited by Dominique Collon, pp. 205–222. London: British Museum Press, 1997.

Wakayama Kenritsu Hakubutsukan. *Chūgoku santoshō no tama* [Treasures of Shandong province, China]. Wakayama, Japan: Wakayama Kenritsu Hakubutsukan, 1998.

Waley, Arthur, trans. *The Book of Songs*. New York: Grove Press, 1960.

Wan Quanwen. "Ba ren yu zhunyu" [The Ba people and *chunyu*]. *Wenwu tiandi*, no. 5 (1997), pp. 34–36.

Wang Chong. *Lunheng suoyin* [Concordance to the *Lunheng*]. Edited by Zhang Xiangqing et al. Beijing: Zhonghua shuju, 1994.

Wang Shougong. "Jinan guowang de ling yi chu lingdi—Zhangqiu Weishan Handai muzang ji peizang keng" [Another royal mausoleum at Jinan—Han dynasty tomb and accompanying pit at Weishan, Zhangqiu county]. In *Shandong zhongda kaogu xin faxian 1990–2003*, edited by Xie Zhixiu, pp. 151–58. Beijing: Shandong wenhua yinxiang chubanshe, 2003.

———. "Weishan Hanmu: di wu chu yong bingma tong pei zang de wang ling" [The Han tomb at Weishan: the fifth royal tomb where cavalry figures have been unearthed]. *Wenwu tiandi*, no. 2 (2004), pp. 58–65.

Wang Zhijie and Zhu Jieyuan. "Han Maoling ji qi peizang zhong fujin xin fajue de zhongyao wenwu" [Important relics unearthed in the vicinity of Maoling and its satellite tombs of the Western Han dynasty]. *Wenwu*, no. 7 (1976), pp. 51–55.

Wang Zhongshu. *Han Civilization*. New Haven: Yale University Press, 1982.

Watson, Burton, trans. *Basic Writings of Mo Tzu, Hsün Tzu, and Han Fei Tzu*. New York: Columbia University Press, 1963.

———, trans. *The Tso Chuan: Selections from China's Oldest Narrative History*. New York: Columbia University Press, 1989.

Watson, William. *The Genius of China: An Exhibition of the Archaeological Finds of the People's Republic of China*. London: The Royal Academy, 1973.

Wilford, John Noble. "Terra-Cotta Army from Early Han Dynasty is Unearthed." *New York Times*, 18 February 2003.

Wong, Grace, ed. *Treasures from the Han*. Singapore: Historical and Cultural Exhibitions and The Empress Place, 1990.

Wu, Hung. "Art in a Ritual Context: Rethinking Mawangdui." *Early China* 17 (1992), pp. 111–44.

———. "A Sanpan Shan Chariot Ornament and the Xiangrui Design in Western Han Art." *Archives of Asian Art* 37 (1984), pp. 38–59.

———. *The Wu Liang Shrine: The Ideology of Early Chinese Pictorial Art*. Stanford, Calif.: Stanford University Press, 1989.

Xie Zhixiu, ed. *Shandong zhongda kaogu xin faxian, 1990–2003* [Largest New Archaeological Discoveries in Shandong 1990–2003]. Beijing: Shandong wenhua yinxiang chubanshe, 2003.

Xiong Zhuanxin. "Tan Mawangdui sanhao Xi-Han mu chutu de liubo" [Discussion of the *liubo* game excavated from Western Han Tomb M3 at Mawangdui]. *Wenwu*, no. 4 (1979), pp. 35–39.

Xunzi jinzhu jin yi [Modern Annotation And Explanation of *Xunzi*]. Annotated by Xiong Gongzhe. Rev. ed. Taibei: Taiwan shangwu yinshuguan, 1984.

Xuzhou bowuguan. "Xuzhou Houloushan Xi-Han mu fajue baogao" [Excavation report for the Western Han tomb at Houloushan, Xuzhou]. *Wenwu*, no. 4 (1993), pp. 29–45.

Yan tie lun jiaozhu [*Yan tie lun* with Critical Annotations]. Annotated by Wang Liqi. Tianjin: Tianjin guji chubanshe, 1983.

Yang Hongxun. "Cong yizhi kan Xi-Han Chang'an mingtang (biyong) xingzhi" [Configuration of the Mingtang (Biyong) as viewed from the remains at Western Han dynasty Chang'an]. In Yang Hongxun, *Jianzhu kaogu xuelun wenji* [Essays on Archaeology and Architecture in China], pp. 169–200. Beijing: Wenwu chubanshe, 1987.

Yang, Lien-sheng. "A Note on the So-Called TLV Mirrors and the Game of *Liu-po*." *Harvard Journal of Asiatic Studies* 9 (1947), pp. 202–206.

———. "An Additional Note on the Ancient Game of *Liu-po*." *Harvard Journal of Asiatic Studies* 15 (1952), pp. 124–39.

———. *Money and Credit in China: A Short History*. Harvard-Yenching Institute Monograph Series 12. 1952. Reprint, Cambridge: Harvard University Press, 1971.

Yang, Xiaoneng, ed. *The Golden Age of Chinese Archaeology*. New Haven: Yale University Press, 1999.

Yinan gu huaxiangshi mu fojue baogao [Report of the Excavation of Ancient Stone Pictorial Carvings at Yinan Tomb]. Beijing: Wenwubu wenwu guanliju, 1956.

Yü, Ying-shih. "Life and Immortality in the Mind of Han China." *Harvard Journal of Asiatic Studies* 25 (1964–65), pp. 80–122.

———. "'O Soul, Come Back!' A Study in the Changing Conceptions of the Soul and Afterlife in Pre-Buddhist China." *Harvard Journal of Asiatic Studies* 42, no. 2 (1987), pp. 363–95.

———. "New Evidence on the Early Chinese Conception of Afterlife — A Review Article." *Journal of Asian Studies* 41, no. 1 (1981), pp. 81–85.

Zeng Lanying [Lillian L. Tseng]. "Divining from the Game *Liubo*: An Explanation of a Han Wooden Slip Excavated at Yinwan." *China Archeology and Art Digest* 4, no. 4 (April-May, 2002), pp. 55–62.

Zhang Maohua. "Money Trees Explained." *China Archaeology and Art Digest* 4, no. 4 (April-May 2002), pp. 20–21.

Zheng Dekun and Shen Weijun. *Zhongguo mingqi* [Chinese Mingqi]. Beijing: Harvard-Yenjing Institute, 1933.

Zheng Yan. *Anqiu Dongjiazhuang Han huaxiangshi mu*. Jinan, Shandong: Jinan chubanshe, 1992.

———. "Kaogu fajue chutu de Zhongguo Dong-Han (Binwang mu) bihua" [Archaeological excavation of the Chinese Eastern Han (Tomb of King Bin) paintings]. In *Yishu shi yanjiu* [Study of Art History], vol. 5, pp. 510–18. Guangzhou: Zhongshan daxue chubanshe, 2003.

———. *Wei Jin Nanbeichao bihua mu yanjiu* [Research on Tomb Painting of the Wei, Jin, and Northern and Southern Dynasties]. Beijing: Wenwu chubanshe, 2002.

Zheng Yan'e. "Preliminary Remarks on the Games of *Liubo* and *Saixi*." *China Archaeology and Art Digest* 4, no. 4 (April-May 2003), p. 80. pp. 89–95

Zhongguo huaxiangshi quanji [Collected Pictorial Stones of China]. Jinan: Shandong meishu chubanshe, 2000.

Zhongguo kexueyuan kaogu yanjiusuo. *Luoyang Zhongzhoulu (Xigongduan)*. Beijing: Kexue chubanshe, 1959.

Zhongguo meishu quanji: Gongyi meishu bian. Vol. 10, *Jin yin boli falang qi* [Gold, Silver, Glass, Cloisonne]. Beijing: Wenwu chubanshe, 1988.

Zhongguo shehui kexueyuan kaogu yanjiusuo. "Chang'an Zhangjiapo Xi Zhou Jing Shu mu fajue baogao" [Excavation of the tomb of Jing Shu from the Western Zhou at Zhangjiapo, Chang'an]. *Kaogu*, no.1 (1986), pp. 22–27, 11.

Zhongguo shehui kexueyuan kaogu yanjiu suo and Hebei sheng wenwu guanli chu. *Mancheng Hanmu fajue baogao* [Report of the Han Tombs Excavated at Mancheng]. 2 vols. Beijing: Wenwu chubanshe, 1980.

Zhongguo wenwu jinghua [Gems of China's Cultural Relics]. Beijing: Wenwu chubanshe, 1990.

Zhongguo wenwu jinghua da cidian: jin yan yu shi juan [Compendium of Archaeological Treasures of China: Gold, Silver, Jade, and Stone Volume]. 2nd ed. Shanghai: Shanghai cishu chubanshe, 1999.

Zhou Xun and Gao Chunming. *Zhongguo fu shi wu qian nian / 5000 Years of Chinese Costumes*. 3rd Chinese ed. Hong Kong: The Commercial Press, 1988.

Zhouli zhushu [*Zhou Rites* and Annotations]. In *Shisan jing zhushu*. Beijing: Zhonghua shuju, 1980.

CHINA INSTITUTE GALLERY EXHIBITIONS: 1966–2004

** 1. SELECTIONS OF CHINESE ART FROM PRIVATE
COLLECTIONS IN THE METROPOLITAN AREA
November 15, 1966–February 15, 1967
Curator: Mrs. Gilbert Katz

** 2. ART STYLES OF ANCIENT SHANG
April 5–June 11, 1967
Curator: Jean Young

** 3. ANIMALS AND BIRDS IN CHINESE ART
October 25, 1967–January 28, 1968
Curator: Fong Chow

** 4. GARDENS IN CHINESE ART
March 21–May 26, 1968
Curator: Wan-go H.C. Weng

** 5. CHINESE JADE THROUGH THE CENTURIES
October 24, 1968–January 26, 1969
Curator: Joan M. Hartman

** 6. FOREIGNERS IN ANCIENT CHINESE ART
March 27–May 25, 1969
Curator: Ezekiel Schloss

** 7. CHINESE PAINTED ENAMELS
October 23, 1969–February 1, 1970
Curator: J.A. Lloyd Hyde

**8. ALBUM LEAVES FROM THE SUNG AND
YUAN DYNASTIES
March 26–May 30, 1970
Curator: C.C. Wang

** 9. MING PORCELAINS: A RETROSPECTIVE
October 29, 1970–January 31, 1971
Curator: Suzanne G. Valenstein

**10. CHINESE SILK TAPESTRY: K'O-SSU
March 24–May 27, 1971
Curator: Jean Mailey

** 11. EARLY CHINESE GOLD AND SILVER
October 21, 1971–January 30, 1972
Curator: Dr. Paul Singer

** 12. DRAGONS IN CHINESE ART
March 23–May 28, 1972
Curator: Hugo Munsterberg

** 13. WINTRY FORESTS, OLD TREES: SOME
LANDSCAPE THEMES IN CHINESE PAINTING
October 26, 1972–January 28, 1973
Curator: Richard Barnhart

** 14. CERAMICS IN THE LIAO DYNASTY:
NORTH AND SOUTH OF THE GREAT WALL
March 15–May 28, 1973
Curator: Yutaka Mino

** 15. CHINA TRADE PORCELAIN:
A STUDY IN DOUBLE REFLECTIONS
October 25, 1973–January 27, 1974
Curator: Claire le Corbeiller

** 16. TANTRIC BUDDHIST ART
March 14–May 24, 1974
Curator: Eleanor Olson

** 17. FRIENDS OF WEN CHENG-MING:
A VIEW FROM THE CRAWFORD COLLECTION
October 24, 1974–January 26, 1975
Curators: Marc F. Wilson and Kwan S. Wong

** 18. ANCIENT CHINESE JADES FROM THE
BUFFALO MUSEUM OF SCIENCE
April 3–June 15, 1975
Curator: Joan M. Hartman

** 19. ART OF THE SIX DYNASTIES:
CENTURIES OF CHANGE AND INNOVATION
October 29, 1975–February 1, 1976
Curator: Annette L. Juliano

** 20. CHINA'S INFLUENCE ON AMERICAN
CULTURE IN THE 18TH AND 19TH CENTURIES
April 8 –June 13, 1976
Curators: Henry Trubner and William Jay Rathburn
(Exhibition traveled to the Seattle Art Museum,
October 7–November 28, 1976.)

21. CHINESE FOLK ART IN AMERICAN
COLLECTIONS: EARLY 15TH THROUGH
20TH CENTURIES
October 27, 1976–January 30, 1977
Curator: Tseng Yu-Ho Ecke

22. EARLY CHINESE MINIATURES
March 16–May 29, 1977
Curator: Dr. Paul Singer

** 23. I-HSING WARE
October 28, 1977–January 29, 1978
Curator: Terese Tse Bartholomew
(Exhibition traveled to the Nelson Gallery of Art,
Kansas City, February 19–May 21, 1978,
and the Asian Art Museum of San Francisco,
June 16–September 21, 1978.)

** 24. EMBROIDERY OF IMPERIAL CHINA
March 17–May 28, 1978
Curator: Jean Mailey

** 25. ORIGINS OF CHINESE CERAMICS
October 25, 1978–January 28, 1979
Curator: Clarence F. Shangraw

** 26. ART OF THE HAN
March 14–May 27, 1979
Curator: Ezekiel Schloss

27. TREASURES FROM THE METROPOLITAN
MUSEUM OF ART
October 25–November 25, 1979
Curator: Clarence F. Shangraw

** 28. CHINESE ART FROM THE NEWARK MUSEUM
March 19–May 25, 1980
Curators: Valrae Reynolds and Yen Fen Pei

29. CHINESE PORCELAINS IN
EUROPEAN MOUNTS
October 22, 1980–January 25, 1981
Curator: Sir Francis Watson

* 30. FREEDOM OF CLAY AND BRUSH THROUGH
SEVEN CENTURIES IN NORTHERN CHINA:
TZ'U-CHOU TYPE WARES 960–1600 A.D.
March 16–May 24, 1981
Curator: Yutaka Mino
(Exhibition originated at Indianapolis Museum of Art.)

**31. THE ART OF CHINESE KNOTTING
July 29–September 21, 1981
Curator: Hsia-Sheng Chen

**32. MASTERPIECES OF SUNG AND YUAN
DYNASTY CALLIGRAPHY FROM THE
JOHN M. CRAWFORD JR. COLLECTION
October 21, 1981–January 31, 1982
Curator: Kwan S. Wong, assisted by Stephen Addiss
(Exhibition traveled to the Spencer Museum,
University of Kansas, March 14–April 18, 1982.)

33. THE COMMUNION OF SCHOLARS:
CHINESE ART AT YALE
March 20–May 30, 1982
Curator: Mary Gardner Neill
(Exhibition traveled to the Museum of Fine Arts,
Houston, June 22–August 22, 1982, and the Yale Art
Gallery, New Haven, October 5, 1982–April 17, 1983.)

* 34. CHINA FROM WITHIN
November 4–December 12, 1982
A Smithsonian Institution Travelling Services
Exhibition, organized by the International Photography
Society in cooperation with the China Exhibition
Agency, Beijing, and the Chinese Embassy,
Washington, DC

**35. BAMBOO CARVING OF CHINA
March 18–May 29, 1983
Curators: Wang Shixiang and Wan-go H.C. Weng
(Exhibition traveled to The Nelson-Atkins Museum of
Art, Kansas City, July 24–September 11, 1983, and
the Asian Art Museum of San Francisco, October 3,
1983–January 15, 1984.)

36. CHINESE CERAMICS OF THE
TRANSITIONAL PERIOD: 1620–1683
October 21, 1983–January 29, 1984
Curator: Stephen Little
(Exhibition traveled to the Kimbell Art Museum,
Fort Worth, May 26–August 26, 1984.)

* 37. MASTERPIECES OF CHINESE EXPORT
PORCELAIN AND RELATED DECORATIVE
ARTS FROM THE MOTTAHEDEH COLLECTION
February 10–March 7, 1984
U.S.–China 200 Bicentennial Exhibition,
organized by Anita Christy

**38. CHINESE TRADITIONAL ARCHITECTURE
April 6–June 10, 1984
Curator: Nancy Shatzman Steinhardt
(A permanent travelling exhibition of China Institute.
Shown at Allegheny College, Meadeville, PA,
March 28–April 19, 1985; Marlboro College,
Marlboro, VT, September 11–October 31, 1985;
State University of New York, Binghamton,
January 7–February 27, 1986.)

** 39. CHINESE RARE BOOKS IN
AMERICAN COLLECTIONS
October 20, 1984–January 29, 1985
Curator: Soren Edgren

40. THE SUMPTUOUS BASKET: CHINESE
LACQUER WITH BASKETRY PANELS
March 20– June 3, 1985
Curator: James C.Y. Watt

** 41. KERNELS OF ENERGY, BONES OF EARTH:
THE ROCK IN CHINESE ART
October 26, 1985–January 26, 1986
Curator: John Hay

* 42. PUPPETRY OF CHINA
April 19–June 29, 1986
Curator: Roberta Helmer Stalberg
Organized by the Center for Puppetry Arts, Atlanta

43. SELECTIONS OF CHINESE ART FROM
PRIVATE COLLECTIONS
October 18, 1986–January 4, 1987
Exhibition celebrating the 60th Anniversary of China
Institute and the 20th Anniversary of China Institute
Gallery, organized by James C.Y. Watt and
Annette L. Juliano.

* 44. 1987 NEW YEAR EXHIBITION

* 45. CHINESE FOLK ART
April 4–May 30, 1987
Curator: Nancy Zeng Berliner

46. RICHLY WOVEN TRADITIONS:
COSTUMES OF THE MIAO OF
SOUTHWEST CHINA AND BEYOND
October 22, 1987–January 4, 1988
Curator: Theresa Reilly

* 47. 1988 NEW YEAR EXHIBITION
February 4–February 24, 1988

** 48. RITUAL AND POWER:
JADES OF ANCIENT CHINA
April 23–June 19, 1988
Curator: Elizabeth Childs-Johnson

* 49. STORIES FROM CHINA'S PAST
September 17–November 12, 1988
Curator: The Chinese Culture Center of San Francisco

* 50. 1989 NEW YEAR EXHIBITION: LANTERNS
January 28–February 25, 1989

* 51. MIND LANDSCAPES:
THE PAINTINGS OF C.C. WANG
April 3–May 27, 1989
Curator: Jerome Silbergeld

**52. CHINA BETWEEN REVOLUTIONS:
PHOTOGRAPHY BY SIDNEY D. GAMBLE, 1917–1927
June 29–September 9, 1989
Curator: The Sidney D. Gamble Foundation for
China Studies and China Institute in America

* 53. VIEWS FROM JADE TERRACE:
CHINESE WOMEN ARTISTS, 1300–1912
October 5–December 2, 1989
Organized by Indianapolis Museum of Art

* 54. 1990 NEW YEAR EXHIBITION:
THE CHINESE EARTH–VIEWS OF NATURE
January–March 1990
Curator: Anita Christy

55. CLEAR AS CRYSTAL, RED AS FLAME:
LATER CHINESE GLASS
April 21–June 16, 1990
Curator: Claudia Brown and Donald Robiner

56. THE ECCENTRIC PAINTERS OF YANGZHOU
October 20–December 15, 1990
Curator: Vito Giacalone

* 57. 1991 NEW YEAR EXHIBITION:
CHILDREN IN CHINESE ART
January 26–March 2, 1991
Organized under the auspices of the China Institute
Women's Association

**58. ANCIENT CHINESE BRONZE ART:
ASTING THE PRECIOUS SACRAL VESSEL
April 20–June 15, 1991
Curator: W. Thomas Chase

59. EARLY CHINESE CERAMICS FROM
NEW YORK STATE MUSEUMS
October 19–December 14, 1991
Curator: Martie W. Young

60. TREASURES OF THE LAST EMPEROR:
SELECTIONS FROM THE PALACE MUSEUM,
BEIJING
February 1–March 7, 1992
Curator: Lawrence Wu

**61. LAMAS, PRINCES AND BRIGANDS:
PHOTOGRAPHS BY JOSEPH ROCK OF THE
TIBETAN BORDERLANDS OF CHINA
April 15–July 31, 1992
Curator: Michael Aris

62. WORD AS IMAGE:
THE ART OF CHINESE SEAL ENGRAVING
October 21–December 12, 1992
Curator: Jason C. Kuo

63. A YEAR OF GOOD FORTUNE:
LEGENDS OF THE ROOSTER AND
TRADITIONS OF THE CHINESE NEW YEAR
January 19–March 6, 1993
Curator: Willow Weilan Hai

* 64. DISCARDING THE BRUSH:
GAO QIPEI, 1660–1734
April 17–June 12, 1993
Curator: Klass Ruitenbeek
Organized by the Rijksmuseum Amsterdam

**65. AS YOU WISH: SYMBOL AND MEANING ON
CHINESE PORCELAINS FROM THE TAFT
MUSEUM
October 23–January 15, 1994
Curator: David T. Johnson

* 66. SENDING AWAY THE OLD,
WELCOMING THE NEW
February 5–March 5, 1994
Curator: Karen Kane

* 67. CAPTURING A WORLD:
CHINA AND ITS PEOPLE–
PHOTOGRAPHY BY JOHN THOMSON
March 26–June 11, 1994
Curator: organized by the British Council,
catalog by the British Council

* 68. AT THE DRAGON COURT:
CHINESE EMBROIDERED MANDARIN
SQUARES FROM THE SCHUYLER V.R.
CAMMANN COLLECTION
October 20–December 22, 1994
Brochure from similar show which took place at
Yale Univ. Art Gallery
Curator: John Finlay

**69. ANIMALS OF THE CHINESE ZODIAC:
CELEBRATING CHINESE NEW YEAR
January 20–March 4, 1995
Curator: Willow Weilan Hai

70. CHINESE PORCELAINS OF THE
SEVENTEENTH CENTURY: LANDSCAPES,
SCHOLARS' MOTIFS AND NARRATIVES
April 22–August 5, 1995
Curator: Julia B. Curtis

71. ABSTRACTION AND EXPRESSION IN
CHINESE CALLIGRAPHY
October 14–December 21, 1995
Curator: H. Christopher Luce
(Exhibition traveled to the Seattle Art Museum,
Washington, November 21, 1996 to March 23, 1997.)

* 72. CALLIGRAPHY AS LIVING ART:
SELECTIONS FROM THE JILL SACKLER
CHIENSE CALLIGRAPHY COMPETITION
Feburary 3–March 9, 1996
Curator: Willow Weilan Hai, in conjunction with the
A. M. Sackler Foundation, Washington, D.C.

* 73. HARE'S FUR, TORTOISESHELL AND
PARTRIDGE FEATHERS CHINESE BROWN-
AND BLACK-GLAZED CERAMICS, 400–1400
April 20–July 6, 1996
Curator: Robert Mowry
Organized by the Harvard University Art Museum,
Massachusetts

74. THE LIFE OF A PATRON: ZHOU LIANGGONG (1612–1672) AND THE PAINTERS OF SEVENTEENTH-CENTURY CHINA
October 23–December 21, 1996
Curator: Hongnam Kim

*75. ADORNMENT FOR ETERNITY: STATUS AND RANK IN CHINESE ORNAMENT
February 6-July 14, 1997
Curators: Julia White and Emma Bunker
Organized by the Denver Art Museum

76. POWER AND VIRTUE: THE HORSE IN CHINESE ART
September 11 - December 13, 1997
Curator: Robert E. Harrist, Jr.

*77. SCENT OF INK: THE ROY AND MARILYN PAPP COLLECTION OF CHINESE ART
February 5 – June 20, 1998
Curator: Claudia Brown
Organized by the Phoenix Art Museum

*78. CHINESE SNUFF BOTTLES FROM THE PAMELA R. LESSING FRIEDMAN COLLECTION
September 16 – December 13, 1998
Organized by the Asian Art Coordinating Council

79. A LITERATI LIFE IN THE TWENTIETH CENTURY: WANG FANGYU—ARTIST, SCHOLAR, CONNOISSEUR
February 11-June 20, 1999
Curator: H. Christopher Luce

80. THE RESONANCE OF THE QIN IN EAST ASIAN ART
September 17-December 12, 1999
Curator: Stephen Addiss

*81. THE STORY OF RED: CELEBRATE THE CHINESE NEW YEAR IN 2000
January 12 - February 11, 2000
Curator: Willow Weilan Hai Chang

82. DAWN OF THE YELLOW EARTH: ANCIENT CHINESE CERAMICS FROM THE MEIYINTANG COLLECTION
March 21-June 18, 2000
Curator: Regina Krahl

83. THE CHINESE PAINTER AS POET
September 14-December 20, 2000
Curator: Jonathan Chaves

*84. LIVING HERITAGE: VERNACULAR ENVIRONMENT IN CHINA
January 25-June 10, 2001
Curator: Kai-yin Lo

85. EXQUISITE MOMENTS: WEST LAKE & SOUTHERN SONG ART
September 25-December 9, 2001
Curator: Hui-shu Lee

*86. CIRCLES OF REFLECTION: THE CARTER COLLECTION OF CHINESE BRONZE MIRRORS
February 7-June 2, 2002
Curator: Ju-hsi Chou
Organized by the Cleveland Museum of Art

87. BLANC DE CHINE: DIVINE IMAGES IN PORCELAIN
September 19–December 7, 2002
Curator: John Ayers

*88. WEAVING CHINA'S PAST: THE AMY S. CLAGUE COLLECTION OF CHINESE TEXTILES
January 30–June 7, 2003
Curator: Claudia Brown
Organized by the Phoenix Art Museum

89. PASSION FOR THE MOUNTAINS: 17TH CENTURY LANDSCAPE PAINTINGS FROM THE NANJING MUSEUM
September 18 – December 20, 2003
Curator: Willow Weilan Hai Chang

*90. GOLD AND JADE: IMPERIAL JEWELRY OF THE MING DYNASTY FROM THE NANJING MUNICIPAL MUSEUM
February 12, 2004 – June 5, 2004
Re-organized by the China Institute Gallery in collaboration with the Nanjing Municipal Museum

*91. THE SCHOLAR AS COLLECTOR: CHINESE ART AT YALE
September 3, 2004 – December 11, 2004
Curator: David Ake Sensabaugh
Organized by the Yale University Art Gallery

For information on availability of these titles and others, please contact China Institute in America at (212) 744–8181

* No catalogue or exhibition catalogue published by another institution*

** Catalogue out of print*

CHINA INSTITUTE

Virginia A. Kamsky
Yue-Sai Kan
William W. Karatz
Alice King
Angela H. King
Marie and Shau Wai Lam
John Jody and Yue Tao Lee
John M. Leger and Sophie Orloff
Karen Li
William M. Lipton
William E. and Helen Y. Little
Robert W. and Virginia Riggs Lyons
Christophe Mao and John Tanrock
Clare Tweedy and Howard McMorris
Robert E. and Joyce H. Mims
Mechlin and Valerie Moore
Theresa M. Reilly
James and Joanne Quan Reynolds
Peter Scheinman
Daniel Shapiro
Linda R. Shulsky
Anthony M. Solomon
Martha Sutherland
Charles J. Tanenbaum
Henry and Patricia P. Tang
Theow-Huang Tow
Shao F. and Cheryl L. Wang
Yvonne C. and Frederick Wong
Yvonne Veronica Wong
Savio and Emily Chang Woo
Robert P. and Barbara Youngman
Ivan D. Zimmerman and Taryn L. Higashi

Academic
Julia Fochler
Annette L. Juliano and Joseph L. Geneve
William Raiford
June de H. Weldon
Laura B. Whitman and Thomas Danziger

GALLERY COMMITTEE

Yvonne L.C. Wong, *Chair*

Susan L. Beningson
Claudia G. Brown
John R. Curtis, Jr., Past Chair
Robert Harrist
Maxwell K. Hearn
Annette L. Juliano
David Ake Sensabaugh
Jerome Silbergeld
Marie-Hélène Weill

GALLERY

Willow Weilan Hai Chang, Director
Pao Yu Cheng, Gallery Coordinator
Jennifer Choiniere, Gallery Registrar

DOCENTS

Nora Ling-yun Shih, Senior Docent
Stephanie Lin, Senior Docent
Roberta Nitka
Peggy Hung

VOLUNTEERS

Mary Mc. Fadden
Jeannette N. Rider
Anna-Rose Tykulsker
Pamela May
Jackie Handel
Ann Dillion
Hunter Demos